AUGUSTINE

De Civitate Dei

Book V

ARIS & PHILLIPS CLASSICAL TEXTS

AUGUSTINE
De Civitate Dei
Book V

edited with an Introduction, Translation and Commentary by
P.G. Walsh

Aris & Phillips is an imprint of
Oxbow Books

ISBN 978-0-85668-793-8 Paperback
ISBN 978-0-85668-798-3 Hardback

A CIP record for this book is available from the British Library

Cover design by Mya Padget
Photography by Joey Boylan

Printed and bound by
Athenaeum Press, Gateshead, Tyne & Wear

Contents

Preface

As this is the third volume in this edition of *The City of God*, I must refer readers to Volume I for detailed acknowledgements. I again owe a heavy debt to the excellent edition of B. Dombart–A. Kalb (5th edn., Stuttgart–Leipzig 1993), and to the Commentaries of G. Bardy (*Oeuvres de S. Augustin* 33, Paris 1954) and of J. Welldon (London 1924). From time to time I have consulted the Loeb translation of W.M. Green, and the Cambridge rendering of R.W. Dyson.

Professor Christopher Collard has read the proofs with his diligent eye and professional expertise, and has eliminated many errors. I am particularly indebted to Mya Padget for her meticulous preparation of this volume for publication.

Abbreviations

(For citations of individual authors, see the Bibliography)

ACW	Ancient Christian Writers
CAH	Cambridge Ancient History
CD	De Ciuitate Dei
GR	Greece and Rome
LSJ	Liddell–Scott–Jones, Greek-English Lexicon
Mnem.	Mnemosyne
Mus. Helv.	Museum Helveticum
*OCD*³	Oxford Classical Dictionary, 3rd edn. (1999)
*ODCC*³	Oxford Dictionary of the Christian Church, 3rd edn. (1997)
PL	Patrologia Latina
RAC	Reallexikon für Antike und Christentum
RE	Real-Encyclopädie (edd. Pauly–Wissowa–Kroll)
TLL	Thesaurus Linguae Latinae

Bibliography

This list does not include the numerous monographs on Augustine, or more general accounts of *The City of God*. For these, see the bibliographies in *CCL* 47 and in O'Daly (see below). The titles here have particular reference to Book V.

S. Angus	*The Sources of the First Ten Books of Augustine's De Civitate Dei* (Princeton 1906)
A.H. Armstrong (ed.)	*The History of Later Greek and Early Medieval Philosophy* (Cambridge 1970)
G. Bardy–G. Combès	*La cité de Dieu I–V* (Paris 1954)
T.D. Barnes	*Constantine and Eusebius* (Oxford 1981)
P. Brown	*Augustine of Hippo* (London 1967)
	Religion and Society in the Age of St Augustine (London 1972)
A. Cameron	*Claudian* (Oxford 1970)
F. Homes Dudden	*Saint Ambrose, his Life and Times* (Oxford 1935)
D. Earl	*The Moral and Political Tradition of Rome* (London 1967)
A. Erskine	*The Hellenistic Stoa* (London 1990)
J. Fontaine (ed.)	*Ambroise de Milan: Hymnes* (Paris 1992)
W.H.C. Frend	*The Donatist Church* (Oxford 1952)
M.T. Griffin	*Nero, the End of a Dynasty* (London 1984)
W.K.C. Guthrie	*A History of Greek Philosophy VI* (Cambridge 1981)
H. Hagendahl	*Augustine and the Latin Classics* (Stockholm 1967)
A.E. Housman	*Manilius II* (Cambridge 1937)
A.H.M. Jones	*The Later Roman Empire* (2 vols., Oxford 1964)
I.G. Kidd–L. Edelstein	*Posidonius, the Fragments* (2 vols., Cambridge 1988–9)
C. Kirwan	*Augustine* (London 1989)
A. Labhardt,	'Curiositas', *Mus. Helv.* 17 (1950), 206ff.
E. Littré	*Oeuvres complets d'Hippocrate* (10 vols., Paris 1839–61)
A.A. Long–D.N. Sedley	*The Hellenistic Philosophers* (2 vols., Cambridge 1987)
A.A. Long	*Hellenistic Philosophy* (London 1974)
S. MacCormack	*The Shadow of Poetry: Virgil in the Mind of Augustine* (Berkeley 1998)
N.B. McLynn	*Ambrose of Milan* (Berkeley 1994)
R.A. Markus	*The End of Ancient Christianity* (Cambridge 1990)
G.B. Matthews (ed.)	*The Augustinian Tradition* (Berkeley 1999)
J.B. Mayor	*Cicero, De natura deorum II* (Cambridge 1883)
G. O'Daly	*Augustine's City of God; a Reader's Guide* (Oxford 1999)
R.M. Ogilvie	*A Commentary on Livy I–V* (Oxford 1965)
A.S. Pease	*Cicero, De divinatione* (2 vols., Urbana 1920–23)
H. Rahner	*Greek Myths and Christian Mystery* (London 1962)

J. Rist	*Stoic Philosophy* (Cambridge 1969)
	Epicurus, an Introduction (Cambridge 1972)
Sir David Ross	*Aristotle*[5] (London 1964)
N. Russell	*The Lives of the Desert Fathers* (Oxford 1981)
E.T. Salmon	*Samnium and the Samnites* (Cambridge 1967)
F.H. Sandbach	*The Stoics* (London 1975)
H.H. Scullard	*From the Gracchi to Nero* (London 1959)
R.W. Sharples	*Cicero, On Fate, and Boethius, The Consolation of Philosophy IV 5–7, V* (Warminster 1991)
S.J. Tester	*A History of Western Astrology* (Woodbridge 1987)
J. Vogt	*The Decline of Rome* (London 1967)
P.G. Walsh (ed.)	*The Poems of Paulinus of Nola* (*ACW* 40, N.Y. 1975)
	Augustine, *De bono coniugali, De sancta uirginitate* (Oxford 2001)
	'The Rights and Wrongs of Curiosity', *GR* 35 (1988), 74ff.
J.E.C. Welldon	*S. Aurelii Augustini, De civitate Dei contra paganos libri XXII* (2 vols., London 1924)

Introduction

I

In the closing chapter of this book, Augustine provides a brief account of the progress of *The City of God* thus far. He indicates that he had earlier issued Books I–III separately in AD 412–13 (for the date, see 26.8n. below) and has now in AD 415 appended Books IV–V to complete the first main section of the work. His aims in this first pentad are summarised in a letter of AD 415 addressed to bishop Evodius: "To the three books written on the city of God in opposition to its enemies, the worshippers of the Roman demons, I have added two others. In these five books enough, I think, has been said to counter those who maintain that their gods must be worshipped to secure prosperity in the present life, and who, in the belief that this prosperity is hindered by us, are hostile to the Christian name" (*Ep.* 169.1). A second letter, composed later between 417 and 419, states that the first five books "refute those who claim that to attain or preserve earthly life and temporal happiness in human affairs, what is necessary is not the worship of the one supreme and true God, but that of a large number of gods". (*Ep.* 180A.5).[1]

Book I, composed in the years following the world-shattering news of the sack of Rome by the Goths in 410, rebutted the charge that the disaster was attributable to the ban on pagan ritual and the imposition of Christianity, with the claims that the conversion to the new religion had alleviated the sufferings of pagans and Christians alike, and that Rome had endured other such reverses in its chequered history. Books II and III take up this theme systematically. In Book II Augustine exploits the judgements of Cicero and Sallust to underline the moral decline of the Roman state, and in Book III to recount the physical reverses and injustices which had beset her from the foundation.

Book IV then presents a devastating critique of the absurdities and contradictions implicit in Roman polytheism, though the final chapters (27–32) confront more respectfully the rationalising of Roman intellectuals like Varro, who seek to justify the traditional religion as a symbolic representation of the forces of nature.

II

In Book V Augustine searches out and presents an answer to the question which lies behind the earlier books. In spite of the moral bankruptcy of the Roman state, and in spite of the disasters and injustices which have marked her history since the foundation, Rome has extended her imperial sway throughout Europe and the Near

East. If the pagan gods have not guided her to this terrestrial eminence, how has this success been achieved? Augustine divides his response into four main sections.

In the first section (chs. 1–11) he reviews at length the solution offered by some philosophers; that the expansion and consolidation of empire was the outcome of chance or fate.[2] His rejection of this explanation is linked with his assertion of free will under the guidance of divine Providence. Providence has endowed Roman leaders with traditional virtues, and the second section of the book (chs. 12–20) offers a respectful account of these virtues, but with the caveat that the aims of glory and honour for the individual, and dominion for the state, are at odds with Christianity's application of the virtues. This discussion leads on to the third section (chs. 21–23) which is the key to Augustine's philosophy of history: the Roman empire has spread and is maintained in existence by divine Providence. In the final section (chs. 24–26) there is a reflection on the fact that the agents of such providential governance can be pagans as well as Christians, but Constantine and Theodosius are singled out as representing the ideal of the Christian emperors.[3]

III

In his discussion of fate, the central focus of the first section (chs. 1–11), Augustine initially restricts the concept to condemn the predictions of the astrologers, in particular their claim to foretell the future from the position of the stars. Though his ultimate purpose is to reject the thesis that the expansion and continuing existence of the Roman empire are to be the mere process of impersonal fate, he narrows the issue down to the destiny of individuals, in relation to which the claims of the astrologers can be more effectively refuted.

The cult of astrology had spread from Babylon to Alexandria in Hellenistic times, and thereafter attracted increasing respect in the later empire. Augustine had himself dabbled in it during his flirtation with Manichaeism.[4] His later rejection of the doctrine root and branch was in part the result of his study of Cicero's *De diuinatione* and *De fato*, treatises which in turn owe much to the scepticism towards the claims of the astrologers of the reforming Stoic Panaetius.[5] In his *De fato*, Cicero had contrasted the conflicting explanations in Hippocrates and Posidonius of the identical medical histories of a certain pair of twins; Augustine follows Cicero in supporting the arguments of the physician against those of the philosopher-astrologer, and he reinforces them with personal testimony of twins whose social and medical histories differed totally from each other. After brief consideration of the celebrated experiment of the Potter's Wheel (Augustine is willing to accept the analogy, but rejects the conclusion which Nigidius draws from the parallel), he cites

further examples of twins with dissimilar subsequent careers first from scripture, in the persons of Esau and Jacob (ch. 4), and from personal knowledge of twins of different sexes, who embraced totally different life-styles (ch. 6). While accepting that the position of heavenly bodies can exercise physical effects upon the world of nature, he pours scorn on the practice of consultation of astrologers when choosing a propitious date for marriage, or for routine agricultural practices. Where such dates prove auspicious, we are to suspect the intervention of the demons.[6]

Thus far Augustine has been concerned solely with astrology; with ch. 8 he turns to those philosophers who envisage fate as the nexus of causes and effects established by God. These are Stoics, against whom Cicero had inveighed in his *De diuinatione* and *De fato*. As at many points in his writings, Augustine signals his deep respect for Cicero (9.5 and n.), but here he differs sharply from him. Cicero's main thrust is to vindicate the freedom of the human will against the claim that all is predetermined. While he accepts that foreknowledge of some events is possible on the evidence of the senses or rational inference, he claims, with his mentor Carneades, that events which occur at random or by chance – that is, events with no antecedent cause – cannot be foreknown not only by man but even by God. Augustine by contrast argues that all events are attributable to the antecedent cause of the will of God or of the wills of his creatures. The free will of his creatures is foreordained by God, so that its existence is not inconsistent with his foreknowledge.

At this point (ch. 9, 8 and 11) Augustine invokes the authority of scripture in his claim that God is the efficient cause of all things. The word fate, he reminds us, derives from *fari* or utterance, and the concept of fate is acceptable only if it is interpreted as what God has declared. God, who has spoken once (*Ps.* 61.12), is spirit and life (*John* 6.64). Augustine concludes this first main section of the book with highly rhetorical observations of God as the source of all things in nature (ch. 11).[7]

IV

Since God exercises providence over all things, that providence extends to kingdoms and their rulers, and in the second main section (chs. 12–20), Augustine turns to consideration of the moral characters of the leaders who established the Roman empire. In contrast to his judgements in Book II, where he invokes Sallust and Cicero to witness the moral decadence of the Roman state, he here offers a more positive analysis of the qualities which made the Romans the masters of the world. His short answer to the question of why God aided the Romans to imperial glory is that a minority of them were good men in their earthly roles, worthy of emulation in their commitment by Christians.

Augustine begins his survey with early Rome. What motivated Romans in first seeking freedom from the oppression of the second Tarquin, and subsequently, as the city grew, dominion over neighbouring states, was their desire for glory. The classic literary accounts of Roman imperial progress – Virgil's *Aeneid* and Sallust's history – are exploited to lend authenticity to this thesis. In spite of the injustices perpetrated from the beginning, the few good men ensured that by industry and frugality, rather than indolence and luxury, they achieved that success to which their passion for glory in the service of the state impelled them.

It was God who granted Rome such men as these. The love of praise and honour which motivated them, though criticised by the poet Horace (13.2), led them to repress grosser vices, especially avarice, and Cicero is invoked (13.6) to indicate the importance of aspiring to honour and glory. By contrast, Augustine devotes a brief chapter (14) to injunctions from holy scripture which warn Christians against aspiring to praise from their fellow-men. While the Romans gained their recompense from such plaudits, Christians are to look to heaven for their reward (chs. 15–16).

Augustine next pays tribute to the rule of law which the Romans established throughout the empire. Here he offers a significant clue to his political attitudes, as always offering a God's-eye view. Though he condemns the slaughter by aggressive imperialism, he admires the equality of rulers and subjects before the law, which offers the possibility of security and upright behaviour to all. Conquerors and conquered alike pay their taxes, and education is available to both (17.3).

Augustine's readers are next exhorted to examine the signal virtues of Romans which were inspired by patriotism, and to emulate them out of love for the heavenly city. A catalogue of heroic leaders and of the sacrifices which they endured offers a challenge to Christians. Brutus and Torquatus sacrificed their sons for the safety or welfare of the state, whereas Christians are asked merely to relinquish their wealth. Camillus rose above dishonour and victimisation to save Rome; why, then, should Christians boast of lesser hardships? Scaevola surrendered his right arm, and Curtius and the Decii their lives; Regulus endured torture and death. Such noble behaviour should inspire Christian martyrs. As signal examples of frugality Augustine adduces L. Valerius, Cincinnatus, and Fabricius; Christians in the spirit of the *Acts of the Apostles* should share their possessions, and without boasting. Augustine concludes that Romans such as these offer a twofold challenge to Christians: we must emulate such virtues, but we must do so with humility. He suggests that God in his providence sponsored the growth of the empire so that the Roman virtues could be embraced by Christians (18.13).[8]

In this sense Augustine lends modified approval to the Roman ambition for glory, and in ch. 19 he distinguishes such glory sought honourably from the naked lust for power which Cicero and Sallust characterised as unjust and depraved

(19.1n.). The emperor Nero is cited as the arch-example of the unscrupulous ruler, an exemplar which is to father numerous such judgements in medieval literature. By citation of *Job* 34.30, Augustine implies that Nero was set on the imperial throne as punishment for the sins of the people, but in general he believes that God accorded the Romans divine favour because they rose superior to other races in virtue (19.5). Nonetheless, he emphasises that their aspiration to human glory is comparable with the Epicurean exaltation of pleasure as the chief good, and he closes this section with Cleanthes' satirical depiction of Pleasure being served by the cardinal virtues. A similar picture, he suggests, could depict Glory on the pedestal, for the virtues have no truck with it. The godly man would rather eye his faults than the qualities which nurture self-esteem (ch. 20).

V

In the third section of the book (chs. 21–23) Augustine states explicitly what has been implicit in the previous section; that the Roman empire was set in place by God, and is governed by his providence. This is a sub-theme of his later thesis that God has ordered the entire history of man from Adam to the present days of the Church. God is the measure of human history, which is divided into three eras: sinless humanity before the Fall, sinful humanity until Christ's coming, and thereafter humanity partly redeemed and partly damned. God exists timelessly beyond all history, guiding the world on a course which is just for all men, but which remains unfathomable to us until the final judgement.[9]

In ch. 21 Augustine contrasts the Romans with other nations to which God has apportioned lengthy dominion. Persians and Jews rise superior to Romans in their systems of beliefs, for Persians acknowledge only two gods, and Jews only one, as against the polytheism of Rome. Implicit here is the notion that God does not promote one system of belief over another, but mysteriously bestows empire on all alike. It is the same with the allotment of political power to individuals. Some are more and some less worthy, as his examples (21.3) indicate, the final pairing of which brings together the Christian ruler Constantine and the apostate Julian his nephew. Both take their parts in the divine plan.

As with the varying cults of empires and the contrasting morals of rulers, so God ordains differing lengths of wars. Some, like the war with the pirates, the Third Punic War, and the Slave and Social Wars, were short, whereas others, like the first two Punic Wars, the struggle with Mithradates, and the Samnite wars, lasted for decades. It seems curious at first sight that Augustine takes all his examples from Roman republican history half a millennium earlier. The reason is doubtless

because when he turns to the protracted struggle with the Visigoths in his own day, which educated pagans were claiming would have been swiftly concluded in the pre-Christian era, he is able to demonstrate that they are neither more arduous nor longer-lasting than the wars fought in the heyday of republican Rome.

In ch. 23 Augustine continues to challenge the claim that the hardships of recent years are attributable to the banning of pagan ritual and the promotion of Christianity as the state-religion. He adduces in support the great victory of Stilicho, regent in the west, over the pagan Radagaesus, leader of the German hordes, in AD 406. He is at pains to contrast the barbaric manners of the leader of the Goths, who is motivated by pagan religion, with the civilised behaviour of the Arian Alaric in the sack of Rome in AD 410, and he suggests that God inspired the crushing victory of Stilicho to ensure that the demons posing as pagan deities gained no credit, whereas Alaric's moderation in the capture of Rome was evidence of the beneficial change brought about by Christianity.[10]

VI

The final section of the book (chs. 24–26) is devoted to the advent of Christian emperors, with particular reference to Constantine and Theodosius. But before launching into a panegyric of Constantine (the first Christian to mount the imperial throne), Augustine devotes a brief chapter to the criteria for measuring the success (*felicitas*) of such leaders. We are not to judge their worth by worldly standards of length of office, dynastic succession, or success in repression of external foes or internal insurgents; such consolations have been granted to Christians and non-Christians alike. The true marks of the Christian emperor are justice, humility, and the religious observance which entails not merely personal piety but also zeal to spread the truth of Christianity far and wide. Particularly notable is the emphasis on compassionate government and contempt for empty glory.

In his brief encomium of Constantine, however, Augustine stresses precisely the worldly successes which he has accounted of lesser importance in a Christian emperor. He claims that because the emperor abandoned worship of the demons and turned to the Christian God, he was granted the felicity of founding the second capital at Constantinople, of success against external foes and internal usurpers, of living to an advanced age, and of successfully arranging a dynastic succession. He closes the chapter, however, with the repeated warning that such worldly blessings are not the prescriptive right of Christian emperors, instancing Jovian and Gratian as examples of Christians whose rule was short-lived, and in the case of Gratian ended violently.

Theodosius the Great (AD 346–395) is the subject of the final chapter of the book. He attracts Augustine's unstinted admiration as the emperor who had firmly established Christianity as the state-religion, and had decreed the destruction of pagan temples and their statues. After paying tribute to his *pietas* in affording shelter to the youthful Valentinian II when he was expelled from the western throne by the usurper Maximus, Augustine praises his Christian devotion in his reliance on the prophetic utterance of the Egyptian monk, John of Lycopolis, rather than on pagan oracles. He next turns to Theodosius's military campaign against the western pretender Eugenius, who had been proclaimed Augustus on the death of Valentinian II, and who showed himself increasingly favourable towards a revival of the traditional pagan worship. At the battle of the Frigidus close to the Julian Alps in September 394, Theodosius, it was claimed, received divine aid when a sudden storm discomfited the forces of Eugenius. In his account of the aftermath of the battle, Augustine lays particular emphasis on the demolition of pagan statues which lined the passages through the Alps, and also on the emperor's compassionate treatment of his foes; he does not mention the role which bishop Ambrose played in this enlightened treatment.[11]

Rather surprisingly, Augustine does not dwell for long on 'the just and merciful laws' which Theodosius issued from 380 onward in support of Christian orthodoxy against the Arians on the one hand and the traditional Roman religion on the other. His predecessor as Augustus in the east from 364 to 378, Valens, was a baptised Arian who had vigorously persecuted the orthodox flock who had supported the decrees passed at the Council of Nicaea. Theodosius in 381 ordered all Christian churches to be surrendered to the orthodox bishops. More momentously for the future of Christianity, further edicts in 391–2 forbade pagan sacrifices, including even private worship of the Lares and Penates.

Instead of dwelling on this public persona as apologist for the Christian faith, Augustine prefers to present the human face of Christianity, and above all the 'religious humility' with which he submitted to public penance at Milan when excommunicated by Ambrose in consequence of the slaughter of the citizens of Thessalonica. Humility is for Augustine a leading Christian virtue.[12]

Augustine brings the book to an end with mention of the intelligence which he had received of a pagan riposte to his publication of the first three books of *The City of God*. In withering condemnation he advises strongly against publication. In view of the imperial decrees condemning all manifestations of the pagan religion, it is improbable that it ever appeared.

VII

The sources which Augustine consulted for the content of Book V are few, and not difficult to ascertain.[13] His discussion of fate, free will, and providence in the first section rests mainly on Cicero's *De fato, De diuinatione,* and *De natura deorum.* When he begins his refutation of astrology as the factor controlling human life, his mention of the Platonist concept of the heavenly bodies as ensouled and divine probably derives from the apologia of the Stoic Balbus in *De natura deorum* 2, 34–58. In chs. 2 and 5 Cicero is cited directly in approval of the thesis of Hippocrates that the reasons why twins suffered identical illnesses later in life were environmental rather than because their horoscopes were identical; there is general agreement among scholars that this derives from a lost passage of the *De fato.* Augustine contrasts this explanation with the standpoint of the philosopher Posidonius, whose arguments supporting astrological determinism are criticised by Cicero in his *De diuinatione* 2.94ff. When Augustine next (ch. 3) refutes the inference drawn from the potter's wheel by Nigidius Figulus, contemporary and friend of Cicero, in support of the influence of astrology, he is continuing to draw upon the discussion in the *De fato.*[14]

At ch. 4 Augustine turns from Cicero to sacred scripture to exemplify twins who, though born under the same constellation, experienced different fortunes. Esau had a less prosperous life than Jacob. He reinforces this biblical example with a further instance from his own experience in ch. 6, in which mention is made of the coincidence of high tides with the full moon; *De natura deorum* 2.19 is probably the quarry here. In ch. 7 Augustine will have had the first book of Virgil's *Georgics* in mind when he cites the claims of the astrologers that particular days should be chosen for the performance of routine agricultural tasks.

In ch. 8 Augustine turns from astrology to consider the Stoic view of determinism as the chain of causes and effects regulated by God's will. Here the initial definition derives from *De diuinatione* 1.125. Thereafter some poetic lines are attributed to the Younger Seneca (*Ep.* 107.11); Augustine is unaware that they are a translation of lines of the early Stoic philosopher Cleanthes. The citation of Homer which follows in a free translation by Cicero will have been taken from the *De fato.*

When in ch. 9 Augustine claims that divine foreknowledge is compatible with our free will, he makes it clear that he is seeking to refute Cicero's argument at *De fato* 32, which was adopted from the Academic philosopher Carneades; he has also in mind *De diuinatione* 2.15 and 18, the thesis that chance events cannot have been foreknown by God. His counter-argument, a refinement of the position adopted in *De libero arbitrio,* has no obvious philosophical source, but it rests upon statements of holy scripture at *Ps.* 61.12, *John* 6.64, and finally (in ch. 11) *Wis.* 11.21.

In the second section, a discussion of Roman virtues, Augustine reverts to the secular authorities Sallust and Virgil, whom he has earlier exploited together with Cicero and Livy as authorities on the Roman national character. In ch. 12 he cites Sallust no fewer than ten times; all except the last, a passage from *Histories* 11M, which he had already quoted at II 18, are taken from the *Catiline*. They are incorporated to demonstrate two basic themes: the Roman passion for glory, and the virtues which made Rome great. Thus citations of *Cat.* 7.6, 7.3, and 11.1 all indicate that her citizens were motivated by the desire for glory; 6.7 and 7.3 describe how consuls as counsellors replaced kings as tyrants in consequence of the desire for glory, and it was this motivation which led to the subsequent expansion of the state; 53.4 instances two notable leaders, Cato and Julius Caesar, who were motivated in this way, and 54.6 declares that the less Cato sought glory, the more it attended him. The second group of citations from the *Catiline*, 52.19 and 21, and 53.2ff., centre on the outstanding virtue of the few, which rather than the force of arms made Rome great, and on the contrast with the vices which later dominated when the citizens became enslaved to riches.

Virgil similarly is harnessed to exemplify these same themes. After brief evocation of *Aen.* 8.703 to describe how the Romans, 'great in virtue', induced 'Bellona, with her blood-stained whip' to harass wretched nations so as to allow Roman virtue to shine forth, a passage from *Aen.* 8.646ff. recounts how, in their zeal to retain freedom, the Romans resisted the attacks of Porsenna, and further citations from *Aen.* 1.279ff. and 6.847ff. describe how subsequently they sought dominion over other nations and regarded the art of ruling as their supreme skill.[15]

The message in both Sallust and Virgil is that glory must be won only in the service of the state. But the nobles of the late Republic had betrayed that ideal, and by seeking glory solely for self-fulfilment had destroyed the cohesion of the state. This lesson was not lost on the poet Horace, and in ch. 13 he becomes the mouthpiece of Augustine in the warning against the danger of such selfish ambition. Horace is quoted only once elsewhere in the *C.D.* at I.3, but Augustine is well aware that the poet repeatedly dissociates pursuit of glory from true virtue. So in this chapter *Ep.* 1.1.36f. is cited, recommending the study of philosophy as medicine to cure love of praise, and *Odes* 2.2.9ff. which Augustine mistakenly believes was written to suppress the lust for dominion as a means to glory.[16]

Augustine thus signals the dangers of love of praise and the need to repress it 'by love of intelligible beauty' (an expression adopted from Plotinus), but he concedes that desire for human glory makes men less despicable as countering other vices. Here he has recourse to another of his main sources in earlier books, the *De republica* of Cicero, who claims that political leaders should be nurtured on glory, and that their forbears had been inspired by it to perform outstanding deeds

(so *Rep.* 5.7.9). The message is reinforced by citation of a maxim from *Tusculans* 1.4: "All men are fired by glory to undertake endeavours...". But with a hint of ambivalence Augustine then returns to the theme of the dangers of love of praise (ch. 14), where he quotes the gospel of *John* (5.44, 12.43), together with extracts from other evangelists (*Matt.* 10.33 joined with *Luke* 12.9; *Matt.* 6.1, 5.16). In ch. 15 he adds a further quotation from *Matthew* (6.2), to stress that human acclaim rather than happiness in heaven is the sole reward for pagan virtue.

In ch. 18 Augustine catalogues the heroic deeds and sufferings of Romans such as challenge Christians to imitate them, or to refrain from boasting if they have already endured them. For the first such example, Brutus's execution of his own sons for treason in the first year of Roman liberty, he quotes the lines of Virgil, *Aen.* 6.820–23. The details of this and the other virtuous deeds that follow derive from the Livian tradition. For Brutus's execution of his sons, see Livy 2.8.6ff.; for Manlius Torquatus who similarly put his son to death, Livy 8.6.7ff.; for Camillus, exiled unjustly, 5.1ff.; for Mucius's burning of his right arm in proclaiming Roman liberty, 2.12; for Curtius and the Decii, who dedicated their lives to the safety of the state, 7.6, 8.9.6, and 10.28.12; for Pulvillus, who ignored the report of his son's death, 2.8.4; for Regulus, who endured torture and death rather than break his oath, Eutropius 2.24. These eight all offer examples of heroic witness by offering their own or their sons' lives (or in the case of Mucius, self-mutilation) for the state. The final three exemplify the voluntary poverty practised by patriots. For Valerius, who had to be buried at public expense as a pauper, see Livy 2.16.7; for Cincinnatus, arch-exemplar of frugality, Livy 3.26.7ff.; and for Fabricius, who greeted with contempt Pyrrhus's offer of a fourth part of his kingdom, see Eutropius 2.17.

These evocations from secular literature cited to inspire Christians to similarly heroic endeavours are reinforced by allusions to holy scripture. So the self-immolation of Curtius is glossed with *Matt.* 10.28, "Fear not those who kill the body...". Pulvillus's refusal to be distracted from dedicating the Capitoline temple by the report of his son's death is made a parable for Christians with the addition of Jesus's words at *Matt.* 8.22, "Let the dead bury the dead". The exhortation to Christians to emulate the voluntary fate of Regulus includes the rhetorical question at *Ps.* 115.12: "What return shall be made to the Lord...?" In commending the Romans who forsook private wealth and enriched the coffers of the community, the *Acts of the Apostles* (2.44, 4.34f.) is offered as a parallel inspiration for Christians. Finally, we are urged to keep in mind the words of Paul at *Rom.* 8.18, to the effect that earthly privations are as nothing compared with the glory of heaven.

In ch. 19, in which Augustine distinguishes between the principled desire for glory through virtue and the pursuit of power regardless of such praise, there are two citations. The first is the repetition of Sallust, *Cat.* 11.1–2 from ch. 12.10, in

which the historian makes the distinction between the pursuit of glory "by the true path", and that sought by guile and deceit. The second is from *Aen.* 7.266, where Augustine wishes to exemplify the use of *tyrannus* in a laudatory sense. This is as postscript to mention of the emperor Nero, a tyrant in the pejorative sense, a meaning of the word which Augustine exemplifies with scriptural quotations from *Proverbs* 8.14–16 and *Job* 34.30.

Ch. 20 is divided into two parts. The first half is concerned with an imaginary picture which the Stoic philosopher Cleanthes outlines to criticise the Epicurean claim that Pleasure as the chief good is attended by the four cardinal virtues. Augustine has derived this anecdote from Cicero's *De finibus* 2.69, developing it further by incorporating elements of the Epicurean theory from *De finibus* 1.42–54, *De officiis* 1.118, and *Tusculans* 5.74. The second half of the chapter, which suggests that a similarly ironical portrait could depict Glory in place of Pleasure, contains no quotations or evocations from earlier literature.

The third section of the book (chs. 21–23), which claims that the establishment of the Roman empire was part of God's design and is governed by his Providence, contains no direct citations. When in ch. 22 Augustine argues that the length of wars is ordained by Providence, it is possible that he has consulted Eutropius and Florus on the length of individual conflicts (see 22.1–2nn.) The incursion by Radagaesus and his barbarian hordes in AD 406, described in ch. 23, had occurred less than a decade before Augustine composed this book, and the claim that the Roman army did not suffer a single casualty while killing a hundred thousand Germans has the resonance of folklore. The account of Orosius (7.37) had not been written in AD 415, and the poems of Claudian do not describe events beyond 402. One possible influence is Paulinus of Nola, *Poem* 21,[17] written in AD 407; like Augustine he claims that the barbarian army were pressing at the very gates of Rome, whereas they were defeated at Faesulae more than a hundred miles to the north (so Zon. 5.26). But more probably Augustine relies upon verbal reports of the battle which circulated in Africa.

In the final section (chs. 24–26), Augustine follows a summary of the qualities of the ideal Christian emperor with a brief laudation of Constantine the Great (ch. 25). This is for the most part couched in general terms, but the claim that his foundation of Constantinople excluded pagan temples and statues may derive from Eusebius, *Vita Constantini* 2.47. When he turns to the reign of Theodosius, Augustine recounts the main features from his own recollection, but for details of the battle of the Frigidus he was able to utilise the letters of Ambrose (*Epp.* 61.3, 62.4) and the evidence of participants. The poems of Claudian were also available to him; he quotes a couplet from *The Third Consulship of Honorius*, though the claim that the lines are addressed to Theodosius rather than Honorius suggests that he had not read the

poem closely.[18] The narrative of the notorious massacre at Thessalonica probably derives in part from Ambrose's *Letter* 51 and his *De obitu Theodosii* 28, 34.

In the final section of ch. 26, in which Augustine turns on pagan opponents who had composed a reply to his arguments in Books I–III, he compares them with the man who Cicero says was called happy because he had licence to do wrong. This is almost certainly a reference to *Tusculans* 5.53, where Cicero criticises Cinna for the murders of august senators in 87 BC.

VIII

As indicated in my edition of Books I–II, two sixth-century manuscripts are of particular importance for the text of Books I–V.

L, Lugdunensis 607, containing Books I–V (where the manuscript has suffered damage, the gaps are filled by a twelfth-century copy, Lugdunensis 608).

C, Parisinus Ord. Lat. 12.214, originally part of the Corbeiensis which contained Books I–IX.[19]

The text printed here is substantially that of A. Dombart–A. Kalb (5th edn., Leipzig 1928–9), which has been adopted as the text in both the *CCL* series (vols. 47–48, Turnhout 1953) and the Loeb edition vol. II (Books IV–VII, tr. W.M. Green). Minor changes are indicated in the notes.

As in the earlier volumes, the Latin chapter-headings are assembled immediately before the text and translation. A translation of each heading appears before the notes to the individual chapters. As explained in the edition of Books I–II, it is uncertain whether the headings were composed by Augustine himself or by a later hand. If Augustine did compose them, he probably did so to make a detached summary of the work. Hence there is little justification for regarding them as a part of the text of the *C.D.*[20]

1 I cite the Latin of these two passages in vol. II (Books III–IV) nn.2–3.

2 Though initially Augustine cites chance (the Epicurean thesis), his analysis concentrates wholly on the Stoic standpoint, that Rome's rise and continuing pre-eminence was predetermined.

3 The closing remarks of ch. 26 append a summary of Augustine's purpose so far (in Books I–V), and advert to the central topic to be treated in VI–X.

4 For a recent discussion of western astrology, see S.J. Tester, *A History of Western Astrology* (Woodbridge 1987); with reference to Augustine, esp. 52ff., 108ff. For earlier bibliography, see *OCD*³, 195. Augustine's earlier flirtation with astrology is described at *Conf.* 4.3 4ff.

5 On Panaetius, see the bibliography in Long–Sedley, 2.494; add Rist, *Stoic Philosophy*, ch. 10; Sandbach, *The Stoics*, ch. 8; A. Erskine, *The Hellenistic Stoa* (London 1990), 150ff.

6 See the n. at 7.5 for the appearance of the demons here.

7 As often in the *C.D.*, Augustine exploits his earlier writings here, drawing upon the exordium of his *De natura boni*.

8 Augustine thus 'Christianises' the exhortation of Livy, *Praef.* 9: "I suggest that each individual directs his attention at their lives and manners, through what men and by what values at home and in war the empire was both attained and increased". Christians are to direct their attention similarly and to emulate their virtues, but with the humility which will aid them to enter the kingdom of heaven.

9 See the excellent essay of R. Bittner, 'Augustine's Philosophy of History', in G.B. Matthews (ed.). *The Augustinian Tradition* (Berkeley 1999), 323–44.

10 Though in *C.D.* I Augustine is justified in signalling acts of clemency shown by the invading Goths to Christians, it becomes clear in chapters 10 onwards that the looting and violence were widespread.

11 See ch. 26.3n.

12 Augustine devotes what is virtually a mini-treatise to the virtue of humility in *De sancta uirginitate*, 31ff.

13 See H. Hagendahl, *Augustine and the Latin Classics* (Stockholm 1967). His list of direct citations draws heavily on S. Angus, *The Sources of the First Ten Books of Augustine's De civitate Dei* (Princeton 1906).

14 For the fragmentary *De fato* and its systematic consultation by Augustine, see the edition of R.W. Sharples (Warminster 1991), esp. 24ff.

15 Augustine's citations of Virgil are examined in S. MacCormack, *The Shadows of Poetry: Virgil in the Mind of Augustine* (Berkeley 1998).

16 For the disillusionment with *gloria* in the poems of Horace, see *Odes* I 18.14ff., *Sat.* 1.6.23f., *Epist.* 1.18.22f., with Donald Earl, *The Moral and Political Tradition of Rome* (London 1967), 69.

17 See my translation in *The Poems of Paulinus of Nola* (*ACW* 40, 133): "the Getae now pressed at the very entrance to the city...madness blazed in the cities of Latium through the unleashing of the enemy".

18 See Alan Cameron, *Claudian* (Oxford 1970), 40f.

19 For details of the manuscript tradition, see Gerard O'Daly, *Augustine's City of God: a Reader's Guide* (Oxford 1999), App. B.

20 The controversy is briefly discussed in O'Daly, App. C.

DE CIVITATE DEI

BOOK FIVE

(Translations of these headings are provided at the head of each chapter in the Notes)

LIBER V

Praefatio

Quoniam constat omnium rerum optandarum plenitudinem esse felicitatem, quae non est dea sed donum dei, et ideo nullum deum colendum esse ab hominibus nisi qui potest eos facere felices (unde si illa dea esset, sola colenda merito diceretur), iam consequenter uideamus qua causa deus, qui potest et illa bona dare quae habere possunt etiam non boni ac per hoc etiam non felices, Romanum imperium tam magnum tamque diuturnum esse uoluerit. Quia enim hoc deorum falsorum illa quam colebant multitudo non fecit, et multa iam diximus et ubi uisum fuerit opportunum esse dicemus.

I

[1] Causa ergo magnitudinis imperii Romani nec fortuita est nec fatalis secundum eorum sententiam siue opinionem qui ea dicunt esse fortuita quae uel nullas causas habent uel non ex aliquo rationabili ordine uenientes, et ea fatalia quae praeter dei et hominum uoluntatem cuiusdam ordinis necessitate contingunt. Prorsus diuina prouidentia regna constituuntur humana. Quae si propterea quisquam fato tribuit quia ipsam dei uoluntatem uel potestatem fati nomine appellat, sententiam teneat, linguam corrigat. Cur enim non hoc primum dicit quod postea dicturus est, cum ab illo quisquam quaesierit quid dixerit fatum? Nam id homines quando audiunt, usitata loquendi consuetudine non intellegunt nisi uim positionis siderum, qualis est quando quis nascitur siue concipitur; quod aliqui alienant a dei uoluntate, aliqui ex illa etiam hoc pendere confirmant.

[2] Sed illi qui sine dei uoluntate decernere opinantur sidera quid agamus uel quid bonorum habeamus malorumue patiamur, ab auribus omnium repellendi sunt, non solum eorum qui ueram religionem tenent sed ⟨et⟩ qui

BOOK FIVE

Preface

Undoubtedly felicity is the full attainment of all things to be desired; it is not a goddess, but a gift from God. It is accordingly clear that men should worship no deity other than him who can bring them felicity, which is why, if it were a goddess, it would be right to claim that she alone should be worshipped. We must now investigate a question arising from this: why did God, who can also bestow goods attainable even by those who are not good and in consequence are not happy either, decide that the Roman Empire should be so great and so long-lasting? We have already explained at length, and we shall repeat this when it seems opportune, that the crowd of false gods worshipped by the Romans was not responsible for it.

I

[1] The rise to greatness of the Roman Empire was not the outcome of chance or of fate (these terms reflect the doctrine or belief of those who say that chance events are those which have no causes or occur from no rational sequence, and that fated events are those that occur by some necessary sequence, independent of the will of God or of men). Assuredly human kingdoms are established by divine Providence. If anyone assigns them to fate because he uses the expression 'fate' for the will or power of God, he should persist in that judgement but amend his language: for why should he not say at the outset what he will subsequently say when someone asks him what he means by fate? For when men hear the word, what they understand by it is nothing but the influence of the position of the stars at a person's birth or conception, for that is the conventional usage; and some people make it independent of the will of God, while others maintain that this too is dependent on his will.

[2] But all should close their ears to those who believe that the stars decide our actions independently of the will of God, and that likewise they bestow the blessings we are to enjoy or the ills we are to suffer. By 'all' I mean not only those who possess the true religion, but also those who

deorum qualiumcumque licet falsorum uolunt esse cultores. Haec enim opinio quid agit aliud nisi ut nullus omnino colatur aut rogetur deus? Contra quos modo nobis disputatio non est instituta, sed contra hos qui pro defensione eorum quos deos putant Christianae religioni aduersantur.

[3] Illi uero qui positionem stellarum quodam modo decernentium qualis quisque sit et quid ei proueniat boni quidue mali accidat ex dei uoluntate suspendunt, si easdem stellas putant habere hanc potestatem traditam sibi a summa illius potestate ut uolentes ista decernant, magnam caelo faciunt iniuriam, in cuius uelut clarissimo senatu ac splendidissima curia opinantur scelera facienda decerni, qualia si aliqua terrena ciuitas decreuisset, genere humano decernente fuerat euertenda. Quale deinde iudicium de hominum factis deo relinquitur, quibus caelestis necessitas adhibetur, cum dominus ille sit et siderum et hominum? Aut si non dicunt stellas, accepta quidem potestate a summo deo, arbitrio suo ista decernere, sed in talibus necessitatibus ingerendis illius omnino iussa complere, itane de ipso deo sentiendum est quod indignissimum uisum est de stellarum uoluntate sentire?

[4] Quod si dicuntur stellae significare potius ista quam facere, ut quasi locutio quaedam sit illa positio praedicens futura, non agens (non enim mediocriter doctorum hominum fuit ista sententia), non quidem ita solent loqui mathematici, ut uerbi gratia dicant 'Mars ita positus homicidam significat' sed 'homicidam facit'. Verumtamen ut concedamus non eos ut debent loqui, et a philosophis accipere oportere sermonis regulam ad ea praenuntianda quae in siderum positione reperire se putant, quid fit quod nihil umquam dicere potuerunt cur in uita geminorum, in actionibus, in euentis, in professionibus artibus honoribus ceterisque rebus ad humanam uitam pertinentibus, atque in ipsa morte sit plerumque tanta diuersitas ut similiores eis sint, quantum ad haec attinet, multi extranei quam ipsi inter se gemini perexiguo temporis interuallo in nascendo separati, in conceptu autem per unum concubitum uno etiam momento seminati?

aspire to the worship of any gods whatsoever, even false gods. For what is the implication of that belief, except that we should worship or supplicate no god at all? However, our discussion here is levelled not against those holding such views, but against men who in defending those whom they believe to be gods are hostile to the Christian religion.

[3] As for those who make the location of the stars, which they say in some way decides the nature of the individual and the good or ill which is to befall him, dependent on the will of God, if they believe that those stars have power conferred on them by the sovereign power of God to decide those issues at their own discretion, they inflict a grave injustice on the heavens; for what they suggest is that (to use a metaphor) in the radiantly shining senate and uniquely brilliant senate-house of the heavens, the inevitability of evil deeds is decreed, such that if some earthly city decreed them, it would be doomed to destruction by the decision of the human race. Moreover, what judgement of the deeds of men is then left to God, for though he is lord of both stars and men they are subject to the necessity imposed by the heavens? Or if they say that the stars in imposing such necessities do not make these decisions on their own authority, but receive this power from the highest God and wholly fulfil his commands, are we then to take a view of God himself which it seemed wholly unworthy to take of the will of the stars?

[4] But the supposition may be made that the stars reveal but are not responsible for such actions, so that their location is a kind of mouthpiece which foretells but does not affect future events. This is the doctrine of men of no mean learning. But astrologers do not usually express themselves in that way. For example, they do not say "When Mars is in such-and-such a position it connotes a murderer", but "it produces a murderer". However, we can concede that they do not express themselves as they ought, and that they should obtain from philosophers the correct wording by which to declare in advance what they think they infer from the location of the stars. Yet why is it that they have never been able to explain why there are often such great contrasts in the lives of twins, in their actions, outcomes, professions, accomplishments, distinctions, and the other aspects of human life, and also in the manner of their deaths? The differences are so striking that many outsiders resemble one or other of them in these respects more closely than they resemble each other. This is in spite of the fact that the twins were born and detached within a very short time from each other, and have been conceived at the very same moment in the same act of intercourse.

II

[1] Cicero dicit Hippocratem, nobilissimum medicum, scriptum reliquisse quosdam fratres, cum simul aegrotare coepissent et eorum morbus eodem tempore ingrauesceret, eodem leuaretur, geminos suspicatum; quos Posidonius Stoicus, multum astrologiae deditus, eadem constitutione astrorum natos eademque conceptos solebat asserere. Ita quod medicus pertinere credebat ad simillimam temperiem ualetudinis, hoc philosophus astrologus ad uim constitutionemque siderum quae fuerat quo tempore concepti natique sunt.

[2] In hac causa multo est acceptabilior et de proximo credibilior coniectura medicinalis, quoniam parentes ut erant corpore adfecti dum concumberent, ita primordia conceptorum adfici potuerunt, ut consecutis ex materno corpore prioribus incrementis paris ualetudinis nascerentur. Deinde in una domo eisdem alimentis nutriti, ubi aërem et loci positionem et uim aquarum plurimum ualere ad corpus uel bene uel male accipiendum medicina testatur, eisdem etiam exercitationibus adsuefacti tam similia corpora gererent ut etiam ad aegrotandum uno tempore eisdemque causis similiter mouerentur. Constitutionem uero caeli ac siderum quae fuit quando concepti siue nati sunt, uelle trahere ad istam aegrotandi parilitatem, cum tam multa diuersissimi generis diuersissimorum effectuum et euentorum eodem tempore in unius regionis terra eidem caelo subdita potuerint concipi et nasci, nescio cuius sit insolentiae.

[3] Nos autem nouimus geminos non solum actus et peregrinationes habere diuersas, uerum etiam dispares aegritudines perpeti. De qua re facillimam, quantum mihi uidetur, rationem redderet Hippocrates: diuersis alimentis et exercitationibus, quae non de corporis temperatione sed de animi uoluntate ueniunt, dissimiles eis accidere potuisse ualetudines. Porro autem Posidonius uel quilibet fatalium siderum assertor mirum si potest hic inuenire quid dicat, si nolit imperitorum mentibus in eis quas nesciunt rebus inludere.

II

[1] Cicero states that Hippocrates, that most renowned of physicians, left a written record of certain brothers who fell ill together, whose condition worsened at the same time, and who then simultaneously recovered, so that he suspected that they were twins. The Stoic Posidonius, a keen student of astrology, was in the habit of claiming that they had been conceived and born under the same constellation. So what the physician thought was attributable to the almost identical blend of physical health, the philosopher-astrologer ascribed to the influence and location of the stars at the time when the brothers were conceived and born.

[2] In this case what the physician hazarded is much more acceptable and closely credible, since the physical condition of the parents at the time of intercourse could have affected the early stages of the children who were conceived, so that having achieved their initial growth in their mother's body, their health at birth was identical. Thereafter they were nurtured on the same diet in the same home, and, as the art of medicine attests, climate, geography, and quality of water have the greatest impact on bodily development for good or ill. Since they were accustomed too to the same modes of exercise, they developed such similar physiques that they were affected in the same way also in falling ill at the same time and from the same causes. On the other hand it would be remarkably arrogant to claim that the position of sky and stars at the moments of conception and birth was responsible for their falling ill in the identical way. There could have been numerous instances of conceptions and births in totally different races, under totally different effects and outcomes and circumstances, all occurring at the same time in a land within the one region subject to the same climate.

[3] I am myself acquainted with twins who not only indulge in different activities and journeys abroad, but also suffer from different maladies. In my view, Hippocrates would offer the most obvious explanation for this, suggesting that their various states of health arose from different diets and exercises, which are the outcome not of bodily make-up but of the mind's choice. However, it would be surprising if Posidonius or any other apologist for the stars as vehicles of fate can devise any explanation for this, so long as he is unwilling to have fun at the expense of ignorant minds with no knowledge of such things.

[4] Quod enim conantur efficere de interuallo exiguo temporis, quod inter se gemini dum nascerentur habuerunt, propter caeli particulam ubi ponitur horae notatio quem horoscopum uocant, aut non tantum ualet quanta inuenitur in geminorum uoluntatibus actibus moribus casibusque diuersitas, aut plus etiam ualet quam est geminorum uel humilitas generis eadem uel nobilitas, cuius maximam diuersitatem non nisi in hora qua quisque nascitur ponunt. Ac per hoc si tam celeriter alter post alterum nascitur ut eadem pars horoscopi maneat, paria cuncta quaero quae in nullis possunt geminis inueniri; si autem sequentis tarditas horoscopum mutat, parentes diuersos quaero, quos gemini habere non possunt.

III

[1] Frustra itaque adfertur nobile illud commentum de figuli rota quod respondisse ferunt Nigidium hac quaestione turbatum, unde et Figulus appellatus est. Dum enim rotam figuli ui quanta potuit intorsisset, currente illa bis numero de atramento tamquam uno eius loco summa celeritate percussit; deinde inuenta sunt signa quae fixerat, desistente motu, non paruo interuallo in rotae illius extremitate distantia. 'Sic' inquit 'in tanta rapacitate caeli, etiamsi alter post alterum tanta celeritate nascatur quanta rotam bis ipse percussi, in caeli spatio plurimum est. Hinc sunt' inquit 'quaecumque dissimillima perhibentur in moribus casibusque geminorum'.

[2] Hoc figmentum fragilius est quam uasa quae illa rotatione finguntur. Nam si tam multum in caelo interest quod constellationibus comprehendi non potest ut alteri geminorum hereditas obueniat, alteri non obueniat, cur audent ceteris qui gemini non sunt, cum inspexerint eorum constellationes, talia pronuntiare quae ad illud secretum pertinent quod nemo potest comprehendere, et momentis adnotare nascentium? Si autem propterea talia dicunt in aliorum genituris, quia haec ad productiora spatia temporum

[4] They try to establish significance for the short period of time which elapsed between the births of the twins by referring to the tiny section of sky which marks the passing of one hour (they call this the horoscope), but this is not sufficiently great to encompass the difference between the wishes, actions, behaviour, and fortunes of the twins, or alternatively it is too great to denote the same menial or noble origin of the twins, for they ascribe the huge difference merely to the hour at which each was born. Thus if one is born so soon after the other that the same section of the horoscope remains in place, I look for total parity between them such as cannot be found in any twins. But if the late arrival of the second child brings a change in the horoscope, I look for different parents such as twins cannot have.

III

[1] So it is vain to adduce the celebrated thesis adopted from the potter's wheel, which they say was the response of Nigidius when he was thrown off balance in this issue, and which earned him the name of The Potter. What he did was to spin the potter's wheel with all the force he could muster, and as it whirled around, he very rapidly twice marked it with ink, apparently at the same spot. Then, when the movement stopped, the marks which he had made on the rim of the wheel were found to be a considerable distance apart. "It is the same", he said "with the swift movement of the heavens. Even though one twin were to be born after the other as quickly as I made those marks on the wheel, that represents an enormous distance in the expanse of the heavens. This explains", he added "all those very great divergences reported in the characters and fortunes of twins."

[2] This flight of fancy is more fragile than the vessels fashioned on the turning wheel. For if the change in the disposition of the heavens which is unobservable in the constellations is so great that one twin obtains an inheritance and the other does not, how have astrologers the nerve to pronounce to others, who are not twins, after observing their constellations, the factors which relate to the hidden truth which no man can grasp, and apply them to the moments when such persons were born? Suppose, however, that they make such pronouncements concerning the horoscopes of non-twins, because these relate to more extended periods of time, whereas the

pertinent, momenta uero illa partium minutarum quae inter se gemini possunt habere, rebus minimis tribuuntur de qualibus mathematici non solent consuli (quis enim consulat quando sedeat, quando deambulet, quando uel quid prandeat?), numquid ista dicimus quando in moribus operibus casibusque geminorum plurima plurimumque diuersa monstramus?

IV

[1] Nati sunt duo gemini antiqua patrum memoria (ut de insignibus loquar) sic alter post alterum ut posterior plantam prioris teneret. Tanta in eorum uita fuerunt moribusque diuersa, tanta in actibus disparilitas, tanta in parentum amore dissimilitudo ut etiam inimicos eos inter se faceret ipsa distantia. Numquid hoc dicitur quia uno ambulante alius sedebat, et alio dormiente alius uigilabat, et alio loquente tacebat alius, quae pertinent ad illas minutias quae non possunt ab eis comprehendi qui constitutionem siderum qua quisque nascitur scribunt, unde mathematici consulantur? Vnus duxit mercennariam seruitutem, alius non seruiuit; unus a matre diligebatur, alius non diligebatur; unus honorem qui magnus apud eos habebatur amisit, alter indeptus est. Quid de uxoribus, quid de filiis, quid de rebus, quanta diuersitas!

[2] Si ergo haec ad illas pertinent minutias temporum quae inter se habent gemini et constellationibus non adscribuntur, quare aliorum constellationibus inspectis ista dicuntur? Si autem ideo dicuntur quia non ad minuta incomprehensibilia sed ad temporum spatia pertinent quae obseruari notarique possunt, quid hic agit rota illa figuli nisi ut homines luteum cor habentes in gyrum mittantur ne mathematicorum uaniloquia conuincantur?

brief periods which can separate twins at birth are connected with wholly unimportant matters on which astrologers are normally not consulted (for who would ask their advice on when to sit down, when to take a stroll, when or what to eat?). Our discussion is surely not concerned with these trivialities when we point to the numerous and extensive differences between the characters, activities, and fortunes of twins.

IV

[1] Within the ancient recollection of the Fathers (I intend to discuss a celebrated case) twins were born so close to each other that the second was grasping the heel of the first. So great were the differences in their lives and characters, so great the divergence between their activities, so great the contrast in the love their parents showed to each, that the very disparity made them hostile to each other. We do not imply by this that one would take a stroll while the other was seated, that one slept while the other stayed awake, that one talked while the other was silent. These things fall into the category of trivialities which cannot be grasped by those who record the location of the stars under which each individual is born and which provide the reason for consultation of the astrologers. One slaved as a hireling, the other did not slave; one was loved by his mother, the other was not; one lost the birthright held in great esteem among them, while the other obtained it. Then, too, what a great contrast there was between their wives, their children, their property!

[2] If, then, these differences relate to the brief period between the births of the twins, and are not attributed to their horoscopes, why are they cited when the horoscopes of non-twins are analysed? If, on the other hand, they are cited because they are associated not with moments too brief to be grasped, but with long periods of time which can be observed and recorded, what point is there in that comparison with the potter's wheel, except to cause men with muddied minds to spin around in such a way as not to find astrologers guilty of fatuous talk?

V

[1] Quid idem ipsi quorum morbum, quod eodem tempore grauior leuiorque apparebat amborum, medicinaliter inspiciens Hippocrates geminos suspicatus est, nonne satis istos redarguunt qui uolunt sideribus dare quod de corporum simili temperatione ueniebat? Cur enim similiter eodemque tempore, non alter prior alter posterior, aegrotabant sicut nati fuerant, quia utique simul nasci ambo non poterant?

[2] Aut si nihil momenti adtulit ut diuersis temporibus aegrotarent quod diuersis temporibus nati sunt, quare tempus in nascendo diuersum ad aliarum rerum diuersitates ualere contendunt? Cur potuerunt diuersis temporibus peregrinari, diuersis temporibus ducere uxores, diuersis temporibus filios procreare et multa alia propterea quia diuersis temporibus nati sunt, et non potuerunt eadem causa diuersis etiam temporibus aegrotare? Si enim dispar nascendi mora mutauit horoscopum et disparilitatem intulit ceteris rebus, cur illud in aegritudinibus mansit quod habebat in temporis aequalitate conceptus? Aut si fata ualetudinis in conceptu sunt, aliarum uero rerum in ortu esse dicuntur, non deberent inspectis natalium constellationibus de ualetudine aliquid dicere, quando eis inspicienda conceptionalis hora non datur. Si autem ideo praenuntiant aegritudines non inspecto conceptionis horoscopo, quia indicant eas momenta nascentium, quomodo dicerent cuilibet eorum geminorum ex natiuitatis hora quando aegrotaturus esset, cum et alter, qui non habebat eandem horam natiuitatis, necesse haberet pariter aegrotare?

[3] Deinde quaero si tanta distantia est temporis in natiuitate geminorum ut per hanc oporteat eis constellationes fieri diuersas propter diuersum horoscopum, et ob hoc diuersos omnes cardines ubi tanta uis ponitur ut hinc etiam diuersa sint fata, unde hoc accidere potuit, cum eorum conceptus diuersum tempus habere non possit? Aut si duorum uno momento temporis conceptorum potuerunt esse ad nascendum fata disparia, cur non et duorum uno momento temporis natorum possint esse ad uiuendum atque moriendum fata disparia? Nam si unum momentum, quo ambo concepti sunt, non

V

[1] What, then, are we to say of the brothers whose illnesses worsened and then subsided at the same time as each other, leading Hippocrates in his diagnosis as physician to suspect that they were twins? Is not this a sufficient refutation of those who seek to ascribe to the stars what was in fact the result of similar bodily conditions? Why did they experience similar sickness and at the same time, rather than one after the other in the order in which they were born, for obviously they could not have been born at the same time?

[2] Or if being born at different times did not cause them to be ill at different times, why do astrologers claim that a different time of birth causes differences in other respects? Why could men have travelled abroad at different times, married wives at different times, begotten children at different times, and done much else at different times because they were born at different times, yet could not for the same reason fall sick at different times? If delay causing different times of birth changed horoscopes and caused disparity in all else, why did the similarity in their simultaneous conception persist merely in their illnesses? If a person's future health is decided at conception, and his future in other respects is said to be decided at birth, astrologers should refrain from making pronouncements about health when they observe the constellations on the days of birth, for the hour of conception is not available to them for observation. But if they forecast illnesses without observation of the horoscope at the time of conception because the moment at which infants are born reveals those illnesses, how could they divulge to one or other of twins when he was to fall sick by basing this on the hour of his birth, seeing that the other, though not born at the same hour, would of necessity be ill at the same time?

[3] My second enquiry is this: if there is such a great lapse of time between the births of twins, with the inevitable consequence that their constellations differ because of the change of horoscope, with the resultant divergence of the cardinal points in which such great power resides that they cause destinies to differ as well, how could this possibly happen when the twins cannot have been conceived at different times? Or if the destinies of two persons conceived at the one moment of time could diverge at birth, why cannot the destinies of the two born at the same moment also diverge during life and at death? For if the fact that both were conceived at the same moment

impediuit ut alter prior alter posterior nasceretur, cur, uno momento si duo nascantur, impedit aliquid ut alter prior alter posterior moriatur?

[4] Si conceptio momenti unius diuersos casus in utero geminos habere permittit, cur natiuitas momenti unius non etiam quoslibet duos in terra diuersos casus habere permittat, ac sic omnis huius artis uel potius uanitatis commenta tollantur? Quid est hoc, cur uno tempore, momento uno, sub una eademque caeli positione concepti diuersa habent fata quae illos perducant ad diuersarum horarum natiuitatem, et uno momento temporis sub una eademque caeli positione de duabus matribus duo pariter nati diuersa fata habere non possint quae illos perducant ad diuersam uiuendi uel moriendi necessitatem?

[5] An concepti nondum habent fata, quae nisi nascantur habere non poterunt? Quid est ergo quod dicunt, si hora conceptionalis inueniatur, multa ab istis dici posse diuinius? Vnde etiam illud a nonnullis praedicatur, quod quidam sapiens horam elegit qua cum uxore concumberet unde filium mirabilem gigneret.

[6] Vnde postremo et hoc est, quod de illis pariter aegrotantibus geminis Posidonius magnus astrologus idemque philosophus respondebat ideo fieri quod eodem tempore fuissent nati eodemque concepti. Nam utique propter hoc addebat conceptionem, ne diceretur ei non ad liquidum eodem tempore potuisse nasci, quos constabat omnino eodem tempore fuisse conceptos, ut hoc, quod similiter simulque aegrotabant, non daret de proximo pari corporis temperamento, sed eandem quoque ualetudinis parilitatem sidereis nexibus adligaret.

[7] Si igitur in conceptu tanta uis est ad aequalitatem fatorum, non debuerunt nascendo eadem fata mutari. Aut si propterea mutantur fata geminorum quia temporibus diuersis nascuntur, cur non potius intellegamus iam fuisse mutata ut diuersis temporibus nascerentur? Itane non mutat fata natiuitatis uoluntas uiuentium cum mutet fata conceptionis ordo nascentium?

did not prevent one being born earlier and the other later, why, if two were born at the same moment, should anything prevent one from dying earlier and the other later?

[4] If conception at the same moment allows twins to experience differing fortunes in the womb, why should birth at the same moment not likewise allow any two persons on earth to experience different fortunes, which would dispose of all the fabrications of the astrologers' profession – or rather, of their fatuity? How can it be that those who are conceived at one time, at a single moment between one and the same location of the heavens, have different destinies, so that they are brought to birth at different hours, yet two infants born alike of different mothers at the one moment of time under one and the same location of the heavens cannot experience different destinies so as to be led by them to the different modes of life and death which are enjoined by necessity?

[5] Is it that at conception they do not as yet have destinies, and will be unable to have them unless they are born? In that case, why do astrologers claim that if they could elicit the hour of conception, they could make many more predictions? This claim is the source of the allegation made by some of them that a wise man chose the hour at which to have intercourse with his wife so as to beget a son who would be a genius.

[6] A final point. That claim was also the basis of that response of the great astrologer and philosopher Posidonius, on the matter of the twins who fell ill together. He said that this occurred because they had been both born and conceived at the same time. He undoubtedly included conception in case he was told that it was not crystal-clear that they could have been born at the same time, whereas it was absolutely certain that they had been conceived at the same time. He sought to avoid ascribing their similar and simultaneous illnesses to their clearly similar physical make-up, and rather to attribute the identical course of their health to its interconnection with the stars.

[7] It follows, then, that if conception exercises such influence in establishing parallel destinies, those destinies ought not to have changed at birth. Alternatively, if the destinies of twins undergo change because they are born at different times, why should we not prefer to believe that they had already changed so that they could be born at different times? So, since the sequence of births changes their futures fixed at conception, does not men's free will during life change their destinies fixed at birth?

VI

[1] Quamquam et in ipsis geminorum conceptibus, ubi certe amborum eadem momenta sunt temporum, unde fit ut sub eadem constellatione fatali alter concipiatur masculus, altera femina? Nouimus geminos diuersi sexus; ambo adhuc uiuunt, ambo aetate adhuc uigent, quorum cum sint inter se similes corporum species quantum in diuerso sexu potest, instituto tamen et proposito uitae ita sunt dispares ut praeter actus quos necesse est a uirilibus distare femineos (quod ille in officio comitis militat et a sua domo paene semper peregrinatur, illa de solo patrio et de rure proprio non recedit), insuper – quod est incredibilius, si astralia fata credantur; non autem mirum si uoluntates hominum et dei munera cogitentur – ille coniugatus, illa uirgo sacra est; ille numerosam prolem genuit, illa nec nupsit.

[2] At enim plurimum uis horoscopi ualet. Hoc quam nihil sit iam satis disserui. Sed qualecumque sit, in ortu ualere dicunt; numquid et in conceptu? Vbi et unum concubitum esse manifestum est, et tanta naturae uis est ut, cum conceperit femina, deinde alterum concipere omnino non possit; unde necesse est eadem esse in geminis momenta conceptus. An forte quia diuerso horoscopo nati sunt, aut ille in masculum, dum nascerentur, aut illa in feminam commutata est?

[3] Cum igitur non usquequaque absurde dici posset ad solas corporum differentias adflatus quosdam ualere sidereos, sicut in solaribus accessibus et decessibus uidemus etiam ipsius anni tempora uariari et lunaribus incrementis atque detrimentis augeri et minui quaedam genera rerum, sicut echinos et conchas et mirabiles aestus oceani, non autem et animi uoluntates positionibus siderum subdi, nunc isti, cum etiam nostros actus inde religare conantur, admonent ut quaeramus unde ne in ipsis quidem corporibus eis possit ratio ista constare. Quid enim tam ad corpus pertinens quam corporis sexus? Et tamen sub eadem positione siderum diuersi sexus gemini concipi potuerunt.

VI

[1] A further problem. How does it happen, when twins are conceived (and this undoubtedly happens to both at the same moment in time) that under the same constellation which ordains their destiny one is conceived as male and the other as female? I am acquainted with twins of different sexes, both still alive and of an age when they are still thriving. Though similar in appearance so far as difference of sex allows, they are quite unlike each other in their planned mode of life. Thus, quite apart from the inevitable differences between their activities as men and women, (he serves on the staff of the military commander, and is almost always travelling away from home, whereas she never leaves her native habitat and her country region), there is the additional fact (which is more surprising if we are to lend credence to destinies imposed by the stars, but not so if we reflect on human aspirations and divine gifts) that he is married while she is a consecrated virgin. He has fathered a large family, but she has not even married.

[2] Nonetheless, astrologers claim that the influence of the horoscope is strong, but I have already indicated sufficiently how empty it is. But whatever the truth of this, they stress that it holds good for the moment of birth. But is it not also applicable to the time of conception? It is clear that at that time there is the one act of intercourse, and the impact of nature is so great that once a woman has conceived, there is no possibility of a second conception, so that twins must be conceived at the same moment. Or because twins are born under different horoscopes, is it possible that at the time of their birth one has changed into a male, or the other into a female?

[3] It is possible to claim that it is not wholly absurd that differences are caused by certain influences from the stars, though only in our bodies. We see, for example, how at the approach and departure of the sun, the seasons of the year also manifest variations, and as the moon waxes and wanes, certain features in creation expand and contract, for example sea-urchins and oysters, and amazing ocean tides. But it cannot be similarly claimed that decisions made by the mind are subject to the locations of the stars. When astrologers seek to harness our actions as well to the stars, they issue a warning to us to investigate where this logic cannot square even in bodily matters, for what is so prominent a feature of the body as its sex? Yet under the same location of the stars it has been possible for twins of different sexes to be conceived.

[4] Vnde quid insipientius dici aut credi potest quam siderum positionem, quae ad horam conceptionis eadem ambobus fuit, facere non potuisse ut, cum quo habebat eandem constellationem, sexum diuersum a fratre non haberet; et positionem siderum, quae fuit ad horam nascentium, facere potuisse ut ab eo tam multum uirginali sanctitate distaret?

VII

[1] Iam illud quis ferat, quod in eligendis diebus noua quaedam suis actibus fata moliuntur? Non erat uidelicet ille ita natus ut haberet admirabilem filium, sed ita potius ut contemptibilem gigneret, et ideo uir doctus elegit horam qua misceretur uxori. Fecit ergo fatum quod non habebat, et ex ipsius facto coepit esse fatale quod in eius natiuitate non fuerat. O stultitiam singularem! Eligitur dies ut ducatur uxor; credo propterea quia potest in diem non bonum, nisi eligatur, incurri et infeliciter duci. Vbi est ergo quod nascenti iam sidera decreuerunt? An potest homo quod ei iam constitutum est diei electione mutare, et quod ipse in eligendo die constituerit non poterit ab alia potestate mutari?

[2] Deinde si soli homines, non autem omnia quae sub caelo sunt, constellationibus subiacent, cur aliter eligunt dies accommodatos ponendis uitibus uel arboribus uel segetibus, alios dies pecoribus uel domandis uel admittendis maribus, quibus equarum uel boum fetentur armenta, et cetera huius modi? Si autem propterea ualent ad has res dies electi quia terrenis omnibus corporibus siue animantibus secundum diuersitates temporalium momentorum siderum positio dominatur, considerent quam innumerabilia sub uno temporis puncto uel nascantur uel oriantur uel inchoentur, et tam diuersos exitus habeant ut istas obseruationes cuiuis puero ridendas esse persuadeant.

[4] So what more foolish claim or belief can there be than that on the one hand the location of the stars, which at the hour of conception was identical for both twins, could not have prevented the sister from being of a different sex from her brother with whom she shared the same constellation, but on the other that the location of the stars at the hour when they were born could have been the cause of her signal difference from him in the holiness of her virginity?

VII

[1] Who can tolerate the further notion that men engineer some change in their destinies by choosing the days for their actions? Presumably the sage whom I mentioned was not destined at his own birth to father a genius of a son, but instead to beget one who was worthless. So the learned fellow chose the hour at which to have intercourse with his wife. In this way he opted for a destiny not laid down for himself, and as the outcome of what he did, a destiny which had not existed at his birth was put in train. What egregious stupidity! A day for marrying a wife is chosen, presumably because, I suppose, without such selection an unlucky day could be encountered, and an unfortunate marriage contracted. So in that case what happens to what the stars have already decreed at his birth? Can a man by choosing a day change his appointed destiny, and will it not then be possible that the destiny which he established by changing the day may be changed by some other impetus?

[2] However, if humans alone, and not all things under heaven, are subject to the constellations, why do they choose some days as suitable for planting vines or trees or crops, and other days for taming farm-animals or for giving male animals access to enable herds of mares and cows to breed, and for other procedures of that kind? But if the days chosen for these activities are effectual because the location of the stars, varying from one moment to another, holds sovereign sway over all bodies or creatures on the earth, they should ponder how countless are the things which are born or arise or commence at any one moment of time, yet have such divergent outcomes as to make these astrological observations appear a laughing-stock in the eyes of any child.

[3] Quis enim est tam excors ut audeat dicere omnes arbores, omnes herbas, omnes bestias serpentes aues pisces uermiculos momenta nascendi singillatim habere diuersa? Solent tamen homines ad temptandam peritiam mathematicorum adferre ad eos constellationes mutorum animalium quorum ortus propter hanc explorationem domi suae diligenter obseruant, eosque mathematicos praeferunt ceteris, qui constellationibus inspectis dicunt non esse hominem natum, sed pecus. Audent etiam dicere quale pecus, utrum aptum lanitio an uectationi an aratro an custodiae domus. Nam et ad canina fata temptantur, et cum magnis admirantium clamoribus ista respondent.

[4] Sic desipiunt homines ut existiment, cum homo nascitur, ceteros rerum ortus ita inhiberi ut cum illo sub eadem caeli plaga nec musca nascatur. Nam si hanc admiserint, procedit ratiocinatio quae gradatim accessibus modicis eos a muscis ad camelos elephantosque perducat. Nec illud uolunt aduertere, quod electo ad seminandum agrum die tam multa grana in terram simul ueniunt, simul germinant, exorta segete simul herbescunt pubescunt flauescunt, et tamen inde spicas ceteris coaeuas atque, ut ita dixerim, congerminales alias robigo interimit, alias aues depopulantur, alias homines auellunt. Quo modo istis alias constellationes fuisse dicturi sunt, quas tam diuersos exitus habere conspiciunt? An eos paenitebit his rebus dies eligere easque ad caeleste negabunt pertinere decretum, et solos sideribus subdent homines, quibus solis in terra deus dedit liberas uoluntates?

[5] His omnibus consideratis non immerito creditur, cum astrologi mirabiliter multa uera respondent, occulto instinctu fieri spirituum non bonorum, quorum cura est has falsas et noxias opiniones de astralibus fatis inserere humanis mentibus atque firmare, non horoscopi notati et inspecti aliqua arte, quae nulla est.

[3] Who is so out of his mind as to claim that all trees, all plants, all brute beasts, snakes, birds, fish, and worms have differing and unique moments of birth? Yet men frequently have recourse to astrologers to try out their expertise; they submit to them horoscopes of dumb animals whose births they carefully monitor at home for the purpose of this investigation. They rank above the rest those astrologers who, upon observing the constellations, pronounce that a farm-animal and not a human being has been born. They even have the nerve to specify the animal, whether it is suitable for shearing or riding or ploughing or guarding the house. Indeed, people try them out even on dogs' destinies, and their responses evoke loud cries of approbation.

[4] Men are such fools as to believe that when a human being is born, an embargo is laid on the births of everything else, so that not even a fly is hatched out with him under the same section of the sky. The reason for this is that if they allow the birth of a fly, a process is set in place which by slight increases leads them on step by step from flies to camels and elephants! They are not keen, either, to observe that on the day chosen to sow a field, innumerable grains fall to the earth together, germinate together, and as the wheat emerges they put out green shoots, mature, and become golden together. But then some ears of the same age, and are (to coin a word) 'congerminal' with the rest, are destroyed by mould, others are plundered by birds, and others pulled from the earth by men. How are they to claim that those which they see had different outcomes were sown under different constellations? Or will they regret having chosen particular days for these things, and claim that they are not subject to the will of heaven, and make human beings alone subject to the stars, though men are the only creatures on earth to whom God has granted free will?

[5] As we ponder all these facts, it is reasonable to believe that when astrologers in remarkable fashion issue numerous true responses, this occurs through hidden prompting by evil spirits, whose concern is to instil into human minds and to lodge there such false and harmful beliefs about destinies dependent on the stars, and not through any technique of observing and reviewing horoscopes, for no such technique exists.

VIII

[1] Qui uero non astrorum constitutionem, sicuti est cum quidque concipitur uel nascitur uel inchoatur, sed omnium conexionem seriemque causarum, qua fit omne quod fit, fati nomine appellant, non multum cum eis de uerbi controuersia laborandum atque certandum est, quando quidem ipsum causarum ordinem et quandam conexionem dei summi tribuunt uoluntati et potestati, qui optime et ueracissime creditur et cuncta scire antequam fiant et nihil inordinatum relinquere; a quo sunt omnes potestates, quamuis ab illo non sint omnium uoluntates. Ipsam itaque praecipue dei summi uoluntatem, cuius potestas insuperabiliter per cuncta porrigitur, eos appellare fatum sic probatur. Annaei Senecae sunt, nisi fallor, hi uersus:

[2] Duc, summe pater altique dominator poli,
 quocumque placuit; nulla parendi mora est.
 Adsum impiger; fac nolle, comitabor gemens
 malusque patiar facere quod licuit bono.
 Ducunt uolentem fata, nolentem trahunt,

Nempe euidentissime hoc ultimo uersu ea fata appellauit, quam supra dixerat summi patris uoluntatem; cui paratum se oboedire dicit, ut uolens ducatur ne nolens trahatur, quoniam scilicet

 Ducunt uolentem fata, nolentem trahunt.

[3] Illi quoque uersus Homerici huic sententiae suffragantur quos Cicero in Latinum uertit:

 Tales sunt hominum mentes, quali pater ipse
 Iuppiter auctiferas lustrauit lumine terras.

Nec in hac quaestione auctoritatem haberet poetica sententia, sed quoniam Stoicos dicit uim fati asserentes istos ex Homero uersus solere usurpare, non de illius poetae sed de istorum philosophorum opinione tractatur, cum per istos uersus quos disputationi adhibent quam de fato habent, quid sentiant esse fatum apertissime declaratur, quoniam Iouem appellant, quem summum deum putant, a quo conexionem dicunt pendere fatorum.

VIII

[1] But there are some who attach the label of fate not to the location of the stars at the time of conception, birth, or commencement of something, but to the chain and sequence of all causes by which everything that takes place comes to pass. There is no need to struggle or compete with them in argument over the word, seeing that they ascribe the very sequence and chain of causes to the will and power of the supreme God, who they most correctly and truthfully believe both knows all things before they occur and leaves nothing out of the scheme of things. All powers proceed from him, though not what all men will is from him. So it is manifest that what they call fate is above all the will of the supreme God, whose power extends unconquerably through all things. These lines, if I am not mistaken, are by Annaeus Seneca:

[2] O supreme Father, master of the lofty sky,
 Lead where you will. Unhesitating I obey.
 Eager I wait. E'en if reluctant, I would still
 Groaning and scowling follow, as good men could do.
 Fate leads the willing, the unwilling drags by force.

This last line makes it absolutely clear that the spokesman attached the label 'fate' to what he had earlier called the will of the supreme Father. He says that he is ready to obey him, to be led willingly so as not to be dragged unwillingly, This is doubtless because

 Fate leads the willing, the unwilling drags by force.

[3] Those well-known lines of Homer too, rendered into Latin by Cicero, support this sentiment:

 Such are the minds of men, like to the light of day,
 Which father Jove dispenses over fertile fields.

A citation from poetry would have no authority on this issue, but since Cicero states that the Stoics were wont to borrow these lines of Homer when arguing for the impact of fate, the point at issue is not the view of the poet Homer, but that of those philosophers. For by citing those lines which they attach to their discussion on fate, they reveal in the clearest way what they think fate is, for they call it Jupiter, who they believe is the supreme God, and they say that the chain of destinies derives from him.

IX

[1] Hos Cicero ita redarguere nititur ut non existimet aliquid se aduersus eos ualere nisi auferat diuinationem. Quam sic conatur auferre ut neget esse scientiam futurorum, eamque omnibus uiribus nullam esse omnino contendat, uel in homine uel in deo, nullamque rerum praedictionem. Ita et dei praescientiam negat et omnem prophetiam luce clariorem conatur euertere uanis argumentationibus et opponendo sibi quaedam oracula quae facile possunt refelli; quae tamen nec ipsa conuincit. In his autem mathematicorum coniecturis refutandis eius regnat oratio, quia uere tales sunt ut se ipsae destruant et refellant.

[2] Multo sunt autem tolerabiliores qui uel siderea fata constituunt quam iste qui tollit praescientiam futurorum. Nam et confiteri esse deum et negare praescium futurorum apertissima insania est. Quod et ipse cum uideret, etiam illud temptauit quod scriptum est: *Dixit insipiens in corde suo: non est deus*, sed non ex sua persona. Vidit enim quam esset inuidiosum et molestum, ideoque Cottam fecit disputantem de hac re aduersus Stoicos in libris *De deorum natura*, et pro Lucilio Balbo, cui Stoicorum partes defendendas dedit, maluit ferre sententiam quam pro Cotta, qui nullam diuinam naturam esse contendit. In libris uero *De diuinatione* ex se ipso apertissime oppugnat praescientiam futurorum. Hoc autem totum facere uidetur ne fatum esse consentiat et perdat liberam uoluntatem. Putat enim concessa scientia futurorum ita esse consequens fatum ut negari omnino non possit.

[3] Sed quoquo modo se habeant tortuosissimae concertationes et disputationes philosophorum, nos ut confitemur summum et uerum deum, ita uoluntatem summamque potestatem ac praescientiam eius confitemur. Nec timemus ne ideo non uoluntate faciamus quod uoluntate facimus quia id nos facturos ille praesciuit, cuius praescientia falli non potest; quod Cicero

IX

[1] Cicero's attempt to refute the Stoics concedes that he cannot make any progress against them unless he can do away with divination. He attempts to achieve this by rejecting knowledge of future events. He maintains with all the force he can muster that foreknowledge does not exist in man or God, and that future events cannot be foretold. He thus both denies God's foreknowledge and attempts to undermine all prophecy, clearer than daylight though it is, by empty arguments, and by subjecting to his own view certain oracles which can readily be refuted. Yet even these he does not rebut, though in rejecting the guesswork of the astrologers his eloquence reigns supreme, for in reality their claims are such that they undermine and refute themselves.

[2] However, even those who argue for destinies dependent on the stars are much more supportable than Cicero, who dispenses with foreknowledge of future events. For it is the most blatant madness on the one hand to maintain that God exists, and on the other to reject his foreknowledge of the future. Since he himself realised this, he even tried out the role described in scripture: *The fool has said in his heart, There is no God.* He did not state this as his own view, for he saw how odious and objectionable it was. Accordingly he depicted Cotta as spokesman arguing on this issue against the Stoics in his book *The Nature of the Gods*, and he preferred to pronounce judgement in favour of Lucilius Balbus, to whom he assigned the role of defender of the Stoics, rather than in favour of Cotta, who maintained that there was no divine nature. But in his books *On Divination*, he spoke in his own person, quite openly attacking foreknowledge of future events. It appears that his whole purpose in doing this is to avoid accepting the existence of fate and the loss of free will, for he believes that if he admits knowledge of future events, the existence of fate follows so logically that it cannot be rejected on any grounds.

[3] But the philosophers can conduct their highly convoluted disputes and discussions as they will. We Christians proclaim our belief in both the existence of the sovereign and true God, and his will, supreme power, and foreknowledge. We have no fear that our acts of free will may not be acts of free will because he whose foreknowledge cannot be mistaken knows beforehand that we will perform them. This was what Cicero feared, causing

timuit, ut oppugnaret praescientiam, et Stoici ut non omnia necessitate fieri dicerent, quamuis omnia fato fieri contenderent.

[4] Quid est ergo quod Cicero timuit in praescientia futurorum, ut eam labefactare disputatione detestabili niteretur? Videlicet quia, si praescita sunt omnia futura, hoc ordine uenient quo uentura esse praescita sunt; et si hoc ordine uenient, certus est ordo rerum praescienti deo; et si certus est ordo rerum, certus est ordo causarum; non enim fieri aliquid potest, quod non aliqua efficiens causa praecesserit; si autem certus est ordo causarum quo fit omne quod fit, fato, inquit, fiunt omnia quae fiunt.

[5] Quod si ita est, nihil est in nostra potestate nullumque est arbitrium uoluntatis. Quod si concedimus, inquit, omnis humana uita subuertitur, frustra leges dantur, frustra obiurgationes laudes, uituperationes exhortationes adhibentur, neque ulla iustitia bonis praemia et malis supplicia constituta sunt. Haec ergo ne consequantur indigna et absurda et perniciosa rebus humanis, non uult esse praescientiam futurorum; atque in has angustias coartat animum religiosum ut unum eligat e duobus, aut esse aliquid in nostra uoluntate aut esse praescientiam futurorum, quoniam utrumque arbitratur esse non posse, sed si alterum confirmabitur, alterum tolli; si elegerimus praescientiam futurorum, tolli uoluntatis arbitrium; si elegerimus uoluntatis arbitrium, tolli praescientiam futurorum. Ipse itaque, ut uir magnus et doctus et uitae humanae plurimum ac peritissime consulens, ex his duobus elegit liberum uoluntatis arbitrium; quod ut confirmaretur, negauit praescientiam futurorum, atque ita, dum uult facere liberos, fecit sacrilegos.

[6] Religiosus autem animus utrumque eligit, utrumque confitetur, et fide pietatis utrumque confirmat. Quomodo? inquit; nam si est praescientia futurorum, sequentur illa omnia quae conexa sunt, donec eo perueniatur ut nihil sit in nostra uoluntate. Porro si est aliquid in nostra uoluntate, eisdem recursis gradibus eo peruenitur ut non sit praescientia futurorum. Nam per illa omnia sic recurritur: si est uoluntatis arbitrium, non omnia

him to confront foreknowledge, and the Stoics feared likewise; they argued that though all things happen by fate, they do not all occur by necessity.

[4] What was it, then, that Cicero feared in foreknowledge of future events that led him to attempt to undermine it by that execrable line of argument of his? Presumably it was the fact that if all future events are foreknown, they will come to pass in the sequence in which it was foreknown that they would; and if they will come to pass in that sequence, then that sequence of events is determined in the eyes of the foreknowing God. Then if the order of events is determined, so is the order of causes, for nothing can take place unless it is preceded by some efficient cause. But if the sequence of causes, by which everything happens which happens, is determined, then, he says, all things which happen happen by fate.

[5] If that is true, nothing lies within our power, and there is no free will. If we grant this, he says, the whole of human life is undermined. The prescription of laws is futile; it is futile to offer rebukes and praises, words of censure and of encouragement; there is no justice by which rewards are instituted for good men, and punishments for the wicked. So he refuses to concede foreknowledge of future events so as to avoid unworthy, ridiculous, and harmful consequences for human affairs. He confines the religious mind to the narrow choice of one of two options: there is either some role for our will, or there is foreknowledge of future events, for he thinks that the two cannot possibly coexist. If we maintain the one, we remove the other. If we opt for foreknowledge of future events, free will is excluded. If we opt for free will, foreknowledge of the future is excluded. Accordingly Cicero himself, as was appropriate for a great and learned man with the profoundest and most experienced concern for human existence, chose free will of the two alternatives, and to underline his choice he denied foreknowledge of future events. Thus in seeking to make men free, he made them sacrilegious.

[6] But the religious mind opts for and proclaims both, and the trust in his devotion induces him to insist on both. "How could that be?" asks Cicero. "Surely if there is foreknowledge of the future, a whole chain of events will ensue, till the point is reached that nothing is left to our will. On the other hand, if anything is subject to our will, by taking the same steps backward we reach the point at which there is no foreknowledge of the future. We trace the argument back through all the following stages: if there

fato fiunt; si non onmia fato fiunt, non est omnium certus ordo causarum; si certus causarum ordo non est, nec rerum certus est ordo praescienti deo, quae fieri non possunt nisi praecedentibus et efficientibus causis; si rerum ordo praescienti deo certus non est, non omnia sic ueniunt ut ea uentura praesciuit; porro si non omnia sic ueniunt ut ab illo uentura praescita sunt, non est, inquit, in deo praescientia omnium futurorum.

[7] Nos aduersus istos sacrilegos ausus atque impios et deum dicimus omnia scire antequam fiant, et uoluntate nos facere quidquid a nobis non nisi uolentibus fieri sentimus et nouimus. Omnia uero fato fieri non dicimus, immo nulla fieri fato dicimus; quoniam fati nomen ubi solet a loquentibus poni, id est in constitutione siderum cum quisque conceptus aut natus est, quoniam res ipsa inaniter asseritur, nihil ualere monstramus.

[8] Ordinem autem causarum, ubi uoluntas dei plurimum potest, neque negamus neque fati uocabulo nuncupamus, nisi forte ut fatum a fando dictum intellegamus, id est a loquendo; non enim abnuere possumus esse scriptum in litteris sanctis: *Semel locutus est deus; duo haec audiui, quoniam potestas dei est, et tibi, domine, misericordia, qui reddis unicuique secundum opera eius.* Quod enim dictum est *Semel locutus est*, intellegitur immobiliter, hoc est incommutabiliter, est locutus, sicut nouit incommutabiliter omnia quae futura sunt et quae ipse facturus est. Hac itaque ratione possemus a fando fatum appellare, nisi hoc nomen iam in alia re soleret intellegi quo corda hominum nolumus inclinari.

[9] Non est autem consequens ut, si deo certus est omnium ordo causarum, ideo nihil sit in nostrae uoluntatis arbitrio. Et ipsae quippe nostrae uoluntates in causarum ordine sunt qui certus est deo, eiusque praescientia continetur, quoniam et humanae uoluntates humanorum operum causae sunt, atque ita, qui omnes rerum causas praesciuit profecto in eis causis etiam nostras uoluntates ignorare non potuit, quas nostrorum operum causas esse praesciuit.

is free will, all things do not happen by fate; if all things do not happen by fate, there is no determined sequence of all causes; if there is no determined sequence of causes, there is no determined sequence of events foreknown by God, for those events cannot occur without their efficient causes preceding them; if there is no determined sequence of events foreknown by God, then all things do not come to pass as he foreknew they would; further, if all things do not come to pass as he foreknew they would, then God" he says, "does not have foreknowledge of all future events".

[7] Our riposte as Christians to these sacrilegious and impious assertions is to state both that God knows all things before they come to pass, and that we use our free will to do whatever we feel and know is done solely of our own volition. We maintain that all things do not happen by fate, and indeed we maintain that nothing happens by fate. This is because the word as commonly used by those who speak of it, namely with reference to the position of the stars at each person's conception or birth, has no validity, for, as we have shown, the claim is totally devoid of substance.

[8] As for the sequence of causes, in which the will of God has the greatest power, we neither deny it nor give it the name of fate, except perhaps in our awareness that the word fate derives from the verb *fari*, which means to speak. We certainly cannot deny that in the sacred scriptures it is written: *God has spoken once. These two things have I heard, that power belongs to God, and mercy is yours, O Lord, for you render to each man according to his works.* The phrase *has spoken once* means he has spoken immovably, in other words unchangeably, just as he knows unchangeably all that will come to pass, and all that he himself will do. So on this assumption we could employ the word fate as deriving from *fari*, were it not for the fact that it is now usually understood in another context, to which we are reluctant to have men turn their minds.

[9] It does not however follow that if the fixed sequence of all causes lies with God, there is no scope for our will to choose, for our wills are themselves contained in the sequence of causes already determined in God and embraced by his foreknowledge, since our human wills too are causes of human actions. Accordingly he who has foreknown all the causes of things could certainly not remain unaware of our wills as well among those causes, for he has foreseen that they are the causes of our actions.

[10] Nam et illud quod idem Cicero concedit, nihil fieri si causa efficiens non praecedat, satis est ad eum in hac quaestione redarguendum. Quid enim eum adiuuat quod dicit nihil quidem fieri sine causa, sed non omnem causam esse fatalem, quia est causa fortuita, est naturalis, est uoluntaria? Sufficit quia omne quod fit non nisi causa praecedente fieri confitetur. Nos enim eas causas quae dicuntur fortuitae, unde etiam Fortuna nomen accepit, non esse dicimus nullas sed latentes, easque tribuimus uel dei ueri uel quorumlibet spirituum uoluntati, ipsasque naturales nequaquam ab illius uoluntate seiungimus qui est auctor omnis conditorque naturae. Iam uero causae uoluntariae aut dei sunt aut angelorum aut hominum aut quorumque animalium, si tamen uoluntates appellandae sunt animarum rationis expertium motus illi quibus aliqua faciunt secundum naturam suam cum quid uel adpetunt uel euitant. Angelorum autem uoluntates dico seu bonorum, quos angelos dei dicimus, seu malorum, quos angelos diaboli uel etiam daemones appellamus; sic et hominum, et bonorum scilicet et malorum.

[11] Ac per hoc colligitur non esse causas efficientes omnium quae fiunt nisi uoluntarias, illius naturae scilicet quae spiritus uitae est. Nam et aër iste seu uentus dicitur spiritus; sed quoniam corpus est, non est spiritus uitae. Spiritus ergo uitae, qui uiuificat omnia creatorque est omnis corporis et omnis creati spiritus, ipse est deus, spiritus utique non creatus. In eius uoluntate summa potestas est, quae creatorum spirituum bonas uoluntates adiuuat, malas iudicat, omnes ordinat et quibusdam tribuit potestates, quibusdam non tribuit. Sicut enim omnium naturarum creator est, ita omnium potestatum dator, non uoluntatum. Malae quippe uoluntates ab illo non sunt, quoniam contra naturam sunt, quae ab illo est.

[12] Corpora igitur magis subiacent uoluntatibus, quaedam nostris, id est omnium animantium mortalium et magis hominum quam bestiarum, quaedam uero angelorum. Sed omnia maxime dei uoluntati subdita sunt, cui etiam uoluntates omnes subiciuntur, quia non habent potestatem nisi quam ille concedit. Causa itaque rerum, quae facit nec fit, deus est; aliae uero causae et faciunt et fiunt, sicut sunt omnes creati spiritus, maxime

[10] Moreover, the principle which Cicero grants, that nothing comes to pass if its efficient cause does not precede it, is sufficient to refute him on this issue. How does his statement that nothing happens without a cause, but that not every cause is predestined (for a cause may be fortuitous, or natural, or voluntary), help his case? It is enough that he grants that everything which comes to pass takes place solely by reason of its preceding cause. We claim not that the causes labelled fortuitous (the source from which Fortune obtained her name) do not exist at all, but that they are hidden, and we attribute them either to the will of the true God or to the wills of certain spirits. As for natural causes, we certainly do not isolate them from the will of him who is the creator and founder of all nature. Beyond these, voluntary causes lie with God or angels or men or the various animals, if indeed we can attach the term 'wills' to those impulses of souls bereft of reason, by which they do certain things as their nature tells them what to seek or avoid. The angels whose wills I mention are either the good angels whom we call God's, or wicked angels whom we term the devil's and also call demons. Likewise with the wills of men; they embrace both good and evil men.

[11] From this we infer that voluntary causes are the only efficient causes of everything that comes to pass. They derive from that nature which is the spirit of life. That word *spiritus* is in fact used of the lower air around us, and also of the wind, but *spiritus* in that sense is physical, and so it is not the spirit of life. The spirit of life, then, which lends life to all things, and creates every body and every created spirit, is God himself, the spirit who is certainly not created. His will embraces the supreme power which lends aid to the good intentions of created spirits, and passes judgement on their evil intentions. All those intentions he orders, assigning powers to some but not to others, for just as he is the creator of all natures, so he dispenses all powers, but not all intentions. Hence evil intentions do not emanate from him because they are opposed to nature, which is from him.

[12] As for bodies, they are subject rather to wills, some of them to ours (the wills, that is, of all living mortal creatures, more especially of humans than of beasts), and some to angels. But all bodies are subject above all to the will of God, and all wills likewise are subject to him, because the sole power which they have is that which he grants them. It follows that the cause of things which creates and is not created is God; other causes, however, both create and are created, for example all created spirits, above all those with

rationales. Corporales autem causae, quae magis fiunt quam faciunt, non sunt inter causas efficientes adnumerandae, quoniam hoc possunt quod ex ipsis faciunt spirituum uoluntates.

[13] Quo modo igitur ordo causarum, qui praescienti certus est deo, id efficit ut nihil sit in nostra uoluntate, cum in ipso causarum ordine magnum habeant locum nostrae uoluntates? Contendat ergo Cicero cum eis qui hunc causarum ordinem dicunt esse fatalem uel potius ipsum fati nomine appellant, quod nos abhorremus praecipue propter uocabulum, quod non in re uera consueuit intellegi. Quod uero negat ordinem omnium causarum esse certissimum et dei praescientiae notissimum, plus eum quam Stoici detestamur. Aut enim esse deum negat, quod quidem inducta alterius persona in libris de deorum natura facere molitus est, aut si esse confitetur deum, quem negat praescium futurorum, etiam sic nihil dicit aliud quam quod ille *dixit insipiens in corde suo: Non est deus*. Qui enim non est praescius omnium futurorum non est utique deus.

[14] Quapropter et uoluntates nostrae tantum ualent quantum deus eas ualere uoluit atque praesciuit; et ideo quiquid ualent, certissime ualent, et quod facturae sunt ipsae omnino facturae sunt, quia ualituras atque facturas ille praesciuit, cuius praescientia falli non potest. Quapropter si mihi fati nomen alicui rei adhibendum placeret, magis dicerem fatum esse infirmioris potentioris uoluntatem qui eum habet in potestate, quam illo causarum ordine, quem non usitato sed suo more Stoici fatum appellant, arbitrium nostrae uoluntatis auferri.

X

[1] Vnde nec illa necessitas formidanda est, quam formidando Stoici laborauerunt causas rerum ita distinguere ut quasdam subtraherent necessitati, quasdam subderent, atque in his quas esse sub necessitate noluerunt, posuerunt etiam nostras uoluntates, ne uidelicet non essent liberae si subderentur necessitati. Si enim necessitas nostra illa dicenda est

reason. Physical causes, however, which are created rather than create, are not to be numbered among efficient causes, since the power they wield is what the wills of spirits perform by deploying them.

[13] How, then, can the pattern of causes fixed in the foreknowledge of God cause our will to have no role, when our wills hold an important place in that very pattern of causes? So we can leave Cicero to fight it out with those who claim that this pattern of causes is the work of fate, or rather, who attach the word fate to the pattern itself. This is a view which we abhor, particularly because of the word fate, which is usually not understood in its true context. But when Cicero denies that the pattern of all causes is wholly fixed and wholly known in the foreknowledge of God, we abominate him more than do the Stoics, for either he is denying that God exists, which he attempted to do by assuming the character of someone else in his books *On the nature of the gods*, or if he accepts the existence of God but says that God has no knowledge of future events, even so he is saying just what *the fool said in his heart: There is no God.* For one who has no prior knowledge of future events is certainly not God.

[14] Accordingly our dispositions of will are as effective as God has willed and has foreknown them to be, so whatever the power they have, they most certainly possess it. What our wills intend to accomplish, they will certainly do of their own accord, because God has foreseen that they will have the power to do it and that they will do it, and his foreknowledge cannot be in error. So if I wanted the term fate to be applied to anything, I should prefer to say that the fate of the weaker is the will of the stronger, who has the weaker in his power, rather than that our free will is eliminated by the pattern of causes which the Stoics by their peculiar rather than common usage call 'fate'.

X

[1] For this reason we need not stand in awe of the necessity which the Stoics feared when they toiled to make a distinction between the causes of things, removing some from the grip of necessity, and subjecting others to it. Under those which they refused to subordinate to necessity they placed our wills; doubtless they feared that these would not be free if they were subjected to necessity. For if the term necessity as it applies to us is used to describe what

quae non est in nostra potestate, sed etiamsi nolimus efficit quod potest, sicut est necessitas mortis, manifestum est uoluntates nostras, quibus recte uel perperam uiuitur, sub tali necessitate non esse. Multa enim facimus quae si nollemus, non utique faceremus. Quo primitus pertinet ipsum uelle; nam si uolumus, est, si nolumus, non est; non enim uellemus si nollemus.

[2] Si autem illa definitur esse necessitas secundum quam dicimus necesse esse ut ita sit aliquid uel ita fiat, nescio cur eam timeamus ne nobis libertatem auferat uoluntatis. Neque enim et uitam dei et praescientiam dei sub necessitate ponimus, si dicamus necesse esse deum semper uiuere et cuncta praescire; sicut nec potestas eius minuitur cum dicitur mori fallique non posse. Sic enim hoc non potest, ut potius si posset minoris esset utique potestatis. Recte quippe omnipotens dicitur, qui tamen mori et falli non potest. Dicitur enim omnipotens faciendo quod uult, non patiendo quod non uult; quod ei si accideret, nequaquam esset omnipotens. Vnde propterea quaedam non potest, quia omnipotens est. Sic etiam cum dicimus necesse esse ut, cum uolumus, libero uelimus arbitrio; et uerum procul dubio dicimus, et non ideo ipsum liberum arbitrium necessitati subicimus quae adimit libertatem.

[3] Sunt igitur nostrae uoluntates, et ipsae faciunt quidquid uolendo facimus, quod non fieret si nollemus. Quidquid autem aliorum hominum uoluntate nolens quisque patitur, etiam sic uoluntas ualet etsi non illius, tamen hominis uoluntas, sed potestas dei. Nam si uoluntas tantum esset nec posset quod uellet, potentiore uoluntate impediretur; nec sic tamen uoluntas nisi uoluntas esset, nec alterius sed eius esset qui uellet, etsi non posset implere quod uellet. Vnde quidquid praeter suam uoluntatem patitur homo, non debet tribuere humanis uel angelicis uel cuiusquam creati spiritus uoluntatibus, sed eius potius qui dat potestatem uolentibus.

[4] Non ergo propterea nihil est in nostra uoluntate quia deus praesciuit quid futurum esset in nostra uoluntate. Non enim qui hoc praesciuit nihil praesciuit. Porro si ille qui praesciuit quid futurum esset in nostra uoluntate

is not in our power, and achieves its force even against our will (I instance the necessity of death), it is clear that our wills, which make for an upright or a depraved life, are not subject to such necessity, for we do many things which we would certainly not do if we had no wish to do so. To begin with, our willing itself falls into this category, for if we will, the will exists, and if we do not, it does not; for if we were unwilling, we would not will.

[2] If, however, necessity is defined as what we claim is necessary for something to be what it is, or to become what it becomes, I see no reason why we should fear that it deprives us of our freedom of will. We do not subject God's life and God's foreknowledge to necessity if we state that it is necessary that God lives for ever and foreknows all things. Likewise his power is not curtailed when we say that he cannot die or be misled. His inability to do these things is such that if he could do them, his power would undoubtedly be diminished, for he is rightly called omnipotent though he can neither die nor be misled. What his omnipotence means is that he does what he wills, not that he suffers what he does not will, for if what he does not will were to happen to him, he would certainly not be omnipotent. Thus it is because he cannot do certain things that he is omnipotent. Similarly we say that it is necessary for us to use our free will when we wish to do so. When we say this, we undoubtedly speak the truth, but we do not on that account subject our free will to necessity which deprives us of our freedom.

[3] Our wills therefore exist, and they carry out what we do by willing it, and this would not happen if we did not will it. But if an individual unwillingly suffers something through the will of others, the will prevails even in that case, for though it is not the victim's will, it is nonetheless a human will, though its power comes from God. If it were merely willing and could not attain its will, it would be hindered by a more powerful will. Yet even so the will would be nothing other than a will, the will not of that other but of him who willed, even if he could not fulfil his wish. So whatever a person suffers against his will he must not ascribe to the wills of humans, or of angels, or of any created spirit, but rather to the will of him who bestows power on those who have the will.

[4] It does not therefore follow that our will has no substance because God has foreseen what it will contain, since his foreknowledge of it means that there was something of which he had foreknowledge. Moreover, if he who foreknew what would lie in our will certainly had foreknowledge of

non utique nihil sed aliquid praesciuit, profecto et illo praesciente est aliquid in nostra uoluntate. Quocirca nullo modo cogimur aut retenta praescientia dei tollere uoluntatis arbitrium, aut retento uoluntatis arbitrio deum, quod nefas est, negare praescium futurorum; sed utrumque amplectimur, utrumque fideliter et ueraciter confitemur, illud ut bene credamus, hoc ut bene uiuamus. Male autem uiuitur si de deo non bene creditur.

[5] Vnde absit a nobis eius negare praescientiam ut libere uelimus, quo adiuuante sumus liberi uel erimus. Proinde non frustra sunt leges obiurgationes exhortationes laudes et uituperationes, quia et ipsas futuras esse praesciuit et ualent plurimum, quantum eas ualituras esse praesciuit, et preces ualent ad ea impetranda quae se precantibus concessurum esse praesciuit, et iuste praemia bonis factis et peccatis supplicia constituta sunt. Neque enim ideo [non] peccat homo, quia deus illum peccaturum esse praesciuit; immo ideo non dubitatur ipsum peccare cum peccat, quia ille cuius praescientia falli non potest non fatum, non fortunam, non aliquid aliud sed ipsum peccaturum esse praesciuit. Qui si nolit, utique non peccat, sed si peccare noluerit, etiam hoc ille praesciuit.

XI

[1] Deus itaque summus et uerus cum Verbo suo et Spiritu sancto, quae tria unum sunt, deus unus omnipotens, creator et factor omnis animae atque omnis corporis, cuius sunt participatione felices quicumque sunt ueritate non uanitate felices, qui fecit hominem rationale animal ex anima et corpore, qui eum peccantem nec inpunitum esse permisit nec sine misericordia dereliquit; qui bonis et malis essentiam etiam cum lapidibus, uitam seminalem etiam cum arboribus, uitam sensualem etiam cum pecoribus, uitam intellectualem cum solis angelis dedit.

[2] A quo est omnis modus, omnis species, omnis ordo; a quo est mensura numerus pondus; a quo est quidquid naturaliter est, cuiuscumque generis est, cuiuslibet aestimationis est; a quo sunt semina formarum, formae seminum, motus seminum atque formarum; qui dedit et carni originem pulchritudinem ualetudinem, propagationis fecunditatem, membrorum dispositionem,

something rather than nothing in it, then there is certainly something in our will, since he foreknows it. Hence we are in no way compelled either to eliminate free will in preserving God's foreknowledge, or by preserving free will to deny God's foreknowledge of the future, which would be blasphemy. We embrace both truths, we proclaim both in faith and truth, in faith for right belief and in truth for right living, for our lives are flawed if our belief in God is flawed.

[5] So heaven forfend that we deny God's foreknowledge so as to assert our free will, for it is by his help that we are or will be free. So laws, rebukes, exhortations, praises, and censure are not vain, for God has had foreknowledge that they will exist, and they have the utmost validity as he foreknew that they would. Our prayers are productive in attaining the things which he foreknew that he would grant to them, and rewards have been justly allocated for good deeds, as punishments have been for sins. Man does not fall into sin because God has foreknown that he would fall into sin; on the contrary, it is beyond doubt that he sins when he sins because he whose foreknowledge cannot be misled foresaw no fate or fortune or anything other than that he would sin. If he is unwilling to sin, he certainly does not sin; if he refuses to sin, God has foreseen this as well.

XI

[1] So the supreme, true God, together with his Word and the holy Spirit, are three in one, the one almighty God, creator and maker of every soul and every body. Those blessed in verity and not vanity are blessed through their sharing in him. He created man as a rational animal consisting of soul and body. When man sinned, he neither allowed him to go unpunished nor mercilessly abandoned him. He bestowed on good and evil men alike existence shared with stones, seminal life shared with trees, the life of the senses shared with beasts, and intellectual life shared with angels alone.

[2] From him comes every mode of being, every species, every dispensation; from him comes all measure, number, and weight; from him comes all that is in nature, whatever its kind and whatever its worth; from him come the seeds of forms, the forms of seeds, and the movements of seeds and forms. He further bestowed on flesh its beginning, beauty, health, fertility

salutem concordiae; qui et animae irrationali dedit memoriam sensum
appetitum, rationali autem insuper mentem intellegentiam uoluntatem; qui
non solum caelum et terram, nec solum angelum et hominem, sed nec exigui
et contemptibilis animantis uiscera nec auis pinnulam, nec herbae flosculum
nec arboris folium sine suarum partium conuenientia et quadam ueluti pace
dereliquit, nullo modo est credendus regna hominum eorumque dominationes
et seruitutes a suae prouidentiae legibus alienas esse uoluisse.

XII

[1] Proinde uideamus quos Romanorum mores et quam ob causam deus
uerus ad augendum imperium adiuuare dignatus est, in cuius potestate
sunt etiam regna terrena. Quod ut absolutius disserere possemus, ad hoc
pertinentem et superiorem librum conscripsimus, quod in hac re potestas
nulla sit eorum deorum quos etiam rebus nugatoriis colendos putarunt, et
praesentis uoluminis partes superiores quas huc usque perduximus, de fati
quaestione tollenda, ne quisquam cui iam persuasum esset non illorum
deorum cultu Romanum imperium propagatum atque seruatum, nescio cui
fato potius id tribueret quam dei summi potentissimae uoluntati.

[2] Veteres igitur primique Romani, quantum eorum docet et commendat
historia, quamuis ut aliae gentes excepta una populi Hebraeorum deos falsos
colerent, et non deo uictimas sed daemoniis immolarent, tamen 'laudis auidi,
pecuniae liberales erant, gloriam ingentem, diuitias honestas uolebant'; hanc
ardentissime dilexerunt, propter hanc uiuere uoluerunt, pro hac emori non
dubitauerunt; ceteras cupiditates huius unius ingenti cupiditate presserunt.

[3] Ipsam denique patriam suam, quoniam seruire uidebatur inglorium,
dominari uero atque imperare gloriosum, prius omni studio liberam, deinde

in reproduction, disposition of limbs and health-giving harmony between them. To the soul without reason he gave memory, sensation, and appetite, and to the rational soul the additional faculties of mind, understanding, and will. He has not left deprived of harmony and peace, as it were, between their parts not only sky and earth, not only angels and men, but even the inward parts of tiny and paltry creatures, the delicate feathers of birds, tiny blossoms on plants, leaves on the trees. So it is impossible to believe that he sought to leave bereft of the laws of providence the kingdoms of men, and the modes of government and subservience within them.

XII

[1] Let us now proceed to examine which manners of the Romans the true God, in whose power earthly kingdoms too reside, deigned to aid for the extension of their empire, and his reason for this. So as to be able to discuss this more fully, I composed the previous book to be also relevant to this topic. The point I make there is that the gods, who the Romans thought should be worshipped even in trivial concerns, exercise no power in that respect. The earlier chapters of the present book, which I have completed up to this point, are also relevant, for they discuss as an issue how fate is to be disregarded. My aim there was to dissuade anyone, now convinced that the Roman Empire had not been enlarged and preserved by worship of those gods, from attributing that development instead to some notion of fate rather than to the most powerful will of the supreme God.

[2] To proceed, then. The ancient Romans of the earliest times (in so far as their written history teaches, and praises them) admittedly worshipped false gods, as other nations did with the sole exception of the Hebrew people, and offered sacrificial victims not to God, but to demons. Nevertheless, "they were eager for praise and generous with money, and they sought great glory and honourable riches". They had the most burning ambition for glory, seeking to make it the purpose of their lives, and they did not hesitate to die for it. All other longings they restrained in their boundless longing for glory alone.

[3] Finally, since they considered it inglorious for their fatherland to be enslaved, and glorious for it to control and rule, their primary, wholly

dominam esse concupiuerunt. Hinc est quod regalem dominationem non ferentes 'annua imperia binosque imperatores sibi fecerunt' qui consules appellati sunt a consulendo, non reges aut domini a regnando atque dominando, cum et reges utique a regendo dicti melius uideantur, ut regnum a regibus, reges autem ut dictum est a regendo; sed fastus regius non disciplina putata est regentis uel beniuolentia consulentis, sed superbia dominantis.

[4] Expulso itaque rege Tarquinio et consulibus institutis, secutum est quod idem auctor in Romanorum laudibus posuit, quod 'ciuitas incredibile memoratu est adepta libertate quantum breui creuerit; tanta cupido gloriae incesserat'. Ista ergo laudis auiditas et cupido gloriae multa illa miranda fecit, laudabilia scilicet atque gloriosa secundum hominum existimationem.

[5] Laudat idem Sallustius temporibus suis magnos et praeclaros uiros, Marcum Catonem et Gaium Caesarem, dicens quod diu illa respublica non habuit quemquam uirtute magnum, sed sua memoria fuisse illos duos ingenti uirtute, diuersis moribus. In laudibus autem Caesaris posuit quod sibi magnum imperium, exercitum, bellum nouum exoptabat ubi uirtus enitescere posset. Ita fiebat in uotis uirorum uirtute magnorum ut excitaret in bellum miseras gentes, et flagello agitaret Bellona sanguineo ut esset ubi uirtus eorum enitesceret. Hoc illa profecto laudis auiditas et gloriae cupido faciebat.

[6] Amore itaque primitus libertatis, post etiam dominationis et cupiditate laudis et gloriae multa magna fecerunt. Reddit eis utriusque rei testimonium etiam poeta insignis illorum; inde quippe ait:

> Nec non Tarquinium eiectum Porsenna iubebat
> accipere, ingentique urbem obsidione premebat;
> Aeneadae in ferrum pro libertate ruebant.

Tunc itaque magnum illis fuit aut fortiter emori aut liberos uiuere.

zealous wish was to make it free, and then to give it mastery. This is why they refused to submit to the control of the kings. "They appointed over themselves yearly periods of rule and twin rulers"; they were called consuls, a word derived from taking counsel, instead of kings or masters, words derived from the Latin for reigning and mastery. But it certainly seems better that kings were called *reges* from *regere*, as 'kingship' is derived from 'kings'. So *reges*, as I have stated, is derived from *regere*. But the hauteur of kings was not considered to be the strict discipline of the ruler or the benevolence of the counsellor, but the arrogance of the despot.

[4] So when king Tarquin had been driven out, and consuls had been established, there followed the period which that same historian numbered among the glories of the Romans. He states: "It is astonishing to relate how great the state grew within a short time, once freedom had been gained; so great a desire for glory had possessed them". So this greed for praise and this desire for glory gained them many remarkable achievements, which by human reckoning were undoubtedly praiseworthy and glorious.

[5] Sallust also praises great and glorious men of his own day, Marcus Cato and Gaius Caesar. He says that for a long time the Roman republic contained no person of outstanding merit, but that within his own recollection there were these two men of signal merit but dissimilar character. In his praises of Caesar, he recorded that he longed to have a high command, an army, and a new war in which his courage would be conspicuous. What these men of great virtue prayed for was that Bellona would rouse wretched nations to war and would incite them with her bloodstained whip, and thus afford a chance for their merit to shine forth. Undoubtedly it was that greed for praise and ambition for glory which inspired this.

[6] Thus initially through their love of freedom, and later through their longing for domination, praise, and glory, they achieved many great deeds. That notable poet of theirs bears witness to both motives, for he says of them:

> Porsenna too commanded Romans to take back
> The banished Tarquin, mounting heavy siege on Rome.
> Aeneas's sons rushed into arms for freedom's sake.

So at that time it was a splendid thing for them either to die bravely or to live in freedom.

[7] Sed cum esset adepta libertas, tanta cupido gloriae incesserat ut parum esset sola libertas nisi et dominatio quaereretur, dum pro magno habetur quod uelut loquente Ioue idem poeta dicit:

> Quin aspera Iuno,
> quae mare nunc terrasque metu caelumque fatigat,
> consilia in melius referet mecumque fouebit
> Romanos rerum dominos gentemque togatam.
> Sic placitum. Veniet lustris labentibus aetas,
> cum domus Assaraci Phthiam clarasque Mycenas
> seruitio premet ac uictis dominabitur Argis.

[8] Quae quidem Vergilius Iouem inducens tamquam futura praedicentem ipse iam facta recolebat cernebatque praesentia. Verum propterea commemorare illa uolui ut ostenderem dominationem post libertatem sic habuisse Romanos ut in eorum magnis laudibus poneretur. Hinc est et illud eiusdem poetae quod, cum artibus aliarum gentium eas ipsas proprias Romanorum artes regnandi atque imperandi et subiugandi ac debellandi populos anteponeret, ait:

> Excudent alii spirantia mollius aera,
> cedo equidem, uiuos ducent de marmore uultus,
> orabunt causas melius, caelique meatus
> describent radio et surgentia sidera dicent;
> tu regere imperio populos, Romane, memento
> (hae tibi erunt artes) pacique imponere mores,
> parcere subiectis et debellare superbos.

[9] Has artes illi tanto peritius exercebant quanto minus se uoluptatibus dabant et eneruationi animi et corporis in concupiscendis et augendis diuitiis et per illas moribus corrumpendis rapiendo miseris ciuibus, largiendo scaenicis turpibus.

[10] Vnde qui tales iam morum labe superabant atque abundabant, quando scribebat ista Sallustius canebatque Vergilius, non illis artibus ad honores et gloriam, sed dolis atque fallaciis ambiebant. Vnde idem dicit: 'Sed primo magis ambitio quam auaritia animos hominum exercebat, quod

[7] But when they had gained that freedom, such great longing for glory had possessed them that it was not enough to seek freedom alone without dominion as well. They laid great emphasis on what that same poet put in the mouth of Jupiter:

> E'en Juno, who in spite
> Now wearies sea and lands and sky with fear,
> Will then reverse her plans, and aid with me
> The togaed Romans, masters of the world.
> The fated age will come as years glide by,
> When Assaracus's house the Phthians will enslave
> And famed Mycenae; Argos will they then subdue.

[8] When Virgil introduced Jupiter thus predicting the future, the poet himself was by then recalling these events as past, and witnessing them as present. But I wanted to cite them to show that the Romans held dominion after liberty in such high regard that it was regarded as one of their praiseworthy achievements. This lies behind that famous passage of the same poet, in which he rated above the accomplishments of other nations the Romans' techniques of ruling and commanding, subjecting and crushing nations in war:

> Others, I grant, will beat from bronze figures that breathe
> A gentler life, create from marble lifelike forms;
> Cases at law they'll better plead; with compass trace
> Pathways of heaven, nominate the stars that rise;
> Remember, Roman, rule the nations with high sway
> For these will be your skills: implant your ways on peace,
> To spare those you have conquered, and war down the proud.

[9] Those skills they practised with expertise all the greater according as they devoted themselves less to pleasures, to the weakening of mind and body in their lust for the amassing of riches, and to undermining their morals through those riches by plundering their wretched fellow-citizens and lavishly rewarding loathsome actors.

[10] The outcome was that when Sallust penned this history, and Virgil this poetry, men who outdid such predecessors in being awash in moral corruption no longer canvassed for glory and high office by those means, but instead with acts of guile and deceit. This is why Sallust further states: "But initially ambition rather than greed preoccupied men's minds, a vice,

tamen uitium propius uirtutem erat. Nam gloriam honorem imperium bonus et ignauus aeque sibi exoptant; sed ille' inquit 'uera uia nititur, huic quia bonae artes desunt dolis atque fallaciis contendit'. Hae sunt illae bonae artes, per uirtutem scilicet non per fallacem ambitionem ad honorem et gloriam et imperium peruenire; quae tamen bonus et ignauus aeque sibi exoptant; sed ille, id est bonus, uera uia nititur. Via uirtus est, qua nititur tamquam ad possessionis finem, id est ad gloriam honorem imperium.

[11] Hoc insitum habuisse Romanos etiam deorum apud illos aedes indicant quas coniunctissimas constituerunt, Virtutis et Honoris, pro diis habentes quae dantur a deo. Vnde intellegi potest quem finem uolebant esse uirtutis et quo eam referebant qui boni erant, ad honorem scilicet; nam mali nec habebant eam, quamuis honorem habere cuperent, quem malis artibus conabantur adipisci, id est dolis atque fallaciis.

[12] Melius laudatus est Cato. De illo quippe ait: 'Quo minus petebat gloriam, eo illum magis sequebatur'. Quando quidem gloria est, cuius illi cupiditate flagrabant, iudicium hominum bene de hominibus opinantium; et ideo melior est uirtus quae humano testimonio contenta non est nisi conscientiae suae. Vnde dicit apostolus: *Nam gloria nostra haec est, testimonium conscientiae nostrae*. Et alio loco: *Opus autem suum probet unusquisque, et tunc in semet ipso tantum gloriam habebit, et non in altero*. Gloriam ergo et honorem et imperium, quae sibi exoptabant et quo bonis artibus peruenire nitebantur boni, non debet sequi uirtus, sed ipsa uirtutem. Neque enim est uera uirtus nisi quae ad eum finem tendit ubi est bonum hominis quo melius non est. Vnde et honores quos petiuit Cato petere non debuit, sed eos ciuitas ob eius uirtutem non petenti dare.

[13] Sed cum illa memoria duo Romani essent uirtute magni, Caesar et Cato, longe uirtus Catonis ueritati uidetur propinquior fuisse quam Caesaris. Proinde qualis esset illo tempore ciuitas et antea qualis fuisset, uideamus in ipsa sententia Catonis: 'Nolite' inquit 'existimare maiores nostros armis

it is true, but one quite close to a virtue. For men both good and base alike long for glory, high office, and military command. But the man who is good" he adds, "strives on the path of truth, but the man who is base lacks noble qualities, and therefore strives with acts of guile and deception". The noble qualities mentioned are the means of attaining high office, glory, and military command not by deceitful ambition but in fact by virtue. Good and base men alike desire to attain these goals, but the good man strives for them by the path of truth. That path is virtue, by which he strives to attain the goal which he seeks to possess, namely glory, high office, and military command.

[11] That this attitude was implanted in the Romans is shown also by the shrines dedicated to the deities Virtue and Honour which they built in close proximity to each other. These gifts of God they regarded as gods. We can appreciate from this the goal of virtue which good men sought, and the purpose to which they applied it, namely to gain honour. As for evil men, they possessed no virtue though they desired to obtain honour, so they sought to obtain it by evil means, by acts of guile and deception.

[12] Cato was allotted the higher praise, for Sallust says of him: "The less he sought glory, the more it pursued him". For that glory, for which in their longing the Romans burned, is the estimation of men who think well of their fellow-men. So that virtue is better which does not rest content with the witness of men without that of a man's own conscience. This is why the Apostle says: *For our glory lies in this, the witness of our own conscience,* and elsewhere: *Each man must approve his own work, and then he will have glory in himself alone, and not in his neighbour.* So virtue must not pursue glory and high office and military command, which good men sought for themselves, and which they strove to attain by noble qualities. Rather, those goals should seek virtue. Virtue is not true virtue unless it aims for the goal wherein lies that good of man which has no better. So Cato should not have sought even those distinctions which he sought. The state should have bestowed them on him for his virtue, without his seeking them.

[13] But though within Sallust's recollection there were these two Romans of substantial merit, Caesar and Cato, the virtue of Cato seems to have been far closer to the reality than that of Caesar. So let us have recourse to Cato's judgement on the nature of the state in his day by comparison with what it was before. "Do not imagine" he says, "that our ancestors made their

rempublicam ex parua magnam fecisse. Si ita esset, multo pulcherrimam eam nos haberemus. Quippe sociorum atque ciuium, praeterea armorum et equorum maior copia nobis quam illis est. Sed alia fuere quae illos magnos fecerunt, quae nobis nulla sunt: domi industria, foris iustum imperium, animus in consulendo liber neque delicto neque libidini obnoxius. Pro his nos habemus luxuriam atque auaritiam, publice egestatem, priuatim opulentiam; laudamus diuitias, sequimur inertiam; inter bonos et malos discrimen nullum; omnia uirtutis praemia ambitio possidet. Neque mirum: ubi uos separatim sibi quisque consilium capitis, ubi domi uoluptatibus, hic pecuniae aut gratiae seruitis, eo fit ut impetus fiat in uacuam rempublicam.'

[14] Qui audit haec Catonis uerba siue Sallustii putat quales laudantur Romani ueteres, omnes eos tales tunc fuisse uel plures. Non ita est; alioquin uera non essent quae ipse item scribit, ea quae commemoraui in secundo libro huius operis, ubi dicit iniurias ualidiorum, et ob eas discessionem plebis a patribus, aliasque dissensiones domi fuisse iam inde a principio, neque amplius aequo et modesto iure actum quam expulsis regibus, quamdiu metus a Tarquinio fuit, donec bellum graue quod propter ipsum cum Etruria susceptum fuerat, finiretur; postea uero seruili imperio patres exercuisse plebem, regio more uerberasse, agro pepulisse, et ceteris expertibus solos egisse in imperio; quarum discordiarum, dum illi dominari uellent, illi seruire nollent, finem fuisse bello Punico secundo, quia rursus grauis metus coepit urguere atque ab illis perturbationibus alia maiore cura cohibere animos inquietos et ad concordiam reuocare ciuilem.

[15] Sed per quosdam paucos qui pro suo modo boni erant magna administrabantur, atque illis toleratis ac temperatis malis paucorum bonorum prouidentia res illa crescebat. Sicut idem historicus dicit multa sibi legenti et audienti quae populus Romanus domi militiaeque mari

small state great by force of arms. If that had been the case, we would now enjoy it in much greater splendour, for we have a greater abundance of allies and citizens, and also of arms and horses, than they had. But there were other things which made them great which we do not possess: application at home, just dominion abroad, in consulting the welfare of the state a free spirit subject neither to crime nor lust. We have replaced these with debased living and greed, public bankruptcy and private wealth. We praise riches, and court idleness. No distinction is made between good and bad citizens; ambition gains all the rewards of virtue. This is not surprising, for each of you individually looks to his own interests. You are slaves to pleasure at home, and to money or influence in public life. The result is that the state is defenceless in the face of attack."

[14] The person who hears these words of Cato (or of Sallust) imagines that all Romans of early days, or a good number of them, were as depicted in these praises. That is not the case. Otherwise what Sallust himself also writes would not be true. I refer to his account which I quoted in Book Two of this work. There he states that the injustices inflicted by more powerful citizens, the resulting secession of the common folk from the Fathers, and other disagreements existed already at Rome from the beginning. After the kings were driven out, the just and temperate rule of law lasted only as long as fear of Tarquin prevailed, in other words until the major war mounted against Etruria because of Tarquin was brought to an end. Sallust says that thereafter the Fathers oppressed the common folk, ruling them like slaves; they whipped their bodies as the kings had been wont to do, they drove them off the land, and they exercised supreme power alone, excluding all other citizens. The end of these disagreements, he says, in which the Fathers sought to play the tyrant and the plebeians refused to be enslaved, came only with the outbreak of the Second Punic War, for it was then that oppressive fear began again to oppress them, to restrain their restless minds from those agitations under the impulse of another greater anxiety, and to recall them to civic harmony.

[15] But these momentous issues were handled by a few individuals who were good according to their lights. They coped with and moderated these evils, and the state expanded through the foresight of those few good men. As that same historian remarks, as he read and heard of the many outstanding deeds which the Roman people achieved at home and in war on sea and land,

atque terra praeclara facinora fecerit, libuisse adtendere quae res maxime tanta negotia sustinuisset; quoniam sciebat saepenumero parua manu cum magnis legionibus hostium contendisse Romanos, cognouerat paruis copiis bella gesta cum opulentis regibus; sibique multa agitanti constare dixit paucorum ciuium egregiam uirtutem cuncta patrauisse, eoque factum ut diuitias paupertas, multitudinem paucitas superaret. 'Sed postquam luxu atque desidia' inquit 'cluitas corrupta est, rursus respublica magnitudine sui imperatorum atque magistratuum uitia sustentabat.'

[16] Paucorum igitur uirtus ad gloriam honorem imperium uera uia, id est ipsa uirtute, nitentium etiam a Catone laudata est. Hinc erat domi industria quam commemorauit Cato, ut aerarium esset opulentum, tenues res priuatae. Vnde corruptis moribus uitium e contrario posuit publice egestatem, priuatim opulentiam.

XIII

[1] Quam ob rem cum diu fuissent regna Orientis inlustria, uoluit deus et Occidentale fieri quod tempore esset posterius sed imperii latitudine et magnitudine inlustrius, idque talibus potissimum concessit hominibus ad domanda grauia mala multarum gentium, qui causa honoris laudis et gloriae consuluerunt patriae, in qua ipsam gloriam requirebant, salutemque eius saluti suae praeponere non dubitauerunt, pro isto uno uitio, id est amore laudis, pecuniae cupiditatem et multa alia uitia comprimentes.

[2] Nam sanius uidet qui et amorem laudis uitium esse cognoscit, quod nec poetam fugit Horatium, qui ait:

> Laudis amore tumes? Sunt certa piacula, quae te
> ter pure lecto poterunt recreare libello.

Idemque in carmine lyrico ad reprimendam dominandi libidinem ita cecinit:

> Latius regnes auidum domando
> spiritum, quam si Libyam remotis
> Gadibus iungas, et uterque Poenus
> seruiat uni.

it was his pleasure to meditate on what quality above all else had shouldered such great affairs. For he was aware that on many occasions the Romans had engaged huge enemy formations with a handful of men. He knew that wars had been waged with minute forces against wealthy kings. On consideration of many issues he said that it had become clear to him that the outstanding merit of a few citizens had achieved everything, that this was how poverty overcame riches, and how the few had conquered the many. "But once the state was corrupted by extravagance and idleness" he added, "the republic in its turn supported with its size the vices of its generals and its magistrates".

[16] Thus Cato too praised the virtue of the few who strove for glory, honour, and dominion by the true path, in other words by virtue itself. Virtue provided the impetus for that application at home which Cato recounted, and thus ensured that the treasury was well stocked while private resources were slender. This was why he categorised as a vice the opposite situation, empty state-coffers and private wealth, once morals had been corrupted.

XIII

[1] This was why, following the long existence of famed kingdoms in the East, God decided that a western empire should also come into being. Though later in time, it was to be more celebrated in its extent and greatness. To ensure the suppression of grievous abuses in many nations, he bestowed this dominion above all on men who in the pursuit of honour, praise, and glory sought the interests of their native land in which they sought to gain that glory. They did not hesitate to put its safety before their own. In order to cherish this one vice of love of praise, they held in check love of money and many other vices.

[2] To be sure, the person who identifies love of praise too as a vice has the clearer vision. This fact did not escape the poet Horace, for he declares:

> Do you swell with love of praise? Specific remedies
> Can bring a cure, if cleansed you read the book thrice o'er.

It was Horace too who in his lyric poetry wrote these lines to curb the lust for dominion:

> You would rule more widely by repressing greed of heart
> Than if you joined the Afric land to furthest Gades,
> Both Punic empires being slaves to you alone.

[3] Verum tamen qui libidines turpiores fide pietatis impetrato Spiritu sancto et amore intellegibilis pulchritudinis non refrenant, melius saltem cupiditate humanae laudis et gloriae non quidem iam sancti sed minus turpes sunt. Etiam Tullius hinc dissimulare non potuit in eisdem libris quos de republica scripsit, ubi loquitur de instituendo principe ciuitatis, quem dicit alendum esse gloria, et consequenter commemorat maiores suos multa mira atque praeclara gloriae cupiditate fecisse. Huic igitur uitio non solum non resistebant, uerum etiam id excitandum et accendendum esse censebant, putantes hoc utile esse reipublicae.

[4] Quamquam nec in ipsis philosophiae libris Tullius ab hac peste dissimulet, ubi eam luce clarius confitetur. Cum enim de studiis talibus loqueretur quae utique sectanda sunt fine ueri boni, non uentositate laudis humanae, hanc intulit uniuersalem generalemque sententiam: 'Honos alit artes, omnesque accenduntur ad studia gloria, iacentque ea semper quae apud quosque improbantur'.

XIV

[1] Huic igitur cupiditati melius resistitur sine dubitatione quam ceditur. Tanto enim quisque est deo similior quanto et ab hac immunditia mundior. Quae in hac uita etsi non funditus eradicatur ex corde, quia etiam bene proficientes animos temptare non cessat, saltem cupiditas gloriae superetur dilectione iustitiae ut, si alicubi iacent quae apud quosque improbantur, si bona, si recta sunt, etiam ipse amor humanae laudis erubescat et cedat amori ueritatis. Tam enim est hoc uitium inimicum piae fidei, si maior in corde sit cupiditas gloriae quam dei timor uel amor, ut dominus diceret: *Quo modo potestis credere, gloriam ab inuicem expectantes et gloriam quae a solo deo est non quaerentes?* Item de quibusdam qui in eum crediderant et uerebantur palam confiteri, ait euangelista: *Dilexerunt gloriam hominum magis quam dei.*

[3] However, even men who fail to curb baser lusts with religious faith, bestowed through the acquisition of the holy Spirit and the love of intelligible beauty, are at any rate better for their desire for human praise and glory. They are not of course holy, but they are less depraved. Cicero too could not turn a blind eye to this in the books which he composed *On the Republic*. He speaks there about educating a leader of the state. He says that he is to be nurtured on glory, and in glossing this he relates that their Roman ancestors had achieved many remarkable and outstanding things in their desire for glory. So not only did they not try to resist this failing, but they even considered it right to arouse and enkindle it, because they thought that it was of service to the state.

[4] Mind you, even in his philosophical works Cicero does not cloak his regard for this baleful trait, for he lauds it there more clearly than daylight. When he discusses pursuits which should especially be adopted in seeking the goal of the true good rather than the empty kind of human praise, he introduced this general statement of universal application: "Honour nurtures the arts. All are fired by glory to undertake endeavours, and those pursuits which meet with general disapproval always lie fallow".

XIV

[1] Undoubtedly therefore it is better to resist this yearning than to yield to it. The more a person is cleansed of this impurity, the more like to God he becomes. Even if in this life it is not utterly uprooted from our hearts because it never ceases to assail even minds which are making moral progress, the desire for glory should at any rate be overcome by love of justice, so that if certain pursuits which are good and upright fall into disuse anywhere because they meet with general disapproval, the fondness for human praise should itself feel shame and give way before the love of truth. For this failing is so hostile to devoted faith, if the desire for glory in our hearts overshadows fear or love of God, that the Lord said of it: *How can you have belief when you look for glory from each other, and you do not seek the glory which is from God alone?* It was the evangelist again who referred to certain men who had believed in him, but were loath to proclaim him openly: *They loved the glory of men more than the glory of God.*

[2] Quod sancti apostoli non fecerunt. Qui cum in his locis praedicarent Christi nomen ubi non solum improbabatur (sicut ille ait, 'Iacentque ea semper quae apud quosque improbantur'), uerum etiam summae detestationis habebatur, tenentes quod audiuerant a bono magistro eodemque medico mentium: *Si quis me negauerit coram hominibus, negabo eum coram patre meo qui in caelis est* (uel *coram angelis dei*), inter maledicta et opprobria, inter grauissimas persecutiones crudelesque poenas non sunt deterriti a praedicatione salutis humanae tanto fremitu offensionis humanae. Et quod eos diuina facientes atque dicentes diuineque uiuentes debellatis quodam modo cordibus duris atque introducta pace iustitiae, ingens in ecclesia Christi gloria consecuta est, non in ea tamquam in suae uirtutis fine quieuerunt, sed eam quoque ipsam ad dei gloriam referentes, cuius gratia tales erant, isto quoque fomite eos quibus consulebant ad amorem illius a quo et ipsi tales fierent accendebant.

[3] Namque ne propter humanam gloriam boni essent, docuerat eos magister illorum dicens: *Cauete facere iustitiam uestram coram hominibus ut uideamini ab eis; alioquin mercedem non habebitis apud patrem uestrum qui in caelis est*. Sed rursus ne hoc peruerse intellegentes hominibus placere metuerent, minusque prodessent latendo quod boni sunt, demonstrans quo fine innotescere deberent, *Luceant*, inquit, *opera uestra coram hominibus, ut uideant bona facta uestra et glorificent patrem uestrum qui in caelis est*. Non ergo *ut uideamini ab eis*, id est hac intentione, ut eos ad uos conuerti uelitis, quia non per uos aliquid estis, sed *ut glorificent patrem uestrum qui in caelis est*, ad quem conuersi fiant quod estis.

[4] Hos secuti sunt martyres, qui Scaeuolas et Curtios et Decios non sibi inferendo poenas, sed inlatas ferendo, et uirtute uera (quoniam uera pietate) et innumerabili multitudine superarunt. Sed cum illi essent in ciuitate terrena, quibus propositus erat omnium pro illa officiorum finis incolumitas eius et regnum non in caelo sed in terra, non in uita aeterna sed in decessione

[2] The holy apostles did not do this. When they proclaimed Christ's name in places where this not only met with disapproval (in Cicero's words "Pursuits which meet with general disapproval always lie fallow"), but was regarded with total abhorrence, they remembered what they had heard from their good master who is also the physician of men's minds: *If anyone denies me in the presence of men, I will deny him in the presence of my father, who is in heaven,* (alternatively, *before the angels of God*). Hounded by curses and reproaches, by most oppressive acts of persecution and cruel punishments, they were not deterred from proclaiming salvation for mankind, in spite of the loud growls of men's displeasure. Their godlike deeds and words, their godlike way of life prevailed in the warfare, so to say, against hard hearts, to usher in the peace of justice; and in consequence great glory accrued to Christ's Church. But they did not rest content with that glory as though it were the goal of their virtue. Instead, they ascribed the very glory they had won to God's glory, whose grace made them what they were, and with this kindling they also fired those whose interests they had at heart to love him by whom they themselves had become what they were.

[3] For their master had taught them not to be good in order to win human glory, when he said: *Beware of practising your justice in the presence of men so as to be observed by them, for otherwise you will obtain no reward at the hands of your father, who is in heaven.* On the other hand, he did not wish them to interpret this in the wrong sense, and to be afraid to win the approval of men, and by cloaking their goodness to be of less service to them. So he indicated with what motive they should become known: *Let your works so shine before men that they may see your good deeds and glorify your father who is in heaven.* So your aim is not *to be observed by men*, in other words your intention should not be to desire them to be drawn to you, for of yourselves you are nothing; rather, it is so that *they may glorify your father, who is in heaven*, and thus by being drawn to him they may become as you are.

[4] The apostles were emulated by martyrs who surpassed men like Scaevola, Curtius, and the Decii, for they did not inflict punishment upon themselves, but they endured that laid upon them, both with *uirtus* which was true (for theirs was true devotion) and in countless numbers. Those Romans dwelt in the earthly city, and the goal of all the tasks they undertook on its behalf was its safety – a kingdom not in heaven but on earth, not in life eternal

morientium et successione moriturorum, quid aliud amarent quam gloriam, qua uolebant etiam post mortem tamquam uiuere in ore laudantium?

XV

[1] Quibus ergo non erat daturus deus uitam aeternam cum sanctis angelis suis in sua ciuitate caelesti, ad cuius societatem pietas uera perducit, quae non exhibet seruitutem religionis (quam *latreian* Graeci uocant) nisi uni uero deo, si neque hanc eis terrenam gloriam excellentissimi imperii concederet, non redderetur merces bonis artibus eorum, id est uirtutibus, quibus ad tantam gloriam peruenire nitebantur. De talibus enim, qui propter hoc boni aliquid facere uidentur ut glorificentur ab hominibus, etiam dominus ait: *Amen dico uobis, perceperunt mercedem suam.*

[2] Sic et isti priuatas res suas pro re communi, hoc est republica, et pro eius aerario contempserunt, auaritiae restiterunt, consuluerunt patriae consilio libero, neque delicto secundum suas leges neque libidini obnoxii. His omnibus artibus tamquam uera uia nisi sunt ad honores imperium gloriam; honorati sunt in omnibus fere gentibus; imperii sui leges imposuerunt multis gentibus, hodieque litteris et historia gloriosi sunt paene in omnibus gentibus. Non est quod de summi et ueri dei iustitia conquerantur; *perceperunt mercedem suam.*

XVI

[1] Merces autem sanctorum longe alia est etiam hic opprobria sustinentium pro ueritate dei, quae mundi huius dilectoribus odiosa est. Illa ciuitas sempiterna est; ibi nullus oritur, quia nullus moritur; ibi est uera et plena felicitas, non dea sed donum dei; inde fidei pignus accepimus quamdiu

but amid the departure of the dying and their replacement by others doomed to die. So what were they to love other than glory, seeking by that means to live on, as it were, even after death, on the lips of those who praise them?

XV

[1] Hence God did not intend to reward these men with eternal life in the company of his holy angels in his heavenly city. Only true devotion leads to fellowship in that city, devotion which manifests the religious observance, which the Greeks call *latreia*, to the one true God alone. But if he had not granted them even this earthly glory of a most outstanding empire, no reward would have been rendered to them for their good qualities, in other words the virtues by which they strove to attain such great glory. With regard to such men the Lord makes this further comment, for they are seen to do some good in order to gain glory from men: *Amen, I say to you, they have received their reward.*

[2] Amongst them are Romans who despised private possessions in the interests of the common weal, which is the state, and of the treasury. They combated greed; they sought the interests of the fatherland with disinterested advice, and were addicted neither to wrongdoing proscribed by their laws nor to lustful behaviour. All these qualities were the way of truth, so to say, on which they strove towards civil honours, military commands, and glory. Almost every nation honoured them. They imposed the laws of their empire on many nations. Today they are famed in literary and historical writing among almost all nations. They cannot complain about the justice of the supreme and true God, for *they have received their reward.*

XVI

[1] The reward gained by the saints is far different. Even here they endure reproaches as they defend God's truth which is hateful to those who love the world. The heavenly city is eternal. No-one is born there, because no-one dies there. True and full felicity (no goddess, but the gift of God) exists there. From that city we have received the pledge of faith. Throughout our

peregrinantes eius pulchritudini suspiramus; ibi non oritur sol super bonos
et malos, sed sol iustitiae solos protegit bonos; ibi non erit magna industria
ditare publicum aerarium priuatis rebus angustis, ubi thesaurus communis
est ueritatis.

[2] Proinde non solum ut talis merces talibus hominibus redderetur
Romanum imperium ad humanam gloriam dilatatum est; uerum etiam ut
ciues aeternae illius ciuitatis, quamdiu hic peregrinantur, diligenter et sobrie
illa intueantur exempla, et uideant quanta dilectio debeatur supernae patriae
propter uitam aeternam, si tantum a suis ciuibus terrena dilecta est propter
hominum gloriam.

XVII

[1] Quantum enim pertinet ad hanc uitam mortalium, quae paucis diebus
ducitur et finitur, quid interest sub cuius imperio uiuat homo moriturus, si
illi qui imperant ad impia et iniqua non cogant? Aut uero aliquid nocuerunt
Romani gentibus quibus subiugatis imposuerunt leges suas, nisi quia id
factum est ingenti strage bellorum? Quod si concorditer fieret, id ipsum
fieret meliore successu; sed nulla esset gloria triumphantium, Neque enim et
Romani non uiuebant sub legibus suis, quas ceteris imponebant. Hoc si fieret
sine Marte et Bellona, ut nec Victoria locum haberet, nemine uincente ubi
nemo pugnauerat, nonne Romanis et ceteris gentibus una esset eademque
condicio?

[2] Praesertim si mox fieret quod postea gratissime atque humanissime
factum est, ut omnes ad Romanum imperium pertinentes societatem
acciperent ciuitatis et Romani ciues essent, ac sic esset omnium quod
erat ante paucorum, tantum quod plebs illa quae suos agros non haberet
de publico uiueret; qui pastus eius per bonos administratores reipublicae
gratius a concordibus praestaretur quam uictis extorqueretur.

journeying abroad we long for its beauty. In that city the sun does not shine on good and bad alike, but the Sun of justice protects the good alone. No great diligence will be needed to enrich the public treasury from scanty private resources, for there the treasury of truth is shared by all.

[2] Therefore the Roman Empire was extended in enhancing human glory, not merely to bestow on such men a reward like this, but also in order that the citizens of that eternal city throughout their pilgrimage here on earth should attentively and soberly gaze on those exemplars, and observe how much love we owe to our fatherland above for the gift of eternal life, since the earthly city was so much loved by its citizens to win glory from men.

XVII

[1] When we consider this mortal life on earth, its duration and end within a few days, what does it matter under whose dominion a man lives when his death is at hand, so long as those who rule over him do not compel him to do impious and unjust deeds? Did the Romans actually damage in any way the nations on whom they imposed their laws after they had subdued them, apart from the fact that they achieved it by large-scale slaughter in wars? If their aim had been achieved by harmonious agreement, their success would have been greater, but there would have been no glory in their triumphs. Then too the Romans were not exempted from living under their laws which they imposed on the rest. If the conquest had taken place without the presence of Mars and Bellona, so that there was no role for the goddess Victory either, since no-one was victorious where no-one had joined battle, would not Romans and other nations have shared one and the same lot?

[2] That would certainly have been true if what developed in most welcome and civilised fashion had ensued without delay, so that all who were joined to the Roman Empire would have received the fellowship of citizenship, and would have become Roman citizens. In that way what was earlier enjoyed by the few would have been the possession of all, except that since the common folk had no lands of their own, they would have lived at public expense. Their sustenance, administered by good men who governed the state, would have been more gracefully furnished by citizens in harmony than extorted from conquered races.

[3] Nam quid intersit ad incolumitatem bonosque mores, ipsas certe hominum dignitates, quod alii uicerunt, alii uicti sunt, omnino non uideo, praeter illum gloriae humanae inanissimum fastum, in quo perceperunt mercedem suam qui eius ingenti cupidine arserunt, et ardentia bella gesserunt. Numquid enim illorum agri tributa non soluunt? Numquid eis licet discere quod aliis non licet? Numquid non multi senatores sunt in aliis terris qui Romam ne facie quidem norunt? Tolle iactantiam, et omnes homines quid sunt nisi homines? Quod si peruersitas saeculi admitteret ut honoratiores essent quique meliores, nec sic pro magno haberi debuit honor humanus, quia nullius est ponderis fumus.

[4] Sed utamur etiam in his rebus beneficio domini dei nostri. Consideremus quanta contempserint, quae pertulerint, quas cupiditates subegerint pro humana gloria qui eam tamquam mercedem talium uirtutum accipere meruerunt, et ualeat nobis etiam hoc ad opprimendam superbiam ut, cum illa ciuitas in qua nobis regnare promissum est, tantum ab hac distet quantum distat caelum a terra, a temporali laetitia uita aeterna, ab inanibus laudibus solida gloria, a societate mortalium societas angelorum, a lumine solis et lunae lumen eius qui solem fecit et lunam, [5] nihil sibi magnum fecisse uideantur tantae patriae ciues, si pro illa adipiscenda fecerint boni operis aliquid uel mala aliqua sustinuerint, cum illi pro hac terrena iam adepta tanta fecerint, tanta perpessi sint, praesertim quia remissio peccatorum, quae ciues ad aeternam colligit patriam, habet aliquid cui per umbram quamdam simile fuit asylum illud Romuleum, quo multitudinem qua illa ciuitas conderetur quorumlibet delictorum congregauit impunitas.

XVIII

[1] Quid ergo magnum est pro illa aeterna caelestique patria cuncta saeculi huius quamlibet iucunda blandimenta contemnere, si pro hac temporali atque terrena filios Brutus potuit et occidere, quod illa facere neminem cogit? Sed

[3] The fact is that so far as security and sound morality are concerned (and these are certainly the true marks of worth in society) I see no difference at all between conquerors and conquered, apart from that most fatuous pride in human glory, in which those who were fired with boundless longing for it, and who fanned the flames of war, obtained their reward. Are not the lands of the victors subject to tax? Can they enrol for learning which is forbidden to others? Are there not numerous senators in lands outside Italy who do not know Rome even by sight? Apart from boastful pride, what are all men but merely men? Even if this topsy-turvy world had allowed individuals to win greater distinction on the basis of merit, distinction bestowed by men should not have been regarded as important, for "smoke has no weight".

[4] But even in considerations like this we must put the kindness of the Lord our God to good account. We must keep in mind the great riches which the Romans despised, the hardships which they endured, the longings which they suppressed in order to gain glory in the eyes of men. They deserved to obtain that glory as reward, in a sense, for such virtues. These facts should impinge on us also to restrain our pride. The city which we are promised as our kingdom is as different from the earthly city as is heaven from earth, eternal life from momentary joy, enduring glory from empty praises, the fellowship of angels from that of mortal men, and the light of the creator of sun and moon from the light of the sun and moon.

[5] So those of us who are citizens of that great fatherland should not imagine that we have performed something great by doing some good works or enduring certain evils to attain it, for the Romans achieved so much and suffered so much on behalf of the earthly city which they already possessed. What we must particularly note is that the remission of sins, which gathers citizens for entry into their eternal fatherland, is foreshadowed by, and bears some resemblance to, the asylum of Romulus, into which an amnesty for crimes of all kinds allowed that crowd to assemble by whom the city was to be established.

XVIII

[1] What, then, is so notable about despising all the charms of the world, however delightful, in order to attain that eternal fatherland in heaven, since Brutus steeled himself even to execute his sons in defence of this transient

certe difficilius est filios interimere quam quod pro ista faciendum est, ea quae filiis congreganda uidebantur atque seruanda uel donare pauperibus uel, si existat temptatio quae id pro fide atque iustitia fieri compellat, amittere. Felices enim uel nos uel filios nostros non diuitiae terrenae faciunt aut nobis uiuentibus amittendae, aut nobis mortuis a quibus nescimus uel forte a quibus nolumus possidendae.

[2] Sed deus felices facit, qui est mentium uera opulentia. Bruto autem quia filios occidit infelicitatis perhibet testimonium etiam poeta laudator. Ait enim:

Natosque pater noua bella mouentes
ad poenam pulchra pro libertate uocabit
infelix, utcumque ferent ea facta minores.

Sed uersu sequenti consolatus est infelicem:

Vincit amor patriae laudumque immensa cupido.

[3] Haec sunt duo illa, libertas et cupiditas laudis humanae, quae ad facta compulit miranda Romanos. Si ergo pro libertate moriturorum et cupiditate laudum quae a mortalibus expetuntur, occidi filii a patre potuerunt, quid magnum est si pro uera libertate, quae nos ab iniquitatis et mortis et diaboli dominatu liberos facit, nec cupiditate humanarum laudum sed caritate liberandorum hominum non a Tarquinio rege sed a daemonibus et daemonum principe, non filii occiduntur, sed Christi pauperes inter filios computantur?

[4] Si alius etiam Romanus princeps, cognomine Tarquinius, filium, non quia contra patriam sed etiam pro patria, tamen quia contra imperium suum, id est contra quod imperauerat pater imperator, ab hoste prouocatus iuuenali ardore pugnauerat, licet uicisset, occidit, ne plus mali esset in exemplo imperii contempti quam boni in gloria hostis occisi, ut quid se iactent qui pro immortalis patriae legibus omnia quae multo minus quam filii diliguntur, bona terrena contemnunt?

and earthly city, a deed which the heavenly city compels no-one to do? It is certainly harder to kill one's own sons than to do what one must do on behalf of the heavenly city, namely to bestow on the poor the wealth which it seemed right to accumulate and to preserve for those sons, or even to renounce it, should a time of testing demand that it be abandoned in the interests of faith and justice. Earthly riches do not make ourselves or our sons happy, for either we are doomed to lose them in our own lifetime, or they are to fall into the hands of persons whom we do not know, or whom we perhaps abhor, once we die.

[2] It is God, the true wealth of minds, who brings us happiness. As for Brutus, even the poet who praises him attests his misery at killing his sons. This is what he says:

> The father, for fair freedom's sake,
> Will call his sons for punishment, for they
> Stirred up fresh wars. Unhappy man indeed,
> However much his deeds win later praise!

But in the next line the poet consoled the unhappy man:

> His love of Rome prevails, and boundless lust for praise.

[3] These are the two incentives, freedom and lust for human praise, which spurred the Romans to remarkable deeds. So if sons could be killed by their father to ensure the freedom of men doomed to die, and to satisfy the longing for praises which mortal men seek, what is so great, not about executing our sons, but about counting Christ's poor among our sons? For this is what we do for true freedom, which delivers us from the tyranny of wickedness, death, and the devil. We do it not out of longing for human praises, but from the love to set men free – free, however, not from king Tarquin, but from the demons and from the prince of the demons.

[4] There was another Roman leader named Torquatus, who executed his son. It was not because the boy had fought against the fatherland – in fact, he fought on its behalf – but because it was against his orders, in other words what his father the general had commanded. When challenged by the enemy, he had fought with youthful ardour, but though he had been victorious, he was put to death. This was to ensure that more evil should not be shown in this example of contempt for the supreme command than good in the glory of slaying an enemy. In view of this, why should Christians, in observing the laws of their immortal fatherland, preen themselves for despising all earthly goods, when these win much less affection than sons do?

[5] Si Furius Camillus etiam ingratam patriam, a cuius ceruicibus acerrimorum hostium Veientium iugum depulerat damnatusque ab aemulis fuerat, a Gallis iterum liberauit quia non habebat potiorem ubi posset uiuere gloriosius, cur extollatur, uelut grande aliquid fecerit, qui forte in ecclesia ab inimicis carnalibus grauissimam exhonorationis passus iniuriam, non se ad eius hostes haereticos transtulit aut aliquem contra illam ipse haeresem condidit, sed eam potius quantum ualuit ab haereticorum perniciosissima prauitate defendit, cum alia non sit, non ubi uiuatur in hominum gloria, sed ubi uita adquiratur aeterna?

[6] Si Mucius ut cum Porsenna rege pax fieret, qui grauissimo bello Romanos premebat, quia Porsennam ipsum occidere non potuit et pro eo alterum deceptus occidit, in ardentem aram ante eius oculos dexteram extendit dicens multos [se] tales qualem illum uideret in eius exitium coniurasse, cuius ille fortitudinem et coniurationem talium perhorrescens sine ulla dubitatione se ab illo bello facta pace compescuit, quis regno caelorum imputaturus est merita sua, si pro illo non unam manum neque hoc sibi ultro faciens, sed persequente aliquo patiens totum flammis corpus impenderit?

[7] Si Curtius armatus equo concito in abruptum hiatum terrae se praecipitem dedit deorum suorum oraculis seruiens, quoniam iusserant ut illuc id quod Romani haberent optimum mitteretur, nec aliud intellegere potuerunt quam uiris armisque se excellere, unde uidelicet oportebat ut deorum iussis in illum interitum uir praecipitaretur armatus, quid se magnum pro aeterna patria fecisse dicturus est qui aliquem fidei suae passus inimicum non se ultro in talem mortem mittens, sed ab illo missus obierit, quando quidem a domino suo eodemque rege patriae suae certius oraculum accepit: *Nolite timere eos qui corpus occidunt, animam autem non possunt occidere?*

[5] Again, Furius Camillus had dislodged the yoke imposed by the Veientines, fiercest of foes, from the necks of his countrymen, but was then banished by envious rivals. Yet he freed his ungrateful land yet again, this time from the Gauls, because he had no land where for preference he could live with greater fame. In view of this, why should a Christian be deserving of praise as having performed some great deed, if he happened to suffer the most grievous insult of being stripped of his office in the Church at the hands of bodily enemies, without seceding to the Church's heretical foes or himself initiating some heresy opposed to her, but instead protecting her with all his strength from the most destructive depravity of heretics? After all, there is no other Church in which to gain not a life of fame bestowed by men, but a life of eternity.

[6] Mucius sought to have peace declared with King Porsenna, who was oppressing the Romans in most grievous war. But because he was unable to kill Porsenna himself and was misled into killing another in his place, he thrust his right hand into the altar-flames while Porsenna looked on, and said that there were many like the one Porsenna saw before him who had made a solemn pact to destroy him. Porsenna was aghast at his courage and at the news of the conspiracy of such youths. Unhesitatingly he withdrew from that war, and made peace. In view of this, what man will calculate his services rendered to the kingdom of heaven, even if to attain it he sacrifices not a single hand, one not spontaneously offered, but under constraint from some persecutor he consigns his whole body to the flames?

[7] Think of Curtius also. Fully armed, he spurred his horse and plunged headlong into a deep chasm in the earth. He did this in compliance with the oracles of his gods, for they had commanded that what the Romans accounted their best possession should be so consigned. The sole interpretation which the Romans could put on this was that their outstanding possessions were men and arms, so it was apparently necessary that by the gods' commands an armed man should be cast headlong down to such a death. In view of this, how will any man claim that he has done anything special for his eternal fatherland if he suffers at the hands of some enemy of his faith, and without willingly subjecting himself to such a death, has died when dispatched by such an enemy? For he has received from his Lord, who is also king of his native land, a more reliable oracular utterance: *Fear not those who kill the body, but cannot kill the soul.*

[8] Si se occidendos certis uerbis quodam modo consecrantes Decii deuouerunt, ut illis cadentibus et iram deorum sanguine suo placantibus Romanus liberaretur exercitus, nullo modo superbient sancti martyres tamquam dignum aliquid pro illius patriae participatione fecerint ubi aeterna est et uera felicitas, si usque ad sui sanguinis effusionem non solum suos fratres pro quibus fundebatur, uerum et ipsos inimicos a quibus fundebatur, sicut eis praeceptum est, diligentes caritatis fide et fidei caritate certarunt.

[9] Si Marcus Puluillus dedicans aedem Iouis Iunonis Mineruae falso sibi ab inuidis morte filii nuntiata, ut illo nuntio perturbatus abscederet atque ita dedicationis gloriam collega eius consequeretur, ita contempsit ut eum etiam proici insepultum iuberet – sic in eius corde orbitatis dolorem gloriae cupiditas uicerat – quid magnum se pro euangelii sancti praedicatione, qua ciues supernae patriae de diuersis liberantur et colliguntur erroribus, fecisse dicturus est, cui dominus de sepultura patris sui sollicito ait: *Sequere me, et sine mortuos sepelire mortuos suos?*

[10] Si M. Regulus, ne crudelissimos hostes iurando falleret, ad eos ab ipsa Roma reuersus est quoniam, sicut Romanis eum tenere uolentibus respondisse fertur, postea quam Afris seruierat dignitatem illic honesti ciuis habere non posset, eumque Carthaginienses, quoniam contra eos in Romano senatu egerat, grauissimis suppliciis necauerunt, qui cruciatus non sunt pro fide illius patriae contemnendi ad cuius beatitudinem fides ipsa perducit? Aut *quid retribuetur domino pro omnibus quae retribuit*, si pro fide quae illi debetur talia fuerit homo passus qualia pro fide quam perniciosissimis inimicis debebat passus est Regulus?

[11] Quo modo se audebit extollere de uoluntaria paupertate Christianus, ut in huius uitae peregrinatione expeditior ambulet uiam quae perducit ad

[8] If the Decii took an oath to kill themselves by consecrating themselves in some way by ritual words to ensure that by dying and appeasing the anger of the gods by shedding their blood, they would deliver the Roman army, the holy martyrs must in no way wax arrogant as if they had done something deserving of a share in the fatherland where there is eternal and true happiness, even if they battled on to the very shedding of their blood, loving not only their brothers for whom that blood was shed, but also the very enemies by whom it was shed, with the faith of love and the love of the faith, as they have been commanded to do.

[9] When Marcus Pulvillus was dedicating the temple to Jupiter, Juno, and Minerva, some jealous individuals brought him untrue tidings of the death of his son. They did this so that dismayed by such news he would abandon the ritual, and allow his colleague to gain the glory of dedicating it instead. But Pulvillus gave so little thought to the death that he even ordered the corpse to be exposed unburied. To such a degree had his longing for glory overcome heartfelt grief at the loss of his son. So when a man anxious to bury his father is told by the Lord *Follow me, and let the dead bury their dead*, how will he be able to claim that he has done something worthwhile for proclaiming the holy gospel, by which citizens of the fatherland in heaven are freed and shepherded from sundry errors?

[10] Marcus Regulus was determined not to break his oath which he had sworn to the most cruel of enemies. So he made his way back to them from Rome itself. His reason, according to the report of what he said in response to the Romans who sought to detain him, was that once he was enslaved to Africans, he could not enjoy at Rome the distinction of being an honourable citizen. Since he had inveighed against the Carthaginians in the Roman senate, they killed him by subjecting him to extreme torture. When we think of him, what tortures are not to be despised when endured in defence of the faith of our native land, to the blessedness of which our faith itself leads us? Or *What return shall be made to the Lord for all that he has rendered*, if a man in defence of the faith owed to God suffers punishments such as Regulus endured to keep the faith which he owed to those most baleful foes?

[11] How will a Christian presume to preen himself because of the voluntary poverty which allows him to travel lighter on the pilgrimage of this life on the road which leads to the fatherland where God himself is true

patriam ubi uerae diuitiae deus ipse est, cum audiat uel legat L. Valerium, qui in suo defunctus est consulatu, usque adeo fuisse pauperem ut nummis a populo conlatis eius sepultura curaretur? Audiat uel legat Quinctium Cincinnatum, cum quattuor iugera possideret et ea suis manibus coleret, ab aratro esse adductum ut dictator fieret, maior utique honore quam consul, uictisque hostibus ingentem gloriam consecutum in eadem paupertate mansisse?

[12] Aut quid se magnum fecisse praedicabit qui nullo praemio mundi huius fuerit ab aeternae illius patriae societate seductus, cum Fabricium didicerit tantis muneribus Pyrrhi, regis Epirotarum, promissa etiam quarta parte regni a Romana ciuitate non potuisse deuelli, ibique in sua paupertate priuatum manere maluisse? Nam illud quod rempublicam (id est, rem populi, rem patriae, rem communem), cum haberent opulentissimam atque ditissimam, sic ipsi in suis domibus pauperes erant ut quidam eorum, qui iam bis consul fuisset, ex illo senatu hominum pauperum pelleretur notatione censoria quod decem pondo argenti in uasis habere compertus est. Ita idem ipsi pauperes erant quorum triumphis publicum ditabatur aerarium. Nonne omnes Christiani, qui excellentiore proposito diuitias suas communes faciunt secundum id quod scriptum est in actibus apostolorum, ut distribuatur unicuique sicut cuique opus est, et nemo dicat aliquid proprium, sed sint illis omnia communia, intellegunt se nulla ob hoc uentilari oportere iactantia, id faciendo pro obtinenda societate angelorum, cum paene tale aliquid illi fecerint pro conseruanda gloria Romanorum?

[13] Haec et alia si qua huius modi reperiuntur in litteris eorum quando sic innotescerent, quando tanta fama praedicarentur, nisi Romanum imperium longe lateque porrectum magnificis successibus augeretur? Proinde per illud imperium tam latum tamque diuturnum uirorumque tantorum uirtutibus praeclarum atque gloriosum et illorum intentioni merces quam quaerebant est reddita, et nobis proposita necessariae commonitionis exempla ut, si uirtutes quarum istae utcumque sunt similes, quas isti pro ciuitatis terrenae

riches, when he hears or reads that Lucius Valerius, who died in the year of his consulship, was so poor that his burial was paid for from coppers collected from the public? He should hearken to or read about Quinctius Cincinnatus, who owned and cultivated with his own hands four acres of land; he was summoned from the plough to become dictator, an office certainly higher than that of consul, and when he had gained great glory by defeating the enemy, he continued to live in poverty as before.

[12] Again, how will anyone boast of having achieved something great in not being enticed by any reward offered by this world to abandon his fellowship in the eternal fatherland, once he learns that Fabricius could not be detached from the Roman state by the great gifts of Pyrrhus, King of the Epirotes, who even promised a fourth part of his kingdom, and that he preferred to remain in his poverty as a private citizen at Rome? Or again, when he learns that though the citizens possessed a republic (that is, the property of the people, the property of the fatherland, their common possession), which was outstandingly rich and wealthy, its leaders in their private houses were so poor that one of them, who had by then been twice consul, was expelled from that senate of poor men by the censors' stigma because he was found to have among his vessels some silver ones weighing ten pounds? So the very men by whose triumphs the public treasury was full to bursting were as poor as that. So all Christians who opt for the higher mode of life and put their riches in a common pool, following the recommendation in the *Acts of the Apostles* that money be apportioned to each according to his need, and that no-one should call anything his own but that everything should be held in common by them, must surely realise that they must not on that account boast or put on airs, since their aim in behaving in that way is to attain fellowship with the angels, whereas those men of old did something virtually comparable to maintain the glory of the Romans.

[13] How could these and other exploits of this kind such as we encounter in Roman literature have become known and proclaimed with such great renown, if the Roman Empire had not extended far and wide, as its splendid successes made it ever greater? So it was through that empire, so widespread and so long-lasting, so celebrated and so famous through the virtues of men so great, that on the one hand their sustained efforts gained the reward which they sought, and on the other they set models before us which offer this salutary reminder: if in defence of the most glorious city of God we do not

gloria tenuerunt, pro dei gloriosissima ciuitate non tenuerimus, pudore pungamur, si tenuerimus, superbia non extollamur, quoniam, sicut dicit apostolus, *Indignae sunt passiones huius temporis ad futuram gloriam quae reuelabitur in nobis*. Ad humanam uero gloriam praesentisque temporis satis digna uita aestimabatur illorum.

[14] Vnde etiam Iudaei qui Christum occiderunt reuelante testamento nouo quod in uetere uelatum fuit, ut non pro terrenis et temporalibus beneficiis quae diuina prouidentia permixte bonis malisque concedit, sed pro aeterna uita muneribusque perpetuis et ipsius supernae ciuitatis societate colatur deus unus et uerus, rectissime istorum gloriae donati sunt, ut hi, qui qualibuscumque uirtutibus terrenam gloriam quaesiuerunt et adquisiuerunt, uincerent eos qui magnis uitiis datorem uerae gloriae et ciuitatis aeternae occiderunt atque respuerunt.

XIX

[1] Interest sane inter cupiditatem humanae gloriae et cupiditatem dominationis. Nam licet procliue sit ut qui humana gloria nimium delectatur etiam dominari ardenter affectet, tamen qui ueram licet humanarum laudum gloriam concupiscunt, dant operam bene iudicantibus non displicere. Sunt enim multa in moribus bona de quibus multi bene iudicant, quamuis ea multi non habeant; per ea bona morum nituntur ad gloriam et imperium uel dominationem.

[2] De quibus ait Sallustius: 'Sed ille uera uia nititur.' Quisquis autem sine cupiditate gloriae, qua ueretur homo bene iudicantibus displicere dominari atque imperare desiderat, etiam per apertissima scelera quaerit plerumque obtinere quod diligit. Proinde qui gloriam concupiscit aut 'uera uia nititur', aut certe 'dolis atque fallaciis contenditt', uolens bonus uideri esse, quod non est.

hold fast to the virtues which those Romans maintained, at least in some similar sense, to exalt the glory of their earthly city, we must be pricked with shame. If we do hold fast to them, we must not be puffed up with pride, for as the Apostle states, *The sufferings of the present time do not merit comparison with the future glory which will be revealed in us.* The lives of those Romans were reckoned sufficiently worthy to merit glory among men in this present time.

[14] This was why the Jews too, who killed Christ, were with complete justice the means of further glory bestowed on the Romans. The New Testament unfolds what was concealed in the Old, that the one true God should be worshipped not for those earthly and transient benefits which divine Providence grants to good and evil men without distinction, but for eternal life and enduring gifts and fellowship in that heavenly city. Thus the men who sought and attained earthly glory by such virtues as they possessed, conquered those whose great defects caused them to kill and to spurn him who bestows true glory and life in the eternal city.

XIX

[1] There is certainly a difference between desire for glory among men, and the desire for dominion, for though there is a tendency for the person who takes excessive delight in glory among men to have also a burning desire for dominion, it is nonetheless true that those who long for true glory, admittedly from the praise of men, take pains not to alienate men of good judgement. There are many good qualities in human behaviour which many regard favourably, though not many possess them. By means of these good manners those who do possess them strive to attain glory and supreme power or dominion.

[2] Sallust remarks of this type: "But a man like that strives on the path of truth". But the person who longs for dominion and supreme power without the desire for that glory such as makes him anxious not to alienate men of good judgement, very often seeks to attain his prized objective by most blatant crimes. So the man who is avid for glory either "strives on the path of truth" or undoubtedly "exerts himself by acts of guile and deceit", wishing to appear to be the good man which he is not.

[3] Et ideo uirtutes habenti magna uirtus est contemnere gloriam, quia contemptus eius in conspectu dei est, iudicio autem non aperitur humano. Quidquid enim fecerit ad oculos hominum quo gloriae contemptor appareat, ad maiorem laudem, hoc est ad maiorem gloriam facere si credatur, non est unde se suspicantium sensibus aliter esse quam suspicantur ostendat. Sed qui contemnit iudicia laudantium, contemnit etiam suspicantium temeritatem, quorum tamen, si uere bonus est, non contemnit salutem, quoniam tantae iustitiae est qui de spiritu dei uirtutes habet ut etiam ipsos diligat inimicos et ita diligat ut suos osores uel detractores uelit correctos habere consortes non in terrena patria, sed superna. In laudatoribus autem suis, quamuis paruipendat quod eum laudant, non tamen paruipendit quod amant, nec eos uult fallere laudantes ne decipiat diligentes; ideoque instat ardenter ut potius ille laudetur a quo habet homo quidquid in eo iure laudatur.

[4] Qui autem gloriae contemptor dominationis est auidus, bestias superat siue crudelitatis uitiis siue luxuriae. Tales quidam Romani fuerunt. Non enim cura existimationis amissa dominationis cupiditate caruerunt. Multos tale fuisse prodit historia; sed huius uitii summitatem et quasi arcem quamdam Nero Caesar primus obtinuit, cuius fuit tanta luxuries ut nihil ab eo putaretur uirile metuendum; tanta crudelitas ut nihil molle habere crederetur, si nesciretur. Etiam talibus tamen dominandi potestas non datur nisi summi dei prouidentia, quando res humanas iudicat talibus dominis dignas. Aperta de hac re uox diuina est loquente dei sapientia: *Per me reges regnant, et tyranni per me tenent terram.* Sed ne tyranni non pessimi atque improbi reges, sed uetere nomine fortes dicti existimentur (unde ait Vergilius:

 Pars mihi pacis erit dextram tetigisse tyranni),

apertissimo alio loco de deo dictum est: *Quia regnare facit hominem hypocritam propter peruersitatem populi.*

[3] Thus for the man who possesses virtues it is a great virtue to despise glory, since his contempt for it is visible to God but is not obvious to human judgement. Whatever he performs before men's eyes which makes him appear to despise glory, should men believe that he does it to win greater praise (in other words, greater glory), there is no way by which he can demonstrate to the perceptions of those harbouring such suspicions that those suspicions are ill-founded. Moreover, the man who despises the judgements of those who praise him, despises also the rash assessment of those who suspect him. But if he is truly good, he is not indifferent to their salvation, for the man who possesses virtues as a gift from the Spirit of God is so righteous that he loves even his enemies, and indeed loves them in such a way that he wishes those who hate or disparage him to associate with him, once they are corrected, as companions in the heavenly but not in the earthly fatherland. As for those who praise him, though he thinks little of their praise, he does not belittle their affection for him, and he does not seek to deceive them when they praise him; he does not wish to beguile their affection for him. So for this reason he urges them earnestly to give praise instead to him from whom men possess anything rightly deserving of praise.

[4] But the man who despises glory but yearns for dominion outdoes the brute beasts in the vices of cruelty and self-indulgence. There were Romans of this kind, for though they had become indifferent to men's good opinions, they had not relinquished their yearning for dominion. History reveals that there were many such, but the man who held first place on the summit and citadel, so to say, of this vice was Nero Caesar. His life of effeminate luxury was so depraved that you could not have believed in the possibility of male violence at his hands, yet his cruelty was so pronounced that if you did not know him, you would have believed that there was nothing effeminate about him. Yet even to such as Nero the power of sovereign rule is bestowed only by the providence of the supreme God, when he regards human affairs as deserving of such masters. The voice of heaven speaks openly on this topic in the words of God's wisdom; *At my discretion is the rule of kings, and at my discretion tyrants possess the earth.* To forestall the notion that 'tyrants' here does not connote most wicked and depraved kings, but is used in the ancient sense of 'brave men', as in Virgil's line

My caveat for peace will be to touch your brave lord's hand,

the sense in another passage which refers to God's decree is absolutely clear: *He sets a hypocrite on the throne because of the perversity of the people.*

[5] Quam ob rem quamuis ut potui satis exposuerim qua causa deus unus uerus et iustus Romanos secundum quamdam formam terrenae ciuitatis bonos adiuuerit ad tanti imperii gloriam consequendam, potest tamen et alia causa esse latentior propter diuersa merita generis humani, deo magis nota quam nobis, dum illud constet inter omnes ueraciter pios, neminem sine uera pietate, id est ueri dei uero cultu, ueram posse habere uirtutem, nec eam ueram esse quando gloriae seruit humanae; eos tamen qui ciues non sint ciuitatis aeternae, quae in sacris litteris nostris dicitur ciuitas dei, utiliores esse terrenae ciuitati quando habent uirtutem uel ipsam quam si nec ipsam.

[6] Illi autem qui uera pietate praediti bene uiuunt, si habent scientiam regendi populos, nihil est felicius rebus humanis quam si deo miserante habeant potestatem. Tales autem homines uirtutes suas, quantascumque in hac uita possunt habere, non tribuunt nisi gratiae dei quod eas uolentibus credentibus petentibus dederit, simulque intellegunt quantum sibi desit ad perfectionem iustitiae, qualis est in illorum sanctorum angelorum societate, cui se nituntur aptare. Quantumlibet autem laudetur atque praedicetur uirtus quae sine uera pietate seruit hominum gloriae, nequaquam sanctorum exiguis initiis comparanda est, quorum spes posita est in gratia et misericordia ueri dei.

XX

[1] Solent philosophi qui finem boni humani in ipsa uirtute constituunt ad ingerendum pudorem quibusdam philosophis qui uirtutes quidem probant, sed eas uoluptatis corporalis fine metiuntur, et illam per se ipsam putant adpetendam, istas propter ipsam, tabulam quamdam uerbis pingere, ubi Voluptas in sella regali quasi delicata quaedam regina considat, eique uirtutes famulae subiciantur, obseruantes eius nutum ut faciant quod illa imperauerit; quae Prudentiae iubeat ut uigilanter inquirat quomodo Voluptas regnet et salua sit; Iustitiae iubeat ut praestet beneficia quae potest ad comparandas amicitias corporalibus commodis necessarias, nulli faciat iniuriam ne

[5] So though I have sufficiently expounded as best I could why the one true and just God aided Romans who were good by the ideal of the earthly city to attain the glory of so great an empire, there can be another more hidden reason. It could be attributable to the differing merits of the human race, which are better known to God than to us. But what all truly religious persons must hold as certain is that no-one without true devotion, that is, the true worship of the true God, can possess true virtue, and that when virtue is a slave to human glory, it is not true virtue. Nevertheless those who are not members of the eternal city, which in our sacred literature is called the city of God, are more useful to the earthly city when they have even that kind of virtue than when they have not.

[6] But human affairs are in no way more blessed than if by God's mercy the power is wielded by those who are endowed with true devotion and live good lives, so long as they have expertise in governing communities. Men like these ascribe their virtues, such as they can possess in this life, to nothing other than God's grace, for he has bestowed them in answer to their wishes, beliefs, and requests. But at the same time they are aware how much they lack to attain the perfection of the righteousness which prevails in the fellowship of the holy angels, for which they strive to equip themselves. But however much men praise and proclaim the virtue which lacks true devotion and is a slave to human glory, it is in no way comparable to the first timid steps of the saints, whose hope rests in the grace and mercy of the true God.

XX

[1] Philosophers who proclaim virtue itself to be the highest human good to be sought are fond of heaping shame on certain other philosophers who indeed approve of the virtues but assess them according to the goal of physical pleasure, which they think should be sought for its own sake, and the virtues for the sake of pleasure. So these critics like to paint a picture in words. In this picture, Pleasure is seated on a royal throne like some decadent queen, with the virtues attending on her as servants, attentive to her nod and ready to carry out her orders. The queen bids Prudence to make careful enquiry how Pleasure can reign in safety. She orders Justice to bestow what benefits she can to secure the friendships vital for promoting the welfare of the body,

offensis legibus Voluptas uiuere secura non possit; Fortitudini iubeat ut, si dolor corpori acciderit qui non compellat in mortem, teneat dominam suam, id est uoluptatem, fortiter in animi cogitatione ut per pristinarum deliciarum suarum recordationem mitiget praesentis doloris aculeos; Temperantiae iubeat ut tantum capiat alimentorum et si qua delectant, ne per immoderationem noxium aliquid ualetudinem turbet, et Voluptas, quam etiam in corporis sanitate Epicurei maximam ponunt, grauiter offendatur.

[2] Ita uirtutes cum tota suae gloria dignitatis tamquam imperiosae cuidam et inhonestae mulierculae seruient Voluptati. Nihil hac pictura dicunt esse ignominiosius et deformius et quod minus ferre honorum possit aspectus, et uerum dicunt.

[3] Sed non existimo satis debiti decoris esse picturam, si etiam talis fingatur ubi uirtutes humanae Gloriae seruiunt. Licet enim ipsa gloria delicata mulier non sit, inflata est et multum inanitatis habet. Vnde non ei digne seruit soliditas quaedam firmitasque uirtutum, ut nihil prouideat Prouidentia, nihil distribuat Iustitia, nihil toleret Fortitudo, nihil Temperantia moderetur, nisi unde placeatur hominibus et uentosae Gloriae seruiatur.

[4] Nec illi se ab ista foeditate defenderint qui, cum aliena spernant iudicia uelut gloriae contemptores, sibi sapientes uidentur et sibi placent. Nam eorum uirtus, si tamen ulla est, alio modo quodam humanae subditur laudi; neque enim ipse qui sibi placet homo non est. Qui autem uera pietate in deum quem diligit credit et sperat, plus intendit in ea in quibus sibi displicet quam in ea, si qua in illo sunt, quae non tam ipsi quam ueritati placent; neque id tribuit unde iam potest placere nisi eius misericordiae cui metuit displicere, de his sanatis gratias agens, de illis sanandis preces fundens.

and to commit no injustices against anyone, to ensure that the laws are not contravened and that Pleasure can live an untroubled life. The command which she gives to Courage is that if some pain which is not death-dealing befalls her mistress's body, she is to keep her mistress Pleasure courageously contemplating, so that by recalling her earlier delights she may alleviate the pangs of her present suffering. She instructs Temperance to restrict her intake of food, even if she particularly likes some of it, to ensure that such excess should not cause some harm which damages her health, for such damage would give serious offence to Pleasure, which Epicureans identify above all with physical health.

[2] In this way the virtues, for all the glory of their lofty status, will be slaves to Pleasure as to a bossy and dishonourable slip of a woman. Those critics say that there is nothing more shameful and ugly and intolerable for the eyes of good men to look upon than this picture, and what they say is true.

[3] But if another such picture were painted, in which the virtues attended on human glory, I do not believe that it would be as fitting as it should be. Admittedly Glory is not a decadent female, but she is puffed up and a great windbag. So it is not fitting that she should be attended by virtues which are, so to say, dependable and stable servants, with the result that Prudence foresees nothing, Justice dispenses nothing, Courage endures nothing, and Temperance governs nothing, except in their providing the means of pandering to men, and attending on inflated Glory.

[4] However, men who despise the judgements of others in their claim to be contemptuous of glory do not acquit themselves of this loathsome charge if they regard themselves as wise and are self-satisfied. Such virtue as they possess is subject to human praise in another way, for the person given to self-satisfaction is, after all, a man. But the man who believes and hopes with true devotion in the God whom he loves concentrates more on his attributes which displease him than on those such as he has which are acceptable – and acceptable not so much to him as to the truth. Any source of such approval he ascribes only to the mercy of him whom he fears to displease. He gives thanks to him for remedying his faults, and offers prayers for those still to be remedied.

XXI

[1] Quae cum ita sint, non tribuamus dandi regni atque imperii potestatem nisi deo uero, qui dat felicitatem in regno caelorum solis piis; regnum uero terrenum et piis et impiis, sicut ei placet cui nihil iniuste placet. Quamuis enim aliquid dixerimus quod apertum nobis esse uoluit, tamen multum est ad nos, et ualde superat uires nostras, hominum occulta discutere, et liquido examine merita diiudicare regnorum.

[2] Ille igitur unus uerus deus, qui nec iudicio nec adiutorio deserit genus humanum, quando uoluit et quantum uoluit Romanis regnum dedit; qui dedit Assyriis, uel etiam Persis, a quibus solos duos deos coli, unum bonum alterum malum, continent litterae istorum, ut taceam de populo Hebraeo, de quo iam dixi quantum satis uisum est, qui praeter unum deum non coluit et quando regnauit. Qui ergo Persis dedit segetes sine cultu deae Segetiae, qui alia dona terrarum sine cultu tot deorum, quos isti rebus singulis singulos uel etiam rebus singulis plures praeposuerunt, ipse etiam regnum dedit sine cultu eorum per quorum cultum se isti regnasse crediderunt.

[3] Sic etiam hominibus. Qui Mario, ipse Gaio Caesari; qui Augusto, ipse et Neroni; qui Vespasianis uel patri uel filio, suauissimis imperatoribus, ipse et Domitiano crudelissimo; et ne per singulos ire necesse sit, qui Constantino Christiano, ipse apostatae Iuliano, cuius egregiam indolem decepit amore dominandi sacrilega et detestanda curiositas, cuius uanis deditus oraculis erat quando fretus securitate uictoriae naues, quibus uictus necessarius portabatur, incendit. Deinde feruide instans immodicis ausibus et mox merito temeritatis occisus in locis hostilibus egenum reliquit exercitum, ut

XXI

[1] Such being the case, the power to bestow rule and empire we must ascribe to none other than the true God, who bestows blessedness in the kingdom of heaven on the devoted alone, but earthly rule on both holy and unholy, according to the will of him whose will is never unjust. For though we have made some observations which God has willed to reveal to us, it is for us a considerable task, and one which extends far beyond our powers, to probe the secret ways of men, and by clear scrutiny to distinguish between the varying merits of kingdoms.

[2] So the one true God who does not withdraw his judgement or his aid from the human race, entrusted dominion to the Romans when and to the degree that he wished. He entrusted it to the Assyrians and to the Persians as well, whose writings indicate that they worship only two gods, one good and the other evil. I say nothing of the Hebrew people, for I have already discussed them as much as seemed sufficient. Even when they had sovereignty they worshipped only the one God, so that same God who bestowed grain on the Persians without worship of the goddess Segetia, and other gifts of the earth without worship of that crowd of gods to each of which the Romans allotted a particular sphere, or even appointed several of them to the one role, also bestowed on the Persians their empire without their worshipping the gods who the Romans believed had conferred rule on themselves because they worshipped them.

[3] God similarly conferred power also on individuals: on Marius and also on Gaius Caesar, on Augustus and on Nero as well, on the Vespasians, father and son, most engaging of emperors, but also on Domitian, most cruel of them. To avoid the need to detail all of them one by one, we note that he conferred power on the one hand on the Christian Constantine, and on the other on the apostate Julian. Julian had notable talent, but it was nullified by a sacrilegious and abominable curiosity, the outcome of his love of power. That curiosity led him to entrust himself to fatuous oracles, when relying on their assurance of victory he set fire to the ships which were bearing vital food supplies. Then, as he feverishly pressed on with his intemperate designs, soon after he was deservedly slain for rashness, he left his army in enemy territory in dire need. They could never have escaped from there if the frontier of the Roman Empire had not been pulled back in contravention

aliter inde non posset euadi nisi contra illud auspicium dei Termini, de quo superiore libro diximus, Romani imperii termini mouerentur. Cessit enim Terminus deus necessitati, qui non cesserat Ioui. Haec plane deus unus et uerus regit et gubernat ut placet; et si occultis causis, numquid iniustis?

XXII

[1] Sic etiam tempora ipsa bellorum, sicut in eius arbitrio est iustoque iudicio et misericordia uel adterere uel consolari genus humanum, ut alia citius alia tardius finiantur. Bellum piratarum a Pompeio, bellum Punicum tertium ab Scipione incredibili celeritate et temporis breuitate confecta sunt. Bellum quoque fugitiuorum gladiatorum, quamuis multis Romanis ducibus et duobus consulibus uictis, Italiaque horribiliter contrita atque uastata, tertio tamen anno post multa consumpta consumptum est. Picentes Marsi et Paeligni, gentes non exterae sed Italicae, post diuturnam et deuotissimam sub Romano iugo seruitutem in libertatem caput erigere temptauerunt, iam multis nationibus Romano imperio subiugatis deletaque Carthagine; in quo bello Italico Romanis saepissime uictis ubi et duo consules perierunt et alii nobilissimi senatores, non diuturno tamen tempore tractum est hoc malum; nam quintus ei annus finem dedit.

[2] Sed bellum Punicum secundum cum maximis detrimentis et calamitate reipublicae per annos decem et octo Romanas uires extenuauit et paene consumpsit; duobus proeliis ferme septuaginta Romanorum milia ceciderunt. Bellum Punicum primum per uiginti et tres annos peractum est, bellum Mithridaticum quadraginta. Ac ne quisquam arbitretur rudimenta Romanorum fuisse fortiora ad bella citius peragenda, superioribus temporibus multum in omni uirtute laudatis bellum Samniticum annis tractum est ferme quinquaginta, in quo bello ita Romani uicti sunt ut sub iugum etiam mitterentur. Sed quia non diligebant gloriam propter iustitiam, sed iustitiam propter gloriam diligere uidebantur, pacem factam foedusque ruperunt.

of that omen of the god Terminus which I described in the previous book. For the god Terminus had not yielded to Jupiter, but he yielded to necessity. Clearly the one true God governs and guides these events as he wills. Though the reasons are hidden, they are certainly not unjust.

XXII

[1] In the same way the duration of wars too lies in God's hands. Depending on whether in his will, just judgement, and mercy he decides to afflict or to console the human race, some are brought to an end earlier, and some later. The war with the pirates and the Third Punic War were both concluded with astonishing speed within a brief period by Pompey and by Scipio respectively. The war with the runaway gladiators too, though it encompassed the defeat of several Roman generals including two consuls, and caused appalling devastation and destruction in Italy, finally exhausted itself, having exhausted much else by the third year. The tribes of the Picentes, Marsi, and Paeligni – no foreigners but Italians – after lengthy and most faithful slavery beneath the Roman yoke, sought to raise their heads to win their freedom, after many nations had been subjected to Roman dominion, and Carthage had been destroyed. In this Italian war the Romans sustained numerous defeats, in the course of which two consuls and other most eminent senators were killed, but this disastrous war did not drag on for long, for it ended in the fifth year.

[2] On the other hand, the Second Punic War lasted for eighteen years, causing massive losses and disaster to the state. It strained and almost exhausted Roman resources, and in two of the battles about seventy thousand Romans fell. The First Punic War ran for twenty-three years, and the fighting with Mithradates for forty. No-one should imagine either that the Romans in their apprenticeship showed greater force in concluding their wars more quickly. In those earlier days which gained great praise for the manifestation of every virtue, war with the Samnites dragged on for almost fifty years, and in the course of it, one defeat of the Romans was so crushing that they were even sent under the yoke. But because they did not love glory in order to achieve justice but were seen to love justice in order to achieve glory, they violated the peace and the treaty which had been agreed.

[3] Haec ideo commemoro quoniam multi praeteritarum rerum ignari, quidam etiam dissimulatores suae scientiae, si temporibus Christianis aliquod bellum paulo diutius trahi uident, ilico in nostram religionem proteruissime insiliunt, exclamantes quod, si ipsa non esset et uetere ritu numina colerentur, iam Romana illa uirtute, quae adiuuante Marte et Bellona tanta celeriter bella confecit, id quoque celerrime finiretur. Recolant igitur qui legerunt quam diuturna bella, quam uariis euentis, quam luctuosis cladibus a ueteribus sint gesta Romanis, sicut solet orbis terrarum uelut procellosissimum pelagus uaria talium malorum tempestate iactari, et quod nolunt aliquando fateantur, nec insanis aduersus deum linguis se interimant et decipiant imperitos.

XXIII

[1] Quod tamen nostra memoria recentissimo tempore deus mirabiliter et misericorditer fecit non cum gratiarum actione commemorant, sed quantum in ipsis est, omnium si fieri potest hominum obliuione sepelire conantur; quod a nobis si tacebitur, similiter erimus ingrati.

[2] Cum Radagaesus, rex Gothorum, agmine ingenti et immani iam in urbis uicinia constitutus Romanis ceruicibus immineret, uno die tanta celeritate sic uictus est ut ne uno quidem non dicam extincto, sed uulnerato Romanorum multo amplius quam centum milium prosterneretur eius exercitus, atque ipse mox captus poena debita necaretur. Nam si ille tam impius cum tantis et tam impiis copiis Romam fuisset ingressus, cui pepercisset? Quibus honorem locis martyrum detulisset? In qua persona deum timeret? Cuius non sanguinem fusum, cuius pudicitiam uellet intactam? Quas autem isti pro diis suis uoces haberent, quanta insultatione iactarent quod ille ideo uicisset, ideo tanta potuisset, quia cotidianis sacrificiis placebat atque inuitabat deos, quod Romanos facere Christiana religio non sinebat?

[3] I recount these facts because many are ignorant of past events, and some even conceal their knowledge of them. If they observe that some war is dragging on rather longer in these Christian times, they at once launch a most shameless attack on our religion. They cry out that if Christianity did not exist and their deities were worshipped by the ritual of old, that war would already have been concluded with the utmost dispatch through that Roman valour which with the aid of Mars and Bellona brought such great conflicts swiftly to an end. So those who have read the accounts must remember how lengthy those wars were, how diverse were their outcomes, and how grievous were the disasters sustained in those wars by the ancient Romans who waged them. But it is the frequent experience of our world to resemble the sea under the heavy lash of a storm, tossed by the diverse impact of a tempest of such evils. They should at last admit what they are sometimes unwilling to admit. They should not by their lunatic utterances against God both destroy themselves and deceive the ignorant.

XXIII

[1] Our adversaries do not thankfully recount God's wonderful and merciful action which occurred within our recollection in very recent days; indeed, so far as they can they try to cloak it in men's forgetfulness. If we were to refrain from mentioning it, we shall be as ungrateful as they are.

[2] Radagaesus, king of the Goths, had taken up his position close to Rome with his massive and monstrous column, and was breathing down Roman necks. But on a single day he was defeated with such rapidity that while not one Roman was wounded, let alone killed, many more than a hundred thousand of his army were slaughtered, and he himself was then captured and suffered the deserved punishment of execution. If that unholy individual had entered Rome with such massive and unholy forces, whom would he have spared? Which martyrs' shrines would he have respected? What individual would have inspired him with fear of God? Whose blood would he not have sought to shed, whose virginity would he have left inviolate? What shouts our adversaries would have raised in praise of their gods, how jeeringly they would have boasted, claiming that Radagaesus had prevailed and achieved such striking success because he appeased and enticed the gods with daily sacrifices, which the Christian religion did not permit Romans to do!

[3] Nam propinquante iam illo his locis ubi nutu summae maiestatis oppressus est, cum eius fama ubique crebresceret, nobis apud Carthaginem dicebatur hoc credere spargere iactare paganos quod ille diis amicis protegentibus et opitulantibus, quibus immolare cotidie ferebatur, uinci omnino non posset ab eis qui talia diis Romanis sacra non facerent, nec fieri a quoquam permitterent. Et non agunt miseri gratias tantae misericordiae dei, qui cum statuisset inruptione barbarica grauiora pati dignos mores hominum castigare, indignationem suam tanta mansuetudine temperauit ut illum primo faceret mirabiliter uinci, ne ad infirmorum animos euertendos gloria daretur daemonibus quibus eum supplicare constabat; [4] deinde ab his barbaris Roma caperetur, qui contra omnem consuetudinem gestorum ante bellorum ad loca sancta confugientes Christianae religionis reuerentia tuerentur, ipsisque daemonibus atque impiorum sacrificiorum ritibus, de quibus ille praesumpserat, sic aduersarentur nomine Christiano ut longe atrocius bellum cum eis quam cum hominibus gerere uiderentur.

[5] Ita uerus dominus gubernatorque rerum et Romanos cum misericordia flagellauit, et tam incredibiliter uictis supplicatoribus daemonum nec saluti rerum praesentium necessaria esse sacrificia illa monstrauit, ut ab his qui non peruicaciter contendunt sed prudenter adtendunt nec propter praesentes necessitates uera religio deseratur, et magis aeternae uitae fidelissima exspectatione teneatur.

XXIV

[1] Neque enim nos Christianos quosdam imperatores ideo felices dicimus quia uel diutius imperarunt uel imperantes filios morte placida reliquerunt, uel hostes reipublicae domuerunt, uel inimicos ciues aduersus se insurgentes

[3] Indeed, as Radagaesus approached the region where he was overthrown at the nod of the supreme Majesty, and rumours of his approach were flying thick and fast everywhere, word came to us at Carthage that the pagans were thinking, disseminating, and boasting that his friends the gods, to whom he was said to sacrifice every day, were protecting and aiding him, and that it was wholly impossible for him to be conquered by those who did not conduct such ritual to the Roman gods, and who refused to allow anyone else to do so. Even now those wretches do not give thanks for God's great mercy, for though by the barbarians' invasion he had purposed to punish the misbehaviour of men who deserved to suffer more harshly, he reined back his anger with such great mildness that to begin with he caused the sensational defeat of Radagaesus. This was to ensure that glory was not bestowed on the demons, to whom that leader was clearly addressing entreaties, to allow them to undermine the minds of our weak brethren.

[4] Secondly, he allowed Rome to be captured by these barbarians, so that contrary to all precedent in wars previously waged, they would with pious reverence for the Christian religion protect those who were fleeing to the sanctuary of the holy shrines, and in Christ's name confront the demons themselves and their rites of unholy sacrifices, on which Radagaesus had relied, so that they were seen to be waging a much more savage war with the demons than with men.

[5] In this way the true lord and helmsman of the universe both in his mercy whipped the Romans, and by this quite astounding defeat of the worshippers of demons demonstrated that those sacrifices to them were unnecessary even to achieve security in the world of the here and now. So those who do not obstinately confront us, but show prudent judgement, have no need to abandon the true religion for the needs of the moment. Rather, they should cling to it in most faithful anticipation of eternal life.

XXIV

[1] Our reason for calling certain Christian emperors blessed is not because of any longer period of rule, nor yet because they have died peacefully, and bequeathed the supreme power to their sons, nor again because they subdued enemies of the state, or were able to take precautions and to suppress hostile

et cauere et opprimere potuerunt. Haec et alia uitae huius aerumnosae uel munera uel solacia quidam etiam cultores daemonum accipere meruerunt, qui non pertinent ad regnum dei, quo pertinent isti; et hoc ipsius misericordia factum est, ne ab illo ista qui in eum crederent uelut summa bona desiderarent.

[2] Sed felices eos dicimus si iuste imperant, si inter linguas sublimiter honorantium et obsequia nimis humiliter salutantium non extolluntur, et se homines esse meminerunt; si suam potestatem ad dei cultum maxime dilatandum maiestati eius famulam faciunt; si deum timent diligunt colunt; si plus amant illud regnum ubi non timent habere consortes; si tardius uindicant, facile ignoscunt; si eandem uindictam pro necessitate regendae tuendaeque reipublicae, non pro saturandis inimicitiarum odiis exerunt; si eandem ueniam non ad impunitatem iniquitatis sed ad spem correctionis indulgent; si quod aspere coguntur plerumque decernere misericordiae lenitate et beneficiorum largitate compensant; si luxuria tanto eis est castigatior quanto posset esse liberior; si malunt cupiditatibus prauis quam quibuslibet gentibus imperare, et si haec omnia faciunt non propter ardorem inanis gloriae, sed propter caritatem felicitatis aeternae; si pro suis peccatis humilitatis et miserationis et orationis sacrificium deo suo uero immolare non neglegunt. Tales Christianos imperatores dicimus esse felices interim spe, postea re ipsa futuros, cum id quod exspectamus aduenerit.

XXV

[1] Nam bonus deus, ne homines qui eum crederent propter aeternam uitam colendum has sublimitates et regna terrena existimarent posse neminem consequi nisi daemonibus supplicet, quod hi spiritus in talibus multum ualerent, Constantinum imperatorem non supplicantem daemonibus, sed ipsum uerum deum colentem tantis terrenis impleuit muneribus quanta optare nullus auderet; cui etiam condere ciuitatem Romano imperio sociam

citizens who revolted against them. These and other functions or consolations of this burdensome life have been permitted to be shouldered also by some who worship the demons, and have no connection with the kingdom of God as have the Christian emperors. This dispensation is the outcome of God's mercy, to ensure that those who believe in him would not aspire to receive such powers from him as if they were the highest good.

[2] We count them blessed if their government is just, if they are not puffed up by those who address them with high praises and by those who greet them over-obsequiously, and if they remember that they are men; if they make their power subject to God's majesty, to extend his worship as widely as possible; if they fear, love, and worship God; if they feel greater affection for that kingdom in which they do not fear to have co-emperors; if they punish more reluctantly, and pardon readily. If in the end they exact such punishment, it is because they must govern and defend the state, not to give vent to hatreds arising from enmities; if they extend that pardon, they do so not to allow wickedness to go scot-free, but in the hope of amendment; if they are frequently impelled to pass harsh decrees, they balance these with lenient acts of mercy and generous gifts of kindness; if, when there is greater scope for self-indulgence, they discipline it the more; if they choose to control their base desires rather than any number of nations; and if they do all this not out of zeal for empty glory, but out of regard for eternal blessedness; if they do not neglect to offer to their true God the sacrifice of humility, compassion, and prayer as atonement for their sins. Christian emperors of this kind we declare to be blessed, in expectation for now, but in reality later when the future which we await comes to pass.

XXV

[1] For God in his goodness did not wish men who believed that he was to be worshipped to attain eternal life to think that no-one could attain these heights of earthly kingship without praying to demons, being under the impression that these spirits exercised great power in such matters. So he filled the emperor Constantine, who did not entreat the demons but worshipped the true God, with such great worldly gifts as no man would have presumed to desire. God granted him even the glory of founding an

uelut ipsius Romae filiam, sed sine aliquo daemonum templo simulacroque concessit. Diu imperauit, uniuersum orbem Romanum unus Augustus tenuit et defendit; in administrandis et gerendis bellis uictoriosissimus fuit, in tyrannis opprimendis per omnia prosperatus est, grandaeuus aegritudine et senectute defunctus est, filios imperantes reliquit.

[2] Sed rursus ne imperator quisquam adeo Christianus esset ut felicitatem Constantini mereretur, cum propter uitam aeternam quisque debeat esse Christianus, Iouianum multo citius quam Iulianum abstulit; Gratianum ferro tyrannico permisit interimi, longe quidem mitius quam magnum Pompeium colentem uelut Romanos deos. Nam ille uindicari a Catone non potuit, quem ciuilis belli quodam modo heredem reliquerat; iste autem, quamuis piae animae solacia talia non requirant, a Theodosio uindicatus est, quem regni participem fecerat, cum paruulum haberet fratrem, auidior fidae societatis quam nimiae potestatis.

XXVI

[1] Vnde et ille non solum uiuo seruauit quam debebat fidem, uerum etiam post eius mortem pulsum ab eius interfectore Maximo Valentinianum eius paruulum fratrem in sui partes imperii tamquam Christianus excepit pupillum, paterno custodiuit affectu quem destitutum omnibus opibus nullo negotio posset auferre si latius regnandi cupiditate magis quam benefaciendi caritate flagraret. Vnde potius eum seruata eius imperatoria dignitate susceptum ipsa humanitate et gratia consolatus est. Deinde cum Maximum terribilem faceret ille successus, hic in angustiis curarum suarum non est lapsus ad curiositates sacrilegas atque inlicitas, sed ad Iohannem in Aegypti eremo constitutum, quem dei seruum prophetandi spiritu praeditum fama crebrescente didicerat, misit atque ab eo nuntium uictoriae certissimum accepit.

allied city within the Roman Empire, a sort of daughter of Rome herself, but a city without any temple or statue of any of the demons. He held power for a long time; as the sole Augustus, he held and defended the entire Roman world. In managing and waging wars he was hugely successful, and he was able to repress usurpers throughout his career. He died at a great age of sickness and of old age, leaving the imperial throne to his sons.

[2] On the other hand, God did not wish any emperor to be a Christian in order to merit the blessed career of Constantine, for a man's motive in being a Christian must be to attain eternal life. So he removed Jovian much more quickly than Julian, and he allowed Gratian to be killed by a tyrant's sword, though admittedly his death was far less savage than that of Pompey the Great, who worshipped the so-called gods of Rome; for Pompey could not be avenged by Cato, whom he had left behind him as heir, so to say, to the Civil War, whereas Gratian – mind you, devoted souls do not need such consolations – was avenged by Theodosius, whom he had adopted as his partner in the rule, in spite of his having a very young brother. For he was keener to forge a reliable alliance than to exercise excessive power.

XXVI

[1] For this reason Theodosius for his part not only maintained his due loyalty to Gratian while he lived, but also after his death like a true Christian received Gratian's young brother Valentinian into his sphere of the empire. The boy had been expelled by Maximus, who had murdered Gratian. Theodosius treated him as his ward, and protected him with paternal affection. Since the boy had been stripped of all his resources, Theodosius could have disposed of him without difficulty, if he had been fired by greed to extend his rule more widely rather than by love of doing good. So he chose to welcome him, preserving his imperial rank and consoling him with kindness and favour. Then, though that earlier success had made Maximus fearsome while he himself was hemmed in by his responsibilities, he did not lapse into sacrilegious and forbidden superstitions, but he communicated with John, who was living in a hermitage in Egypt. He had learnt that this servant of God was endowed with the spirit of prophecy, for his reputation was increasingly widespread, and he obtained from him the clearest assurances of victory.

[2] Mox tyranni Maximi exstinctor Valentinianum puerum imperii sui partibus, unde fugatus fuerat, cum misericordissima ueneratione restituit, eoque siue per insidias siue quo alio pacto uel casu proxime exstincto, alium tyrannum Eugenium, qui in illius imperatoris locum non legitime fuerat subrogatus, accepto rursus prophetico responso fide certus oppressit, contra cuius robustissimum exercitum magis orando quam feriendo pugnauit. Milites nobis qui aderant rettulerunt extorta sibi esse de manibus quaecumque iaculabantur, cum a Theodosii partibus in aduersarios uehemens uentus iret, et non solum quaecumque in eos iaciebantur concitatissime raperet, uerum etiam ipsorum tela in eorum corpora retorqueret. Vnde et poeta Claudianus, quamuis a Christi nomine alienus, in eius tamen laudibus dixit:

O nimium dilecte deo, cui militat aether,

et coniurati ueniunt ad classica uenti!

[3] Victor autem sicut crediderat et praedixerat Iouis simulacra, quae aduersus eum fuerant nescio quibus ritibus uelut consecrata et in Alpibus constituta, deposuit, eorumque fulmina, quod aurea fuissent, iocantibus – quod illa laetitia permittebat – cursoribus et se ab eis fulminari uelle dicentibus hilariter benigneque donauit. Inimicorum suorum filios, quos non ipsius iussu belli abstulerat impetus, etiam nondum Christianos ad ecclesiam confugientes, Christianos hac occasione fieri uoluit et Christiana caritate dilexit; nec priuauit rebus et auxit honoribus. In neminem post uictoriam priuatas inimicitias ualere permisit. Bella ciuilia non sicut Cinna et Marius et Sulla et alii tales nec finita finire uoluerunt, sed magis doluit exorta quam cuiquam nocere uoluit terminata.

[4] Inter haec omnia ex ipso initio imperii sui non quieuit iustissimis et misericordissimis legibus aduersus impios laboranti ecclesiae subuenire, quam Valens haereticus fauens Arrianis uehementer adflixerat; cuius

[2] He disposed of the usurper Maximus with all speed, and with the most compassionate respect he restored the youthful Valentinian to his imperial dominion from which he had been expelled. But the boy soon died through treachery or through some other plot or accident, and Theodosius then crushed Eugenius, another usurper who had been illicitly installed in Valentinian's place as emperor. Having received a second prophetic response, with full trust in its reliability, he engaged with Eugenius's most powerful army by prayer rather than with the sword. Soldiers who were on the spot have told me that the missiles which they were hurling were snatched from their grasp by a fierce wind which sprang up from Theodosius's station in the face of his foes. Not only did it propel with the utmost speed such projectiles as were launched against the enemy, but it also twisted back the darts of his foes to pierce their own bodies. This inspired even the poet Claudian, in spite of his being a foreigner to Christ's name, to express these praises of Theodosius:

> O one so greatly loved by God, heaven fights for you,
> And winds conspire to rally to your trumpet sound!

[3] Once he had gained the victory in which he had believed and had foretold, he dismantled statues of Jupiter which had been consecrated, as it were, by some ritual and erected in the Alps to oppose him. When his couriers in joking fashion (for the joy of the moment allowed such licence) alluded to the thunderbolts on the statues, and as they were made of gold said that they too would love to be struck down by them, he laughingly and indulgently presented the thunderbolts to them. When his enemies lost their lives, not by his command but by the shock of war, and their sons though not yet Christians sought sanctuary in a church, he exploited the opportunity to express the desire that they become Christians. He showed them Christian affection, did not deprive them of their property, and advanced them to higher distinctions. Once victory was won, he did not permit anyone to suffer harm through personal enmities; unlike Cinna, Marius, Sulla and that ilk who refused to foreclose hostilities even when the civil wars were over, he showed more regret at the commencement of wars than desire to harm anyone when they were brought to a close.

[4] In the course of all these events, from the very beginning of his reign he never ceased by most just and merciful laws to aid the Church in her struggle against irreligious foes. The heretic Valens had shown favour to the Arians,

ecclesiae se membrum esse magis quam in terris regnare gaudebat. Simulacra gentilium ubique euertenda praecepit, satis intellegens nec terrena munera in daemoniorum sed in dei ueri esse posita potestate.

[5] Quid autem fuit eius religiosa humilitate mirabilius, quando in Thessalonicensium grauissimum scelus, cui iam episcopis intercedentibus promiserat indulgentiam, tumultu quorumdam qui ei cohaerebant uindicare compulsus est, et ecclesiastica coercitus disciplina sic egit paenitentiam ut imperatoriam celsitudinem pro illo populus orans magis fleret uidendo prostratam quam peccando timeret iratam?

[6] Haec ille secum et si qua similia, quae commemorare longum est, bona opera tulit ex isto temporali uapore cuiuslibet culminis et sublimitatis humanae; quorum operum merces est aeterna felicitas, cuius dator est deus solis ueraciter piis. Cetera uero uitae huius uel fastigia uel subsidia, sicut ipsum mundum lucem auras, terras aquas fructus, ipsiusque hominis animam corpus sensus mentem uitam, bonis malisque largitur, in quibus est etiam quaelibet imperii magnitudo, quam pro temporum gubernatione dispensat.

[7] Proinde iam etiam illis respondendum esse uideo qui manifestissimis documentis quibus ostenditur quod ad ista temporalia quae sola stulti habere concupiscunt nihil deorum falsorum numerositas prosit confutati atque conuicti conantur asserere non propter uitae praesentis utilitatem, sed propter eam quae post mortem futura est colendos deos. Nam istis qui propter amicitias mundi huius uolunt uana colere et non se permitti puerilibus sensibus conqueruntur his quinque libris satis arbitror esse responsum.

[8] Quorum tres priores cum edidissem et in multorum manibus esse coepissent, audiui quosdam nescio quam aduersus eos responsionem scribendo praeparare. Deinde ad me perlatum est quod iam scripserint, sed

and had sorely persecuted the Church. Theodosius took more pleasure in his membership of the Church than in his dominion over the world. He ordered that the statues of the pagans should be dismantled everywhere, for he was well aware that even earthly favours are granted at the discretion of the true God, and not at that of the demons.

[5] Was there anything more remarkable than that religious humility of his? When the agitation by some of his close associates forced him to punish a most serious crime perpetrated by the Thessalonicans, in spite of the fact that at the intercession of the bishops he had promised to pardon it, he fell under the constraints of ecclesiastical discipline. He submitted to the penance in such a way that as those citizens prayed on his behalf, they showed greater grief at witnessing the humiliation of the imperial majesty than fear of his anger because of their sinning.

[6] These worthy deeds and such others like them which would take too long to relate he took with him when he left this life on earth, which is as a whiff of smoke no matter the height and eminence which a man attains. The reward for them is that eternal blessedness which God confers only on those who are truly devoted to the truth. All other lofty distinctions, and all that supports us in this life – the world itself, its light and air, its lands and waters and harvests, man's soul, body, feelings, mind and life – God bestows on good and evil alike. Among these gifts there is also imperial rule which is more or less imposing, and which he allocates according to his governance of temporal affairs.

[7] Accordingly I realise that I must also respond to those who have been given the clearest proofs that the horde of false gods provides no help for the attainment of the temporal advantages which alone they foolishly yearn to possess. Now that they have been thus refuted and proved wrong, they try to maintain that those gods are to be worshipped not for the advantages which they offer in this present life, but for those which they bring to life after death. I think that I have made adequate reply in these first five books to our adversaries, when they seek to engage in futile worship to obtain friendships in this world, and they complain that they are not allowed to indulge their childish fancies.

[8] After I had published the first three of these books, and they had begun to find their way into many people's hands, I heard that some individuals were preparing to write some sort of riposte to them. I was informed subsequently

tempus quaerant quo sine periculo possint edere. Quos admoneo non optent quod eis non expedit; facile est enim cuiquam uideri respondisse qui tacere noluerit. Aut quid est loquacius uanitate? Quae non ideo potest quod ueritas quia, si uoluerit, etiam plus potest clamare quam ueritas.

[9] Sed considerent omnia diligenter, et si forte sine studio partium iudicantes talia esse perspexerint quae potius exagitari quam conuelli possint garrulitate impudentissima et quasi satyrica uel mimica leuitate, cohibeant suas nugas et potius a prudentibus emendari quam laudari ab impudentibus eligant. Nam si non ad libertatem uera dicendi, sed ad licentiam maledicendi tempus exspectant, absit ut eis eueniat quod ait Tullius de quodam qui peccandi licentia felix appellabatur: 'O miserum, cui peccare licebat!' Vnde quisquis est qui maledicendi licentia felicem se putat, multo erit felicior si hoc illi omnino non liceat, cum possit deposita inanitate iactantiae etiam isto tempore tamquam studio consulendi quidquid uoluerit contradicere, et quantum possunt ab eis quos consulit amica disputatione honeste grauiter libere quod oportet audire.

that they have already written this reply, but that they are waiting for the moment when they can publish it without danger to themselves. My advice to them is not to aspire to what is unprofitable to them, for it is easy for one who is reluctant to remain silent to appear to have countered my case. Is there anything more prone to utterance than a vapid mind? Merely because it can shout louder at will than the voice of truth does not lend it the power of truth.

[9] Instead they should ponder the whole question carefully, and if with impartial judgement they chance to realise that my arguments can be more easily criticised than undermined by means of quite shameless prattling and the shallowness typical of lampoons and of the mimic stage, they must refrain from their trifling, and seek correction from men of sense rather than praise from shameless people. If they await the moment not for freedom to speak the truth but for licence to utter abuse, I pray that they may not become like the man who Cicero says was called happy because he had licence to sin; "Poor fellow, free as he was to sin!" So whoever considers himself happy because he has licence to mouth abuse will be much happier if he is not given licence to speak at all. He can abandon his empty boasting, and even as late as this he can show eagerness for consultation, express whatever objections he wishes, and in an honourable, serious, and open way listen to what he ought to hear in friendly exchanges with those whom he consults, in so far as the abilities of those men allow.

Commentary

Book V divides into four sections:

1. A discussion of fate, free will, and Providence (1–11).
2. Roman virtues, good in themselves, were motivated by the desire for glory, honour, and dominion. These aims are in contrast with Christian attitudes (12–20).
3. The Roman Empire was ordained by God, and is governed by his providence (21–23).
4. The virtues of Christian emperors, specifically Constantine the Great and Theodosius (24–26).

Having discussed the moral decline of the Romans (Book II), the physical disasters which plagued them (Book III), and the nature and roles of the deities which presided over this degeneration (Book IV), Augustine now offers a more positive view of the Roman imperial achievement. Having refuted the claim of his opponents that the Roman success was attributable to the pagan deities, he first reviews alternative explanations offered against his conviction that the empire flourished through God's dispensation.

Preface

felicity is the full attainment, etc.: *felicitas* bears different nuances of meaning, including 'good fortune' (IV 18, IV 21), 'happiness' (VII 14), and here 'total success'.
goods attainable even by those who are not good: The problem of God's apportionment of blessings to evil men, and evils to good men, is a recurrent theme throughout *C.D.* Note especially I 8–9, where he advances possible reasons for this dispensation, and XX 2, where he acknowledges that God's justice will become clear to us only at the final Judgement. The later Stoics had been preoccupied with this question; see the discussion in Seneca, *De prouidentia*, where Lucilius asks why, if the world is guided by a beneficent Providence, evils accrue to good men. The Stoic response is that vice is the only evil, a view on which Augustine puts a Christian gloss.
not good, and in consequence...not happy: The notion that only virtue makes for happiness is pervasive in Plato, e.g. at *Rep.* 354 A, *Charm.* 172 A, 173D, and in *Gorgias*, passim.

I *The history of the Roman Empire and of all kingdoms is not the outcome of chance, and is not attributable to the position of the stars*

1 **the outcome of chance or fate:** In this general formulation, Augustine doubtless thinks of the doctrines of Epicureans and Stoics as outlined by Cicero, *N.D.* I–II. Augustine does not pursue the possibility of chance as a factor, but concentrates on the arguments against fate.

the expression 'fate' for the will or power of God: In both Stoicism, where spokesmen from Chrysippus to Seneca identify fate with the process of the divine *pneuma*, and in Middle Platonism, where fate is the subordinate agent of Providence, this notion is central. See Sharples, 29ff.

nothing but the influence of the position of the stars: Augustine at once narrows the discussion of fate to the issue of astrological predetermination. He considers three possibilities: a) the stars themselves determine human actions; this he rejects out of hand. b) God directs the destinies of men through the stars. c) The stars by their locations predict the course of human actions, but are not the cause of them. The robust rejection of astrology in what follows reflects Cicero's extended critique at *Div.* 2. 88–99, which is at least in part derived from the Stoic Panaetius (see *Div.* 2. 88 and 97).

2 **who believe that...independently of the will of God:** Presumably Augustine thinks of those who subscribe neither to the traditions of Platonism nor to those of Stoicism, but are dominated by superstition. See, e.g., Samuel Dill, *Roman Society from Nero to Marcus Aurelius* (repr. N.Y. 1956), 443–83. The reflections in this and subsequent chapters have already been advanced by Augustine in *De doctrina Christiana* 2.82.

 but against men...hostile to the Christian religion: Having for the moment allied Christianity with Roman religion in rejecting the superstition of astrology, Augustine hastily disengages from agreement with his main opponents.

3 **to decide those issues at their own discretion:** The implication is that the stars are sentient and divine, as argued by Plato in *Laws X* and perhaps also by Aristotle in his *De philosophia* (but see W.K.C. Guthrie, *A History of Greek Philosophy* VI (Cambridge 1981), 256, for detailed discussion of this controverted issue). The doctrine was taken up by the Stoics; see Cicero, *N.D.* 2.39, 2.42f., 55, probably the immediate inspiration of Augustine here.

 in the radiantly shining senate, etc.: The lyrical description of the region of the aether is perhaps inspired by Balbus's account of the glories of the empyrean; note especially *N.D.* 2.54f.

 the inevitability of evil deeds is decreed: Augustine briefly anticipates his argument for free will (ch. 10 below) by stressing the illogicality of saddling the stars with human guilt.

4 **men of no mean learning:** Welldon suggests that Augustine may refer to Origen here, citing Eusebius, *Praep. Euang.* 6.11. More probably, however, he has in mind philosophers of the Stoic persuasion, notably Posidonius (cf. Cicero, *Div.* 1.129).

 such great contrasts in the lives of twins: This objection to astrological claims that the position of the stars at conception or at birth foretells or even imposes the pattern of a person's life, which is the theme of the next chapter, had already been aired by the Stoic Diogenes of Babylon (240–152 BC), the teacher of Panaetius (see Cicero, *Div.* 2.90f.), and by the Academic Carneades (214–129 BC; see Gellius 14.1.25, and Sextus Empiricus *Adv. Math.* 5.89).

II *Similarity and difference in the health of twins*

1 **Cicero states:** The citation is almost certainly from the fragmentary *De fato*. Sharples assigns it to fr. 4, but notes that both Ax and Rackham in their editions of *De fato* exclude it as a paraphrase rather than a direct quotation.

Hippocrates, that most renowned of physicians: The corpus of medical writings which bear his name (collected by E. Littré, *Oeuvres complètes d'Hippocrate*, 10 vols. (Paris 1839–61; most influential treatises in the Loeb edition, 4 vols., edd. W.H.T. Jones–E.T. Withington) may not have been written by him. He was probably a contemporary of Socrates; Plato, *Protagoras* 311B states that he taught medicine for a fee. For the traditions of his life and extensive bibliography, see *OCD*[3].

The Stoic Posidonius: The celebrated Stoic (c. 135–50 BC), teacher of Cicero at Rhodes (Plutarch, *Cicero* 4.5), was a versatile scholar who wrote on a wide range of academic disciplines (see *OCD*[3]). Unfortunately only fragments survive (collected by L. Edelstein, *Posidonius, the Fragments* (Cambridge 1989): I.G. Kidd, *The Commentary* (Cambridge 1988; this passage is fr. 111). Posidonius's five books *On the gods* were probably Cicero's main source for Balbus's discourse on Stoic theology in *N.D.* Book II. A few months after composing the *N.D.*, Cicero again exploited the treatise to criticise Posidonius's views on determinism in the *De fato*. Unfortunately only the end of this critique (*De fato* 5–6), on which Augustine bases his case, has survived.

2 **what the physician hazarded:** The argument which follows for preferring the pragmatic causes advanced by medical science to the astrological theory of Posidonius owes something to Panaetius's account mediated through Cicero's *De diuinatione*, notably in the claim that physical traits are derived from parents (*Diu.* 2.94) and from the environment (2.96). It is uncertain whether he draws also here on the *De fato*.

3 **I am myself acquainted with twins:** One wonders if Augustine refers here to the anecdote recorded in *Conf.* 7.8. Firminus, a friend of Augustine at Milan, was born at the same time as a slave of a friend of Firminus's father, but whereas Firminus pursued a distinguished career, the slave remained in his lowly condition. Though they were not twins in the strict sense, they were born virtually simultaneously.

4 **they call this the horoscope:** This is the sector of the sky rising from the east; then more generally the ascendant, the degree under which a child is born, See Manilius 2.826ff.: "The third cardinal, which on the same level of the earth holds in position the shining dawn where the stars first rise, where day returns and divides time into hours, is for this reason in the Greek world called the horoscope", (tr. G.P. Goold Loeb Manilius, 1977). Cf. also 3.537ff.

parity...such as cannot be found: The exemplar of the twins, adduced by Cicero to counter the astrological claims of Posidonius, found its way into literary contexts; see, e.g., Persius 6.18ff.

the late arrival of the second child: Augustine seems to refer to the virtually simultaneous births of children by different mothers, as in the anecdote recorded in §3n. above.

III *The argument concerning twins which the astrologer Nigidius adopted from the potter's wheel*

1 **the response of Nigidius:** P. Nigidius Figulus (c. 100–45 BC; praetor 58 BC) was a supporter of Cicero in the crisis of 63 BC (Cicero, *Sull.* 41.2, *Ad Fam.* 4.13.2), and of the senatorial rump against Caesar in the Great Civil War. After the defeat at Pharsalus (Lucan 1.639), he lived in exile for the rest of his life. As a scholar he was accounted "after Varro, the most learned of men" (Gell. 19.14), with a range of writing which included works entitled *De diis, De hominum natura, De animalibus, De uentis,* and grammatical writings (none have survived). His interest in astrology was developed in his enthusiasm for Pythagoreanism.
 earned him the name of 'the Potter': This is dubious, since Figulus was a plebeian *cognomen* earlier (see W. Kroll, *RE* 17.200ff.).
 What he did was to spin the potter's wheel: The anecdote does not appear earlier in extant literature, and it seems probable that Augustine read it in Cicero's lost *De fato*. D. Pingree in the *Augustinus Lexicon* (1/4 (1990), 484), claims that the conclusion drawn from the experiment is invalid.

2 **how have astrologers the nerve...?** Augustine accepts the validity of the experiment, but argues that if the distance in the heavens between births is so great, astrologers cannot pronounce precisely on the location at the moment of any birth.
 the hidden truth: That is, what the future holds.

IV *The vast difference in the natures of the characters and activities of the twins Esau and Jacob*

1 **twins were born:** See *Genesis* 25.24ff.: "When Rebekah's time to give birth was at hand, there were twins in her womb; the first came out red, all his body like a hairy mantle, so they named him Esau. Afterwards his brother came out with his hand grasping Esau's heel, so he was named Jacob". (Esau means 'hairy'; Jacob means 'supplanter', bearing the double sense of *sub planta*, 'under the sole', and dispossessor.)
 the differences...the contrast: Augustine exaggerates somewhat. Esau was 'a skilful hunter' rather than a hireling, loved by his father as Jacob was loved by his mother. While it is true that *Genesis* lays greater emphasis on Jacob's numerous progeny by his two wives Leah and Rachel and their maidservants, Esau appears to have been similarly prosperous. Augustine had earlier at *De doctrina Christiana* 2.83ff. cited this contrast between Esau and Jacob to discredit the astrologers. Cf. also *Conf.* 7.10.
 one would take a stroll, etc.: Reinforcing the point made in III.2 above, that astrologers' claims refer to careers and not to insignificant habits.
 one lost the birthright: So *Gen.* 25.31ff.

2 **with muddied minds to spin round:** As at III.2 above, a punning connection is made between the cloddish mentality of credulous believers in astrology and the clay vessels turned on the potter's wheel.

V *Ways in which astrologers are found guilty of dispensing bogus knowledge*

1 **the brothers:** Augustine now reverts to the topic of Ch. II, the opposed explanations advanced by Hippocrates and by Posidonius for identical ailments suffered simultaneously by twins. He exploits the experiment of Nigidius to demonstrate the illogicalities of the astrologers.

2 **if delay causing different times of birth**, etc.: Welldon's suggestion that *hora* should be read for *mora* is tempting, but it militates against the principle of *difficilior lectio potior*.

3 **the resultant divergence of the cardinal points:** The importance in ancient astrology of the cardinal points is outlined by Manilius at 2.805–55. A.E. Housman's explanatory preface in his edition of Book II² (Cambridge 1937), XXViff., summarises this as follows: "The zodiac is divided into four quadrants of 90 degrees each by four *cardines*...The place of these four points is fixed as regards the observer, but perpetually changing as regards the zodiac itself. They are the points at which the zodiac, revolving with the sky, is at any moment intersected by the horizon and the meridian, both of which are riveted fast to the spectator. To the east of him he had the *horoscopus* or *ortus*, to the west the *occasus*, overhead the *medium caelum*, underfoot the *imum caelum*...To the *medium caelum* he (sc. Manilius) assigns fame, honours, and success in public life; to the *imum caelum* wealth and its sources; to the Ascendant, character, talents, and the general tenour of life; to the Occident the end of life and labours, together with marriage, social intercourse, and religion". Each of the four quadrants controls one of the four periods of life – infancy, childhood, manhood, and old age. Augustine argues that the position of the zodiac is identical for twins, since they are conceived simultaneously; but if divergence develops at birth, it can surely also develop after birth.

4 **conception at the same moment:** The argument against simultaneous conception of twins determining identical futures develops by emphasising that it is followed by staggered births. Moreover, if twins have different destinies, is it at all likely that infants born from different mothers will have identical fortunes?

5 **the allegation made by some of them:** Augustine recalls such claims as this from his earlier flirtations with astrology, revealed in his accounts of discussions with Vindiciannus and Nebridius, and subsequently with Firminus (*Conf.* 4.3.5, 7.6.8).

6 **Posidonius:** See ch. II, 1n. above. It is interesting that Posidonius laid stress on the sick twins having been not merely born but also conceived at the same time as each other; this was obviously to counter the objections which Nigidius also attempted to meet.

VI *Twins of different sexes*

1 **he serves on the staff of the military commander:** For the establishment of *comites* by Constantine, who classified them in three grades, see A.H.M. Jones, *The Later Roman Empire* (Oxford 1964), 104f. Beyond functions at court, *comites* were appointed to a variety of administrative positions. Some commanded military forces in the provinces with the title of *comites rei militaris*. When Augustine was composing the *C.D.*, there

were 31 regiments in Africa under the command of the *comes Africae* (so the Notitia Dignitatum, cited by Jones, *LRE* 196f.). The male twin serving under him will have travelled with one or more of these units to maintain public order in the province.

she never leaves her native habitat: Augustine advocated a life of poverty in communities for consecrated virgins rather than continuing to live in private residences, as was the practice of many at Milan and Rome; see Augustine's *De sancta uirginitate* (XLV) 46. The circumscribed life of the female twin suggests that she was living in such a community.

2 **no possibility of a second conception:** That is, during the period of pregnancy.

is it possible, etc.: Sentences in Augustine which begin with *An forte* often inject a note of improbability or even irony (see, e.g., Book IV, 14 and 33) such as is implied here. But the point which Augustine is concerned to make is that the male and the female twin will inevitably have different fortunes, so that *ipso facto* a mixed pair of twins negates the claim of astrologers that the same horoscope indicates a similar future.

3 **as the moon waxes and wanes,** etc.: As Tacitus, *Agricola* 10 remarks, "Many have recorded the nature of the ocean and the tides". Posidonius was the first to realise that the highest tides coincide with the full moon (cf. Strabo 3.3). Cicero, *N.D.* 2.19, reflects this learning of Posidonius, a passage which may have inspired Augustine here, for Balbus refers to the effect of the sun's approach and departure on the seasons before asking "How could the sea-tides and the confined waters in the straits be affected by the rising and setting of the moon?" Seneca, *De prouidentia* 1 continues to reflect the interest of the later Stoics in this scientific phenomenon. See J.B. Mayor's learned note in his edition of *N.D.* 2 (Cambridge 1883), 104ff. The alleged effect of the full moon on molluscs is in fact attributable to the effect of the tides, which harden and expand the shells.

VII *The choice of a day for marrying a wife, or for planting or sowing in the fields*

1 **the sage whom I mentioned:** See ch. 5.5 above. Astrologers would doubtless have rebutted this argument by claiming that the sage's horoscope governed his personal future, and not necessarily that of his children.

a day for marrying a wife: According to Manilius 2.836ff., the cardinal point which controls marriages is the Occident. The observer chooses for marriage the day when the confluence of favourable signs appears in the quadrant which links the Occident to the Imum Caelum (see ch. 5.3n.). In *The Golden Ass* of Apuleius (2.12.) there is mention of a Chaldean who advises on a day for marriage.

2 **some days as suitable for planting,** etc.: If Augustine has Virgil, *Georgics* 1.206ff. in mind, it should be noted that the advice to the farmer to choose the time for planting by observation of the constellations is scientific astronomy, not mystical astrology. "Thus can we forecast weather, though the sky/ Be doubtful, thus the time to reap or sow.../ For not in vain we watch the constellations,/ Their risings and their settings, not in vain/ The fourfold seasons of the balanced year." (1.252ff., tr. L.P. Wilkinson).

other days for taming farm-animals, etc.: It is true that Virgil later (*G.* 1.278–86), evoking Hesiod and a Hellenistic moon-calendar (see L.P. Wilkinson, *The Georgics of Virgil* (Cambridge 1969), 58), writes: "The Moon herself has appointed lucky days/ In this degree or that for various tasks" (tr. Wilkinson). Likewise Varro (*De re rustica* 1.37) recommends observation of the moon before performing various tasks, primarily with reference to planting and sowing.

3 **They even…specify the animal:** Augustine describes the practices of charlatans who exploit the credulity of their victims by prophesying the imminent births of sheep, horses, oxen, or dogs. Earlier at *Conf.* 7.6.8 Firminus acquaints Augustine with the practice of his father and a friend: "If dumb animals gave birth at their house, they recorded the moments of birth and made a note of the position of the heaven…" (tr. Chadwick). The Chaldaean Diophanes in Apuleius's tale (1n. above) is a typical example. "He was predicting futures for a circle of bystanders", and when asked by one of them to name a propitious day for a journey, he unwittingly revealed that he had himself recently suffered shipwreck with the loss of his possessions.

4 **step by step from flies to camels**, etc.: Though it is true that Stoics envisaged the stellar aether as governing the whole of the natural world including plant and animal life, few would have taken Posidonius's theories to such lengths as to present a different horoscope for every living creature. Note the qualification in the final sentence of this section ("…make human beings alone subject to the stars"). In his *Tract. in Ioann.* 1.14 (begun earlier, perhaps in 408), Augustine recounts an interchange between a Manichaean and a Catholic who was pestered by flies. The Manichaean leads the Catholic on from fly to bee to locust to lizard to bird to sheep to cow to elephant and finally to man to persuade him that God did not create man. (This was in the course of glossing the verse "All things were made by him".)

5 **through hidden prompting by evil spirits:** At *Conf.* 7.9–10, Augustine twice attributes successful predictions to chance. Presumably his reflections on the role of the demons in Roman annals in Books II–IV have led him to offer this different explanation.

VIII *Men who attach the label of fate not to the location of the stars, but to the chain of causes which issue from the will of God*

1 **Some who attach the label of fate…to the chain and sequence of all causes:** The phraseology suggests that Augustine derives this definition of the Stoic Posidonius from Cicero, *Div.* 1.125: 'Fatum autem id appello quod Graeci εἱμαρμένην, id est ordinem seriemque causarum, cum causae causa nexa rem ex se gignat'.
 what they call fate…is the will of the supreme God: See ch. 1.1n. In the present context, Augustine thinks primarily of the Stoics, as the citation from Seneca in §2 indicates.

2 **O supreme father**, etc.: The citation is from *Ep.* 107.11 of the Younger Seneca (c. 4 BC–AD 65), where the Stoic philosopher is urging Lucilius "without grumbling to accompany God, at whose prompting all things turn out". Augustine may be quoting

from memory, since the first line in the transmitted text reads: 'Duc, O parens celsique dominator poli'. Seneca indicates that the lines are a translation of lines of Cleanthes of Assos (331–232 BC), the second head of the Stoa ('quemadmodum Cleanthes noster uersibus disertissimis adloquitur'). In the original Greek as cited by Epictetus, *Enchir.* 53, the final line does not appear, and may have been added by Seneca himself; see O. Hense's edition of the *Letters*[2] (Teubner 1914), 513.

groaning and scowling follow: Literally, "I shall accompany you with groans, and I shall endure with ill grace what a good man could do".

3 **Those well-known lines of Homer:** The citation is from *Od.* 18.136f.: 'τοῖος γὰρ νόος ἐστὶν ἐπιχθονίων ἀνθρώπων/ οἷον ἐπ' ἦμαρ ἄγῃσι πατὴρ ἀνδρῶν τε θεῶν τε.' ("For the mind of men who dwell upon the earth is as the day which the father of men and gods brings on them.") Odysseus has returned unrecognised to Ithaca, where he is challenged by the arrogant Irus to a contest, and after worsting him, philosophises about the dangers of such *hubris*. The passage from *Illi quoque uersus Homerici* to *dicunt pendere fatorum* is allotted to Cicero's *De fato* as fr. 3; see Sharples, p. 56.

Such are the minds of men, etc.: Cicero's rendering is notably free, though it brings out the main point, that men's feeble faculties are dependent on the divine dispensation. But it fails to bring out the variability of men's responses which vary like the kinds of day which the gods present to them.

for they call it Jupiter: Cicero explains that for the Stoics Jupiter is the personification of nature, the predestined course of which under the impulse of the fiery *pneuma* is identified with fate; see, e.g., A.A. Long, *Hellenistic Philosophy* (London 1974), 181ff.

IX *God's foreknowledge and man's free will in opposition to Cicero's definition*

1 **unless he can do away with divination:** Cicero wrote the two books *On Divination* between February and April 44 BC, immediately before the *De fato* (composed in mid-44). In Book I Cicero's brother Quintus presents the Stoic arguments for belief in the 'artificial' and the 'natural' indications of the future, and Marcus in Book II denies their validity, while as an Academic claiming to suspend judgement about such phenomena. See the edition of A.S. Pease (2 vols. Urbana 1920–23); Paul McKendrick, *The Philosophical Works of Cicero* (London 1989), ch. 14.

Foreknowledge does not exist in man or God: So the *De fato* 32, where Cicero is citing Carneades. H. Hagendahl, *Augustine and the Latin Classics* (Göteborg 1967), 526ff., notes that Cicero and Augustine have different perspectives. Cicero is primarily concerned to oppose the determinism of the Stoics in order to vindicate the freedom of the human will, whereas Augustine attempts to defend divine foreknowledge against Cicero's denial of it.

by subjecting to his own view certain oracles: Augustine refers here especially to Cicero's criticism at *Div.* II 115–18, and perhaps also to *De fato* 32f.

2 **The fool has said**, etc.: So *Ps.* 13 (14).1 (text as in the Vulgate). The theme of the psalm is the godlessness of men.

he depicted Cotta as spokesman: In Book I of *N.D.*, the Epicurean theology is outlined

by C. Velleius, followed by a critique by C. Aurelius Cotta. In Book II, Q. Lucilius Balbus expounds the Stoic theology at greater length, and Book III is devoted to Cotta's response. Gaius Aurelius Cotta (consul 75 BC, the year after the dramatic date of the dialogue, and subsequently governor of Cisalpine Gaul) was an Academic philosopher but also a Roman *pontifex*, so that he adopts an ambivalent attitude towards the question of the existence of gods, upholding their existence as a valued aspect of tradition, but criticising the arguments of Balbus supporting belief in them. Augustine's claim that Cotta "maintained that there was no divine nature" accordingly misleads.

he preferred to pronounce judgement in favour of Lucilius Balbus: A reference to the close of the dialogue, where Cicero states: "In my eyes Balbus's case seemed to come more closely to a semblance of the truth".

in his books *On Divination*...attacking foreknowledge: In this treatise Cicero distinguishes between foreknowledge gained through the senses or through scientific reasoning, and precognition of events which happen "at random, as the result of blind chance or unstable fortune"; so II 15. He argues that it does not fall even to God to know "what will come to be by chance and at random" (II 18).

3 no fear that our acts of free will, etc.: Augustine here takes up the theme handled earlier in *De libero arbitrio*, a treatise on which he embarked in Rome in 388, and completed in Africa by 394. The treatise was primarily a continuation of his preoccupation with the source of evil, a leading theme of the *Confessions*. His conclusion was that it lies in the free will of rational man in his fallen state. The problem raised here, the possible conflict between men's free will and God's foreknowledge, is discussed in *De libero arbitrio* at III (ii) 4 – (iv) 11. For recent commentary, see Kirwan, 95ff.

by fate, not necessity: The Stoic distinction implied is that fate embraces "all things which come to pass do so through antecedent causes", (*De fato* 40); but some causes may be fortuitous and hence not necessary. The two senses of necessity accepted by Augustine are discussed in the next chapter.

4 What was it that Cicero feared in foreknowledge...? The celebrated problem of divine foreknowledge versus human free will, as interpreted by Augustine, is discussed at length by Kirwan, 99ff., and by Sharples, 25ff., who extends the scope of the discussion to include the standpoints of the Neoplatonists and of Boethius. The Ciceronian argument against divine foreknowledge is presented in this chapter in §§4–6, and Augustine's response in §§7–9. For the *De fato* as source here, see Hagendahl, 72ff.

unless...preceded by some efficient cause: For Aristotle's four causes, see *Physics* 2.3, and Sir David Ross, *Aristotle*[5], 71ff.

5 the whole of human life is undermined, etc.: Cf. *De fato* 40: "...neither praise nor blame, nor honours nor punishments, are just".

Cicero...a great and learned man: Throughout the *C.D.* (II.27, III.30, IX.5, X.8) Augustine pays tribute to the man who first inspired him to study philosophy, and thereby set him on the road to reconversion to Christianity; see *Conf.* 3.4.7.

6 "How could that be?" asks Cicero: Augustine here paraphrases the argument of Carneades, founder of the New Academy, as cited by Cicero at *De fato* 31: "If all things come to pass through antecedent causes, they all come to pass interconnectedly and

coherently by natural bonding. But if this is so, all things are the outcome of necessity, and if this is true, nothing is in our power. But there is something in our power, whereas if all things come to pass by fate, they all come to pass through antecedent causes. So all that comes to pass does not come to pass by fate". Carneades and Cicero are arguing that the Stoic position is illogical: if something is in our power, it does not result from antecedent causes.

We trace the argument back, etc.: As conclusion, Carneades (*De fato* 32) argues that "not even Apollo could declare things to come except for those whose causes lie in nature, so that they would necessarily come to pass". Augustine makes an honest attempt to represent Cicero's position, but see Kirwan, 98ff.

7　　**whatever we feel and know,** etc.: As Welldon observes, Augustine falls back on consciousness as the argument for our freedom.

we maintain that nothing happens by fate: Augustine takes for granted that certain things happen by necessity. He is implicitly contrasting the Stoic view with the notion of divine providence.

8　　**the word fate derives from the verb *fari*:** So, correctly, Varro, *L.L.* 6.52; Servius on *fata deum* at Virgil, *Aen.* 2.54: 'fata modo participium est, hoc est quae dii loquuntur'.

God has spoken once, etc.: So *Ps.* 61 (62).12, where the Vulgate reads: 'Semel locutus est deus; duo haec audiui, quia potestas dei est, et tibi, domine, misericordia, quia tu reddes unicuique iuxta opera sua'. Thus the concept of *fatum* is acceptable if interpreted as God's word, but not as the Stoics employ it, as equivalent to the Greek *heimarmene*.

9　　**our wills…contained in the sequence of causes:** Thus Augustine's response to Cicero's rejection of divine foreknowledge is that man's free will is preordained by God, so that its existence is not inconsistent with God's foreknowledge. Kirwan, 191, regards this position as preferable to that taken in *De libero arbitrio* III (iii) 6ff., but still open to objections.

10　　**the principle which Cicero grants:** See *De fato* 34: '…nihil posse euenire nisi causa antecedente'.

not every cause is predestined: The view expressed by Cicero that 'natural' and 'voluntary' processes (*De fato* 24f.), and likewise 'fortuitous' ones (*De fato* 28) have no antecedent causes, is thus rebutted; for Augustine, all events are attributable to the antecedent causes of the will of God or the wills of created creatures.

the source from which Fortune obtained her name: Both Fortuna and *fortuitus* are derived from *fors*.

voluntary causes lie with…the various animals: Augustine argues that natural instinct bestowed by God is the antecedent cause of the actions of animals. When he speaks of such instinct schooling animals on what to seek and what to avoid, he is echoing Aristotle's *De anima*; see Sir David Ross, *Aristotle*[5], 131.

and also call demons: For the identification of the fallen angels with the demons of Middle Platonism, see *C.D.* 8.22, 9.22, 10.16, 11.33, etc.

11　　**The spirit of life:** Augustine here turns from the arguments of secular philosophy to the theology of holy scripture, and in particular to the gospel of John. See 6.64: 'Spiritus est qui uiuificat. Verba quae ego (sc. Iesus) locutus sum uobis spiritus et uita est'. Also

3.6–8: 'Quod natum est, ex Spiritu spiritus est;…sic est omnis qui natus est ex Spiritu'.
His will embraces the supreme power, etc.: See the psalm-citation in §8 above.

because they are opposed to nature, which is from him: Augustine emerged from earlier encounters with the Manichees (see, e.g., *De moribus Manichaeorum* 2.2) with the conviction founded on scripture (*Gen.* 1.12, 20, etc.) that nature is good. So at *De libero arbitrio* III 41 he states: "Nature is perfect. Not only is it free from blame, but in its own order it deserves praise".

12 **subject rather to wills:** For the will as efficient cause, see the extended note by F.J. Thonnard in Bardy, 824–7.

13 **the word fate, which is usually not understood**, etc.: See the note on *The word fate…* at §8 above.

by assuming the character of someone else: See the n. on Cotta at §2 above.

the fool said in his heart, etc.: See the citation from *Ps.* 13 at §2 above.

X *Does some necessity control human wills?*

1 **the necessity which the Stoics feared:** For the Stoics' attempt to wrestle with the concept of necessity, see the texts and commentary in Long–Sedley, I 230ff. Augustine is here concerned more broadly with their attempt to reconcile the doctrine of fate with their emphasis on human responsibility, and in particular to counter the 'Lazy Argument' (if all is fated, all human effort is futile). See Long–Sedley, I 333ff., esp. 343.

the term necessity…used to describe what is not in our power: The example of death posited here suggests that Augustine thinks of 'natural' necessity, which he reasonably argues does not threaten the existence of the human will; the question of its freedom he is to discuss next.

2 **necessity…as what…is necessary for something to be what it is, or to become what it becomes:** The source of this definition is *De fato* 13, where Cicero presents a dispute between the Stoic Chrysippus and the leader of the Dialectical School Diodorus (died c. 284 BC), who argues that whatever will be is necessary, and whatever will not be is impossible.

we do not subject God's life and God's foreknowledge to necessity: It is unlikely that Augustine's philosophical opponents, Stoics or Neoplatonists, would have challenged this statement, though God's lacking liability to death or deceit could constrict "the manner in which things can be or happen" (Kirwan, 92).

it is necessary…to use our free will when we wish to do so: The argument is dependent on the earlier claim at 9.7 above.

3 **not of that other, but of him who willed:** that is, not the will of the weaker party, which will be overridden.

to the will of him who bestows power: that is, to the will of God, who permits the individual's will to be subjected to another's.

4 **our lives are flawed if our belief in God is flawed:** Augustine doubtless refers the aphorism to the Manichees at a personal level, and at a communal level to pagan Rome and its theology as outlined in the earlier books of the *C.D.*

5 **So laws, rebukes**, etc.: Augustine echoes Cicero's refutation of the 'Lazy Argument' (see *De fato* 40), that "neither compliance nor action is in our power, and it follows from this that neither praise nor blame nor honours nor punishments are just". See Hagendahl, 74.
Man does not fall into sin, etc.: The logic of the argument demands the excision of *non* from the transmitted text.

XI *The universal providence of God, by whose laws all things are contained*

1 **the supreme true God, together with his Word and the holy Spirit:** It is useful to recall that Augustine finally completed the fifteen books of *De Trinitate* in 414–5, about the time this book was composed, though he had commenced it fifteen years earlier; see *Ep*. 174: 'De Trinitate libros iuuenis inchoaui, senex edidi'. The first seven books survey the evidence for the Trinity in scripture, and the other eight offer speculative thoughts on the doctrine. His own summary of the work, book by book, is at XV 3.5.
Three in one: Cf. *1 John* 5.7: 'Tres sunt qui testimonium dant in caelo, Pater, Verbum, et Spiritus sanctus; et hi tres unum sunt'. See also *John* 19.30: 'Ego et Pater unum sumus'.
through their sharing in him: The use of the word *participatio* reflects the debt to the Platonist concept, according to which earthly things 'participate' in the realm of the Ideas. For Augustine, every created thing has a twofold existence, the one in itself, and the other in the divine Ideas. So each soul has its own form in God. At *Trin*. XV 3.5 he writes: "In the fourteenth book I discussed the true wisdom of man, namely the wisdom given by gift of God, in the *partaking* of God himself". Cf. *De libero arbitrio* 2 45; *De uero religione* 15.113.
existence shared with stones, etc.: Discussion of the four levels of existence, the inanimate (stones), the nutritive (plants), the sensitive (lower animals), and the intellectual (humans), together with the unity of soul and body, derives from Aristotle's *De anima*. See Sir David Ross, *Aristotle⁵*, ch. V.

2 **From him comes every mode of being:** Cf. *Wisd*. 11.21. This rhetorical close to the first main section of Book V (chs. 1–11) echoes the exordium of Augustine's *De natura boni*, composed in 404 AD as the culminating attack on the Manichees. The emphasis on the goodness of the ordered creation has particular significance in that context.
mind, understanding, and will: At *Trin*. X 11. 17f., Augustine visualises memory, understanding, and will as an image of the Trinity, memory being a vital function of mind. They are in the mind in mutual relationship with each other, with memory bearing a likeness to the Father, understanding to the Son, and will to the holy Spirit (*Trin*. XV 23.43, 20.38). The three are one ('One life, one mind', *Trin*. X 11.17). See further Bardy, 828: 'Les vestiges de la Trinité'.
So it is impossible to believe, etc.: Augustine exploits the theme of God's universal providence in nature to bridge the first part of the book (chs. 1–11) with the second (chs. 12–20).

XII *The deserving manners of the Romans of old, which induced the true God to extend their empire, even though they did not worship him*

1 **I composed the previous book:** Book IV has as its general theme the theology of pagan Rome, subdivided into three topics: the deities to which Romans ascribe the growth and prosperity of empire (chs. 8–13), the prominence of abstract deities (chs. 14–26) and the attitudes of Roman intellectuals towards their gods (chs. 27–32). The claim that the gods were powerless in the extension of empire is at ch. 28.

2 **"they were eager…":** A direct citation from Sallust, *Cat.* 7.6: Sallust, together with Cicero's *De republica* and Livy, has been a main source for the historical survey in the previous books.

 the most burning ambition for glory: As Cicero defines it, *gloria* is "praise given to right actions, and the reputation for great merits in the service of the state" (*Phil.* 1.29). For Cicero and Livy the qualification 'in the service of the state' is paramount; by contrast with the concern of the Homeric hero for personal glory, they stress that it is sought as patriotic duty. See further D.C. Earl, *The Moral and Political Tradition of Rome* (London 1967), 30, 74ff.

3 **"They appointed over themselves…":** This is a further citation from Sallust's *Catiline* (6.7). See also Livy's emphasis on the significance of 'annuos magistratus imperiaque legum potentiora quam hominum' (II 1, with Ogilvie's *Commentary*, 233f.).

 consuls, a word derived from taking counsel: The etymology is disputed. Augustine follows the authority of Cicero, *Leg.* 3.8; Varro, *L.L.* 5.80.

4 **when king Tarquin had been driven out:** Already in Book III Augustine has provided a potted history of early Rome, with details of the first year of Roman liberty in 509 BC (III 16). But there he was reviewing the difficulties which dogged Rome, whereas here he interprets the history in a more positive light.

 "It is astonishing to relate…": So Sallust, *Cat.* 7.3.

5 **Sallust also praises…M. Cato and C. Caesar:** What follows is a faithful version of Sallust (*Cat.* 53), who like Augustine is preoccupied with the qualities which achieved such outstanding exploits (*Cat.* 53.2). When Sallust remarks that the credit was attributable to "the outstanding virtues of a few citizens" (53.4), he is harking back to the era between the Second Punic War and the fall of Carthage, dominated initially by Scipio Africanus the Elder, and later by Cato the Censor and Scipio Aemilianus.

 Bellona…with her bloodstained whip: Evoking Virgil, *Aen.* 8.703, 'cum sanguineo sequitur Bellona flagello'.

6 **that notable poet of theirs:** At *Aen.* 8.648ff., Virgil describes how Venus bestows on her son Aeneas a shield, on which eight scenes are portrayed which depict the crises in Italy which fostered the growth of Rome. The Etruscan Porsenna's demand that the Romans reinstate Tarquinius Superbus as king is answered by the defiant heroism of Horatius Cocles and Cloelia, defenders of Roman liberty.

 to die bravely: The later reading *emori* for *mori* is justified by the artistic balance of syllables, characteristic of Augustine's style, between *fortiter emori* and *liberos uiuere*; compare at §9 below *rapiendo miseris ciuibus/ largiendo scaenicis turpibus.*

7 **what that same poet put in the mouth of Jupiter:** The citation is from *Aen.* I 279–85, a passage in which Jupiter is consoling Venus, as she laments the trials of the Trojans, with the promise of a brighter future. Juno abandons her enmity at XII 841. "The fated age" is to come when Greece becomes the Roman province of Achaia, formally constituted by Augustus in 27 BC.

 Assaracus's house...the Phthians...Mycenae...Argos: Assaracus was the grandfather of Anchises, and thus his 'house', the future Romans, will become lords of Phthia (Achilles' birthplace in Thessaly; the correct form is Pthia), Mycenae (Agamemnon's city), and Argos (home of Diomedes). See Austin on *Aen.* I, ad loc.

8 **Virgil...was...witnessing them as present:** The poet was composing these lines about 27–25 BC; Augustus's formal institution of Achaia in 27 BC was preceded by Julius Caesar's temporary establishment of the province in 46 BC.

 Others, I grant...: This citation of *Aen.* 6.847–53 forms the epilogue to Anchises' prophecy of the future of Rome, addressed to Aeneas in Hades. In the second line, the transmitted reading *credo* is generally preferred to the early variant *cedo*; in the penultimate line *pacique* is the attested reading, and the conjecture *pacisque* has no manuscript authority.

9 **as they devoted themselves less to pleasure**, etc.: Augustine has already discussed at length the theme of Roman moral decline which set in after the fall of Carthage, leading to the political anarchy of the first century BC, in I 30–33, and thereafter in Book II; his censure of the stage-shows at I 28 is repeatedly renewed in the ensuing books.

10 **by those means:** With reference to the techniques of ruling motivated by desire for honour and glory.

 Sallust further states: The citation is from *Cat.* 11.1–2. In this key passage of Sallust's moral interpretation, the *bonae artes* are the principles of conduct in military and political life spelled out in detail by Livy. For these subdivisions, see my *Livy*, 66ff.

11 **shrines dedicated to...Virtue and Honour:** These temples were dedicated to deities 'personifying military courage and its reward' (so *OCD*³, s.v. 'Honos and Virtus'), and not, as Augustine implies, *uirtus* in the wider moral sense. One shrine, outside the Porta Capena, commemorated the victory of Claudius Marcellus at Clastidium, and was dedicated in 205 BC (Cicero, *N.D.* 2.61; Livy 29.11.13). For the reason for separate *cellae* adjoining each other, see Livy 27.25.7. A second shrine dedicated to both deities was established by C. Marius following his victories against the Cimbri and Teutones; for these and other honours paid jointly to these deities, see Latte, 235f.

 These gifts of God they regarded as gods: Augustine devotes a brief chapter to this topic at IV 34.

12 **"The less he sought glory...":** So *Cat.* 54.6, where the transmitted reading is *magis illum* rather than *illum magis*.

 "For our glory...": So *2 Cor.* 1.12 (Latin as in the Vulgate).

 "Each man must approve his own work...": *Gal.* 6.4, where the Vulgate has *et sic in* for Augustine's *et tunc in*.

 glory and high office and military command: Augustine quotes Sallust's own words; see §10 above.

that good of men which has no better: Namely, virtue.

13 **Cato's judgement:** At *Cat.* 51–2, Sallust records the speeches of Caesar and Cato in the senatorial debate which was to decide the fate of the conspirators. Cato, who recommended execution after Caesar had proposed the milder penalty of imprisonment and confiscation of goods, is allotted a speech in which this indictment of contemporary manners (52, 19–23) is incorporated. The text is as transmitted, except that Augustine has *armorum et equorum* for *armorum atque equorum*, and *fecerunt* for *fecere*.

just dominion abroad: Compare the criticisms of Roman policy by Cicero, *Off.* 3.87f.

14 **(or of Sallust):** Augustine recognises that the historian has not reproduced Cato's speech verbatim, but has moulded the content into his own rhetorical shape.

I quoted in Book Two: See II 18.7 and my n. there. There is a contradiction in Sallust's own views between the prologues of the *Catiline* and the *Jugurtha*, in which Sallust claims that there was unbroken concord in Rome's earlier history, and the *Histories* 1.11M., from which this extended quotation is taken.

as long as fear of Tarquin prevailed: After the expulsion of the Tarquins which Livy dates to 509 BC, Tarquinius Superbus attempted to regain the throne with the assistance of the king of Clusium, Lars Porsenna. According to Livy 2.9–15, Porsenna was finally induced to abandon the siege of Rome, whereas Tacitus, *Hist.* 3.72, indicates that Rome fell. See Ogilvie, 255.

the outbreak of the Second Punic War: That is, in 219–18 BC, following the storming of Saguntum, Rome's ally.

15 **As that same historian remarks:** What follows is a close paraphrase of *Cat.* 53.2–5, except that Augustine omits from §3 'ad hoc saepe fortunae uiolentiam tolerauisse; facundia Graecos, gloria belli Gallos ante Romanos fuisse'.

supported with its size: Augustine has *sui* where the transmitted text has *sua*.

16 **which Cato recounted:** See §13 above, 'domi industria'.

XIII *Love of praise is admittedly a vice, but is considered a virtue because it is the means by which greater vices are restrained*

1 **famed kingdoms in the East:** Already at IV 6f. Augustine has reviewed the history of the Assyrian empire, and has added brief mention of the empires of the Medes, the Persians, and Macedonia. See the nn. there.

2 **Horace...declares:** Apart from these citations here, Horace is quoted only at *C.D.* I 3, a brief allusion to *Ep.* 1.2.89f. The first extract here is from *Ep.* 1.1.36f. In this epistle, Horace states that he is abandoning lyric poetry for study of philosophy and the nature of virtue. The couplet here exploits the language of religion to praise philosophy. We must seek expiation for our love of praise; we must read with pure hearts (*pure*) three times (*ter*). Both words have ceremonial connotations (see Tibullus 2.1.13f.; Juvenal 6.522). The *libellus* is probably a collection of Stoic maxims; so J.F. D'Alton, *Horace and his Age* (N.Y. 1962), 136.

You would rule more widely, etc.: This stanza in the Sapphic metre is from *Odes* 2.2.9–12, a poem in praise of the generous patron C. Sallustius Crispus. But the ode is

not written "to curb the lust for dominion", but as a warning against self-indulgence, and as the recommendation of virtue rather than love of money (see D.A. West, *Horace, Odes II* (Oxford 1998), 14ff.; R.G.M. Nisbet–M. Hubbard, *A Commentary on Horace, Odes II* (Oxford 1978), 32ff.). The phrase *latius regnes* is addressed not to Sallustius personally but to the world at large. "Both Punic empires" refers to Carthaginian dominion between the First and Second Punic Wars, when Carthage after losing control of Sicily to Rome colonised southern Spain, where Gades (Cadiz) had been a Phoenician trading-post since the eighth century.

3 **the love of intelligible beauty:** Augustine adapts the concept from Plotinus, for whom "the soul reaches its proper level in intellect by a vigorous combination of intellectual and moral effort and training, helped...by the contemplation of visible beauty", through "our recollection of intelligible beauty as always needing to be quickened again" (A.H. Armstrong, *The Cambridge History of Later Greek and Early Medieval Philosophy* (1970), 259). Augustine adapts the concept to distinguish between enjoyment and use. "The sole object proper for man's enjoyment is 'intelligible beauty, which we call spiritual'; everything else is for use only, to be referred ultimately to this." (R.A. Markus, *Ibid.* 390, citing Augustine, *De diu, qu.* 83.30 (*PL* 40.19f.) and *De lib, arb.* (1.15.33).

 Cicero...On the Republic: This passage (*Rep.* 5.7.9) has been restored from Peter of Poitiers (cited in K. Ziegler's edn. (Leipzig 1958), 119: 'principes ciuitatis gloria esse alendum, et tam diu stare rem publicam quam diu ab omnibus honor principi exhibetur'. The further quotation here ('in glossing this...') is preserved only in this passage of Augustine.

4 **"Honour nurtures the arts...":** So *Tusc.* 1.4, reading *incenduntur* rather than *accenduntur*. The initial phrase echoes an early poet; cf. Seneca, *Ep.* 102.16: '... antiquuus poeta ait: Laus alit artes'. See also Plato, *Rep.* 551a. Cicero's discussion of such recognition of the arts leads into his discussion of philosophy, traditionally neglected ('*iacuit*') at Rome through lack of esteem.

XIV *The need to curtail love of human praise, for all the glory of just men belongs to God*

1 **How can you have belief...:** So *John* 5.44; the Vulgate has 'Quomodo uos potestis credere, qui gloriam ab inuicem accipitis, et gloriam quae a solo deo est non quaeritis?' The minor variations in Augustine suggest that he is citing from memory, since he regularly uses Jerome's version of the gospels.

 They loved the glory...: So *John* 12.43, where the Vulgate has 'dilexerunt enim gloriam hominum magis quam gloriam dei'.

2 **Cicero's words:** The repetition of the passage from *Tusculans* cited at ch. XIII.4 emphasises the disapproval experienced by the martyrs in proclaiming the Christian faith.

 also the physician: For the image of Christ as physician, much favoured by Augustine, see H. Arbesmann, 'The Concept of Christus medicus in St Augustine', *Traditio* 12 (1954), 1ff.

 "If anyone denies me...": Augustine appends Luke's version (12.9: '...negabitur coram angelis dei') to that of *Matthew* 10.33.

Hounded by curses and reproaches: For the nostalgia with which Augustine views the age of the martyrs, and the urgency with which he and Christian contemporaries sought to renew their commitment in their persecution-free lives, see R.A. Markus, *The End of Ancient Christianity* (Cambridge 1990), chs. 6–7.

3 **"Beware of practising your justice…":** So *Matt*. 6.1 (Vulgate: 'Attendite ne iustitiam uestram…').

"Let your works so shine…": *Matt*. 5.16 (Vulgate: 'Sic luceat lux uestra coram hominibus ut uideant opera uestra bona, et glorificent…').

So your aim…as you are: These words are added as if spoken by Christ to the apostles; hence *hos* at the beginning of §4.

4 **men like Scaevola, Curtius, and the Decii:** These exemplars of *uirtus Romana* in early Roman history have already appeared together at IV 20.2, and their roles are described with those of other heroes at ch. 18 below. See the nn. there.

uirtus which was true: It is preferable to retain the Latin word here, for *uirtus* bears a double sense. On the one hand, the Roman heroes showed courage, but their virtue was defective because not directed towards the Christian god.

XV *The transient reward which God bestowed on Romans for their noble manners*

1 **which the Greeks call *latreia*:** It seems probable that Augustine's acquaintance with the Greek word derives from his knowledge of the Greek New Testament, where it is found e.g., at *Rom*. 9.4 and *Hebr*. 9.1, in description of Jewish worship. In Classical Greek the first meaning of the word is menial service by a hired labourer, but as early as Plato it bears the secondary sense of service to God or gods; cf. *Apol*. 23c, *Phaedr*. 244e.

"Amen, I say to you…": So *Matt*. 6.2 (The Vulgate has *receperunt*).

2 **in literary and historical writing:** The distinction is between poetry, rhetoric and philosophy on the one hand, and historiography on the other. Augustine thinks especially of the continuing eminence of the Classical masters, but also of the secular writing of his own day; see R. Hertzog & P.L. Schmidt (edd.), *Handbuch der lat. Lit. der Antike V* (Munich 1989), chs. VII ('Historiographie') and IX ('Poesie').

XVI *The reward gained by the holy citizens of the eternal city. The virtues of the Romans are useful to them as examples.*

1 **Even here:** The use of *etiam* suggests that Augustine refers to the contemporary African situation, in contrast to the era of the martyrs.

no goddess: Felicity as goddess has loomed large In Book IV; see chs. 18, 21, 23; for 'the gift of God', IV 24.

The sun does not shine on good and bad alike: Cf. *Matt*. 5.45: '…ut sitis patris filii qui in caelis est, qui solem suum oriri facit super bonos et malos, et pluit super iustos et iniustos'. At *C.D.* I 8 Augustine exploits this text to explain why the wicked and ungrateful were spared in the sack of Rome; see also III 9.

the Sun of justice: There was biblical justification for Christ as *sol iustitiae* at *Mal.* 4.2, 'ut oriatur uobis timentibus nomen meum sol iustitiae'; and the prophecy of Zekariah (*Luke* 1.78) proclaims that "the dawn from on high will break upon us". But even without this biblical warrant, it was inevitable that Christians would claim for Christ the role of Helios/Sol, so dominant in pagan thought up to and including Plotinus. Ambrose in his *Exameron* (4.1.2) writes: "When you see the sun, think of the Lord…If the sun shines so beneficently, how lovely must Christ, the Sun of righteousness (*sol iustitiae*), be!" In his celebrated hymn, *Splendor paternae gloriae* (see J. Fontaine (ed.), *Ambroise de Milan, Hymnes* (Paris 1992), 129), Ambrose writes: 'Verusque sol, illabere/ micans nitore perpeti'. Cf. H. Rahner, *Greek Myths and Christian Mystery* (London 1962), ch. IV.

XVII *The profit gained by the Romans from waging war, and the great benefit which they bestowed on those whom they conquered*

1 **what does it matter under whose dominion a man lives?:** This is "one of the few chapters where elements of a political theory are adumbrated" (O'Daly, 98), but it should not be read as his indifference to tyranny, oppressive oligarchy, or mob-rule; see his earlier declaration at IV 3f. Rather, he is putting the case for the benefits of Roman rule vis-à-vis local autonomy. Even so, at IV 15 he argues for the opposite in an ideal world.
 without the presence of Mars and Bellona…no role for…Victory: Augustine repeatedly condemns aggressive imperialism; see especially III 14, IV 14f.

2 **and would have become Roman citizens:** This did not occur until the emperor Caracalla, by the edict known as the Antonine Constitutions, awarded the citizenship to all free persons in the empire, probably in AD 212. See Ulpian, *Dig.* 1.5.17. According to Dio Cassius (78.9), his motive was to increase the number liable to pay taxation; hence perhaps Augustine's "extorted from conquered races".
 they would have lived at public expense: Augustine refers to the urban poor, who were traditionally provided with a regular ration of corn, later substituted by bread. It was augmented under Septimius Severus with olive-oil, and under Aurelian with pork and cheap wine (see Jones, *LRE*, 696–705). By Augustine's day the Church was taking an increasingly prominent part in alleviating the plight of the poor; see Ambrose, *De officiis* 2.71f. with the nn. of I. Davidson (Oxford 2000) and Homes Dudden, 117ff. For a magisterial survey of class divisions in the later empire, see Joseph Vogt, *The Decline of Rome* (London 1967), esp. 194ff.

3 **learning…forbidden to others:** Augustine speaks out of his own experience as pupil and teacher in Africa and Italy; see *Conf.* 1.17.27; 3.3.5ff.; 4.2.2; 5.9.14ff.
 numerous senators in lands outside Italy: Under Diocletian the senate had remained a select body of about 600, predominantly domiciled in Italy, but under Constantine the order was rapidly expanded. Consular rank (and thereby senatorial status) was conferred not only on provincial and diocesan governors, but also on decurions (city-councillors) who held the high-priesthood of their provinces. Many of these never set foot in Italy. See Jones, *LRE* 525ff.

"smoke has no weight": Evoking Persius 5.19f.: "I don't aim to make my pages turgid with trifles, fit only to give weight to smoke (*dare pondus idonea fumo*)".

5 **the remission of sins**, etc.: Entry to heaven is possible only when cleansed of sin by baptism or by penance, 'a second baptism'. See O.D. Watkins, *A History of Penance* (London 1920). Augustine will have been familiar with earlier discussions on Penance from Tertullian's *De paenitentia* (tr. P. Le Saint, *ACW* vol. 28) to his mentor Ambrose's *De paenitentia*, with its schematic division between Confession, Contrition, and Satisfaction (see Homes Dudden, 624ff.). The treatise *De uera et falsa paenitentia* earlier ascribed to Augustine (text in *PL* 40) appears not to have been his, but his *Serm.* 351 (*PL* 39.1537ff.) subtitled *De utilitate agendae paenitentiae*, is devoted to the historical development of Penance; cf. also *Serm.* 352.

foreshadowed by...the asylum of Romulus: According to the tradition, Romulus sought to augment the population of infant Rome by offering refuge to individuals from neighbouring peoples. The asylum was situated between the two peaks of the Capitoline hill. See Livy 1.8.5ff., with the *Commentary* of Ogilvie, 62f. Augustine had earlier (*C.D.* I 38) exploited the tradition to claim that the asylum foreshadowed the refuges which the Goths allocated to shelter Roman citizens when the city was overrun in AD 410.

an amnesty for crimes of all kinds: They are detailed in Plutarch, *Romulus* 9 as acts of runaway slaves, debtors, and murderers. Livy's phrase, 'obscuram et humilem multitudinem', delicately alludes to these.

XVIII *Christians should regard boasting as repugnant, if they have done anything out of love for their eternal fatherland, since the Romans performed such great exploits for human glory and for their earthly city*

1 **since Brutus steeled himself**, etc.: Augustine has already recounted this incident, citing the identical lines of Virgil, at III 16, where he records the trials and injustices of Rome's first year of freedom. The conspiracy to restore Tarquin to the Roman throne involved the Vitellii, brothers of the wife of the consul L. Iunius Brutus, and Titus and Tiberius, Brutus's own sons. Their execution is affectingly described by Livy at 2.5.6ff.; for other accounts, see Ogilvie, *ad loc.*

2 **even the poet who praises him**: The Virgilian lines that follow are part of the prophecy of Rome's future history revealed by Anchises to Aeneas in Hades (*Aen.* 6.820ff.).

3 **counting Christ's poor among our sons**: See ch. 17.3n. above (*They would have lived*, etc.) for the developing role of the Church in alleviating the plight of the poor.

4 **Torquatus, who executed his son**: Augustine has already cited this example of *disciplina Romana* at I 23, where he contrasts the attitude of Torquatus towards his son with that of the younger Cato after Utica. T. Manlius Torquatus (consul 347, 344, 340) had refused his son permission to emulate him by fighting a duel with a foe. When his son disobeyed, the father ordered his execution despite the glorious victory which was won (Livy 8.6.7ff.).

5 **Furius Camillus**: Camillus has already figured prominently in earlier books of the *C.D.* (II 17, III 17, IV 7). Marcus Furius Camillus captured and destroyed Etruscan Veii in

396 BC (Livy 5.1ff.), but then retired into exile when unjustly arraigned for peculation. The tradition claims improbably that he was recalled from exile to liberate Rome from the Gallic invasion of 390 BC (see Livy 5.43.6ff. with Ogilvie's n., and my note at *C.D.* II 17.8–9).

without seceding to the Church's heretical foes or himself initiating some heresy: Bardy speculates that Augustine may be thinking of Origen here (he was deprived of the headship of the Catechetical school at Alexandria and deposed from the priesthood by bishop Demetrius). Welldon suggests that 'the heretical foes' may be Tertullian, Valentinian, and Novatian among others. More probably, however, Augustine alludes to more contemporary struggles with the Donatists in Africa (see Frend, *The Donatist Church*, chs. XIV–XV) and with the Arians Italy (Homes Dudden, ch. VII).

6 **Mucius:** See the n. at ch. 16.4 above. C. Mucius Scaevola was apprehended in the Etruscan camp when attempting to assassinate Lars Porsenna, who sought to restore Tarquinius Superbus to the Roman throne in 508 BC. Augustine recounts the details from Livy's memorable account at 2.12. The young man's courage in deliberately maiming his right hand is alleged to be the explanation of his cognomen Scaevola ('Lefty'). See the learned n. of Ogilvie, *ad loc.*

his whole body to the flames: Perhaps with reference to the martyrdom of the deacon Lawrence, allegedly roasted on a gridiron in the reign of Valerian, and subsequently famed in the hymns of Ambrose (*Hymn* 13; ed. Fontaine, 549ff.) and Prudentius, *Peristeph.* 2. His martyrdom is cited by Augustine at *Serm.* 204–5 (*PL* 39, 21.66–7).

7 **Think of Curtius also:** This exemplar of Roman courage is linked with Mucius Scaevola (and the Decii) earlier at IV 20, where Augustine wonders why *fortitudo* never became a goddess. Livy (7.6) describes how in 362 BC an earthquake left a deep chasm in the Roman forum, which resisted all efforts at filling in. Seers enjoined that a solemn dedication of that 'quo plurimum populus Romanus posset' should take place. M. Curtius, 'a youth outstanding in war', interpreted this as 'arma uirtusque', and devoted himself to the gods below by riding in full armour into the chasm.

has died when despatched: Augustine extends the comparisons between *uirtus Romana* and *uirtus Christiana*, but this and the previous example bear little relevance to his own day. He looks back nostalgically to the era of a century earlier, when such trials provided the acid test of Christian commitment. See Markus, ch. VII.

Fear not those who kill the body, etc.: So *Matt.* 10.28; Vulgate has *qui occidunt corpus.*

8 **the Decii:** See earlier, IV 20, V 14. P. Decius Mus (consul 340 BC) during warfare against the Latins in Campania in 340 BC, solemnly dedicated his own life to secure the safety of his army. The formal prayer of *deuotio*, by which he offered himself and the enemy to the deities below, is recorded by Livy at 8.9.6. His son, likewise P. Decius Mus (consul 312, 308, 297, 295), emulated this *deuotio* of his father at the battle of Sentinum in Umbria against the Samnites in 295 BC. That engagement assured Rome of the hegemony of Italy. See Livy 10.28.12ff.

as they have been commanded to do: so *Matt.* 5.44, *Rom.* 12.20, etc.

9 **Marcus Pulvillus:** According to Livy's account (2.8.4) M. Horatius Pulvillus was appointed suffect consul in 509. He and his fellow-consul Valerius Publicola drew

lots to decide who would dedicate the temple. The lot fell on Horatius, whereupon Valerius's kinsmen devised this stratagem to enable Valerius to conduct the dedication. Augustine's version, that on being told of his son's death Horatius "ordered the corpse to be cast out unburied" reflects the tradition recorded by Plutarch, *Publicola* 14, where the consul says: "Throw the corpse where you wish. I cannot grieve for him". Livy more delicately states that he ordered the corpse to be carried out for burial (*efferri*, 2.8.8).

the temple to Jupiter, Juno, and Minerva: Livy merely calls it 'Iouis aedes', but Augustine has already indicated (IV 10) that the Capitoline temple was dedicated to the triad, so that he could have appended the detail to the Livian account.

a man…is told by the Lord, Follow me…: See *Matt.* 8.22 (the Vulgate has *dimitte*, not *sine*). Though Matthew does not say so, Augustine assumes that the disciple obeyed, leaving others to bury his father.

10 **Marcus Regulus:** Like Cicero, Horace, and the unanimous Roman tradition, Augustine accepts Regulus as the epitome of integrity. He devotes two chapters to his heroism at I.15 and 24, and makes favourable mention of him also at II 23, III 18, III 20. M. Atilius Regulus (consul 267, 256 BC), as commander of the army which invaded Africa in the First Punic War, captured Tunis, but in 255 was defeated and captured. The legend of his return to Rome to negotiate exchange of prisoners, and of his return to Carthage after dissuading the Roman senate from agreeing to the proposal, was immortalised by Cicero, *Off.* 1.25, 3.100, Horace *Odes* 3.5, and others; Eutropius 2.24 is probably Augustine's source. This authorised version is viewed sceptically by most modern scholars; see, e.g., F.W. Walbank, *Comm. on Polybius* I.93f.

What return shall be made to the Lord, etc.: So *Ps.* 115 (116).12. The Vulgate has 'Quid retribuam domino pro omnibus quae retribuit mihi?'

11 **to travel lightly on the pilgrimage of this life:** Juvenal 10.19–22 may be in Augustine's mind here.

Lucius Valerius: Augustine nods here. The Valerius in question is P. Valerius Publicola (see §9n., s.v. 'Marcus Pulvillus'), according to Livy 2.16.2 consul for the fourth time in 504 BC. At 2.16.7 Livy writes of him: 'copiis familiaribus adeo exiguis funeri sumptus deesset; de publico est datus'. Augustine may be citing Eutropius 1.11.4 here, since Livy states that Valerius died in the year after his fourth consulship.

Quinctius Cincinnatus: L. Quinctius Cincinnatus provided Livy with a notable opportunity to hymn the merits of *frugalitas* as a traditional Roman virtue. He describes how in 458 BC he was cultivating his four acres across the Tiber when he was summoned to assume the dictatorship and to rescue the Roman army trapped by the Aequi on Mt Algidus (3.26.7ff.). For the varying dates to which the exploit is ascribed, see Ogilvie, *Comm.* 417, 436.

12 **Fabricius:** C. Fabricius Luscinus (consul 282, 278 BC) was regarded by Romans as the epitome of integrity and frugality. Cicero at *Off.* 1.38 cites an extract from Ennius's *Annales* (frr. 186–93 Warmington; cf. O. Skutsch, *The Annals of Quintus Ennius* (Oxford 1985), 347ff.) which records the meeting with Pyrrhus after Heraclea (280 BC) or Asculum (279). Plutarch, *Pyrrhus* 20, provides a lengthy account of the relations between the two men. Augustine's source here is probably Eutropius 2.12: 'Fabricium (sc. Pyrrhus) sic

admiratus est ut, cum pauperem esse cognouisset, quarta parte regni promissa, sollicitare uoluerit ut ad se transiret; contemptusque a Fabricio est'. The ultimate source is Livy's lost book 12. For Fabricius as censor in 275 BC, see the next n.

one of them...twice consul, was expelled...by the censors' stigma: This was P. Cornelius Rufinus (consul 280, 277 BC). In 275 he was struck off the senatorial roll by Fabricius; see Valerius Maximus 2.9.4; Gellius 4.8. Livy may have been Augustine's source; see *Periocha* 14: 'Fabricius censor P. Cornelium Rufinum consularem senatu mouit, quod is decem pondo argenti facti haberet'.

the higher mode of life: That is, the monastic life which Augustine recommends so earnestly in *De sancta uirginitate* (see my edition with *De bono coniugali*, Oxford 2001).

the recommendation in the Acts of the Apostles: See *Acts* 2.44, 4.34f.

they must not boast: In *De sancta uirginitate* XXXff. the need for Christian humility is emphasised.

13	**if the Roman Empire had not extended:** Augustine thus offers his rationale of why God in his providence permitted the growth of the Roman Empire: it was to disseminate more widely the Roman virtues which Christians must emulate, but in a spirit of humility rather than arrogance.

as the Apostle states: See *Rom.* 8.18 (Vulgate has *non sunt condignae...*). The danger of pride which Augustine deprecates earlier (§12n., *they must not boast*) here relates to the indignities suffered by Christians at the hands of pagan opponents.

14	**the Jews...the means of further glory:** For Rome's subjugation of Judaea from AD 64 onward, culminating in the destruction of the temple at Jerusalem by Titus, see M. Goodman, *CAH X*[2], ch. 14d, esp. 757ff.

the New Testament unfolds what was concealed in the Old: Cf. *C.D.* XVI 26 "What is that which we call the New Testament other than the revelation of the Old?" At IV 23 Augustine suggests that the earthly blessings conferred in the O.T. are symbolic of the future joys in the eternal city as depicted in the New Testament. Paul's vision of heaven in *Romans* 8, from which he quotes a verse in §13, is doubtless in Augustine's mind.

XIX *How desire for glory differs from desire for dominion*

1	**desire for glory...and the desire for dominion:** Augustine reverts here to the topic already broached in ch. 12, where he cites Sallust's contrast between the principled Romans of old, who sought glory by deeds of virtue, and the new breed who sought power by treachery and deceit. Cicero's discussions are also in the forefront of his mind. Cicero's two books *On Glory* are lost, but there is a summary discussion in *Off.* 2.30–51 on the proper means of obtaining it. Earlier at *Off.* 1.26 Cicero notes that "most men when fired by desire for military commands, high office, or glory, forget the claims of justice", and Julius Caesar comes under the lash here: "He undermined all laws, divine and human, in order to establish that dominion which his erroneous belief had targeted for himself".

2	**Sallust remarks:** For the two quotations which follow, contrasting the principled and the unscrupulous paths to glory, see *Cat.* 11.1–2, already cited at ch. 12.10 above.

3 **a great virtue to despise glory:** Sallust's extravagant praise of the younger Cato at *Cat.* 54, which culminates in the statement 'quo minus petebat gloriam, eo magis illum sequebatur' (54.6) is probably behind Augustine's initial reflection here before he turns to Christian beliefs.

virtues as a gift from the Spirit of God: For Augustine's insistence that human virtues are the outcome of 'infused' grace, see *De gratia et libero arbitrio 6* (*PL* 44.889) and §6 below.

loves even his enemies: In the spirit of *Matt.* 5.44.

4 **Nero Caesar:** The chief sources for the career of Nero (Tacitus, Suetonius, Cassius Dio, the Elder Pliny) all draw on hostile testimonies (see M.T. Griffin, *Nero, the End of a Dynasty* (London 1984) App. I) and lay particular emphasis on the emperor's debased sexual proclivities and his cruelty; see, e.g., Suetonius, *Nero* 27–9, 33–8 with K. Bradley's *Commentary* (Brussels 1978).

the words of God's wisdom: See *Proverbs* 8.14–16 (Vulgate: 'Per me reges regnant... per me principes imperant'). Chs. 1–9 of *Proverbs* form a sub-section headed "Proverbs of Solomon" consisting of precepts delivered by 'Divine Wisdom'. Wisdom in this context becomes equivalent to Hypostasis or 'individual reality' (see *ODCC*³ s.v. 'wisdom'). Augustine's interpretation of the second verse, based on the rendering of the Itala, is not supported by modern translators or commentators.

the ancient sense of 'brave men...Virgil's line: The citation is from *Aen.* 7.266. The Trojan emissary Ilioneus has explained to King Latinus that the immigrant Trojans are asking to be accepted in partnership by the Latins. In reply, Latinus welcomes the proposal, with the qualification expressed here ("It will be a condition of the peace I offer that I must clasp the hand of your king", tr. David West). The word *turannos* passes into Greek from Asia Minor; it is first used in Greek of deities, and then of princes (so *LSJ*). Fordyce, in his edition of *Aeneid VII–VIII* (Oxford 1977), writes: "In Virgil's use the word has no suggestion of arbitrary or despotic power". Augustine's gloss, 'uetere nomine fortes' is not supported elsewhere.

He sets a hypocrite, etc.: So *Job* 34.30 (Vulgate has 'qui regnare fecit hominem hypocritam propter peccata populi'). The speaker is Elihu, a young participant in the discussion, who rebukes Job and proclaims God's justice. There is no agreement among modern commentators about the interpretation, but the sense in Augustine and the Vulgate is supported in *The Interpreter's Bible III* (Nashville 1954), 1146f.

5 **another more hidden reason:** Augustine implies that not merely the few Romans outstanding for virtue, but also the Roman race as a whole found favour in God's sight. He inherits this doctrine of Roman superiority from the Roman historians: see Livy's comment at *Praef.* 11: 'nulla umquam respublica nec maior nec sanctior nec bonis exemplis ditior fuit'.

in our sacred literature is called the city of God: Cf. *Ps.* 45 (46).5: 'Fluminis impetus laetificat ciuitatem dei', Also *Hebr.* 12.22, *Rev.* 3.12.

6 **those who are endowed with true devotion:** Augustine paves the way for his encomia of Christian emperors in chs. 25–26 below.

ascribe their virtues...to...God's grace: See §3n. above.

XX *It is as demeaning for virtues to be slaves to human glory as to bodily pleasures*

1 **Philosophers who proclaim virtue itself to be the highest human good:** Augustine refers to the Stoics, and in particular to Cleanthes of Assos (331–232 BC), the second head of the Porch after Zeno. Cicero at *Fin.* 2.69 attributes to him the image of enthroned Pleasure served by the cardinal virtues; see the following nn.

philosophers who...assess them according to the goal of physical pleasure: For the Epicurean theory of the relation between pleasure and the cardinal virtues see especially Cicero, *Fin.* 1.42–54 and *Off.* 3.118, together with J.M. Rist, *Epicurus, an Introduction* (Cambridge 1972), 122–6.

in this picture: Unlike Augustine, Cicero at *Fin.* 2.69 does not specify the four virtues individually; collectively they warn Pleasure not to act 'imprudently' by causing public offence or pain, and they add: "We virtues were born to be your servants; we have no other tasks".

Prudence: Pleasure's instruction to her is inspired by the collective advice of the virtues in Cicero. For Epicureans such practical wisdom is vital, because "sober reasoning assures a happy life" (Diogenes Laertes 10.6). In Cicero's words, "Epicureans present prudence as the knowledge which affords pleasures and banishes pains" (*Off.* 3.118: see in greater detail *Fin.* 1.42–6).

Justice: For Epicureans, "laws exist so that men may not suffer injustice. The just man is he who is most undisturbed" (*Basic Doctrines* 17). As Rist, 123, puts it, the aim of justice is "to establish the maximum of security and untroubledness (*ataraxia*)". This attitude incurs the inevitable criticism that this and other virtues are sought not for their own merits but for the pleasurable life, they 'fall flat' (Cicero, *Off.* 3.118).

to secure the friendships: In the Epicurean system of ethics, friendship is associated with justice because it is the most valuable of the social virtues, enabling man to live a more peaceful and less hazardous life, because of the security and reassurance which friends provide. See Rist, *Epicurus*, ch. 7.

The command to Courage: Cf. Cicero, *Off.* 3.118: "Courage too they promote in some sense, when they propound a rationale for disregarding death and enduring pain". The relationship of courage with pleasure is spelled out in greater detail at *Fin.* 1.49, *Tusc.* 5.74.

She instructs Temperance to restrict her intake of food, etc.: Cicero's antipathy towards Epicureanism leads him to overemphasise the cruder elements of the school's doctrine of pleasure as the chief good. The *Letter to Menoeceus*, Epicurus's own summary of the doctrine of pleasure, states: "The habit of simple and inexpensive diet maximises health...so when we say that pleasure is the end, we do not mean the pleasures of the dissipated and those that consist in having a good time, as some out of ignorance and disagreement or refusal to understand suppose we do, but freedom from pain in the body and freedom from disturbance in the soul". (tr. Long–Sedley, *The Hellenistic Philosophers* I (Cambridge 1987), 114).

Pleasure which Epicureans identify above all with physical health: See the passages in Long–Sedley, 112ff., especially *Letter to Menoeceus* 127 (Long–Sedley, p. 113): "Steady observation...makes it possible to refer every choice and avoidance to the health of the body and the soul's freedom from disturbance".

2 These critics say...: For some qualification of the view, advanced by Pohlenz and others, that Stoic ethics are best viewed as hostile reaction to Epicureanism, see J.M. Rist, *Stoic Philosophy* (Cambridge 1969), ch. 3.

4 in their claim to be contemptuous of glory: Augustine initially has in mind the Younger Cato. According to Sallust, *Cat.* 54, "the less he sought glory, the more it attended him". The danger is then addressed to fellow-Christians.

XXI *Rome's rule was ordained by the true God, from whom all power descends, and by whose providence all things are governed*

1 according to the will of him whose will is never unjust: It is a recurrent theme in the work that though we cannot discern God's purposes in the ordering of human affairs, we must never doubt his justice. See especially XX 2, an extended discussion in which he argues that God's just apportionments will become clear to us on Judgement Day.

2 to the Assyrians and to the Persians: Augustine has already adverted briefly to these empires at IV 6–7, where on the authority of Eusebius (via Jerome) he claims that the Assyrian empire endured for 1240 years. Cyrus the Great, king of Persia, conquered the Medes in 550–49 BC, and thereafter the Babylonian empire. For further detail and bibliography, see my nn. on those chapters.

they worship only two gods: Later adherents of Zoroastrianism claimed that the world was created by one 'Wise Lord' (Ahura Mazda, or Ohrmuzd), but that he was opposed by an uncreated evil spirit (Angra Mainyu, or Ahriman). See *ODCC*[3] 'Zoroastrianism', with bibliography. The Greeks knew of Zoroastrianism as early as the fifth century BC (see, e.g., Herodotus 1.131ff. with the *Commentary* of How and Wells, Appendix VIII). Augustine's knowledge of the cult will have dated from the period of his flirtation with the Manichees, whose rivalry with the Zoroastrians led to Mani's execution. See Peter Brown, *Religion and Society in the Days of St Augustine* (London 1972), 99f.

I have already discussed them: The reference is to IV 14, where the monotheism of the Jews is contrasted with the polytheism of the Romans. See my nn. there. The implication here is that the one true God bestowed temporal power on the Romans in spite or their irrational theology, so manifestly inferior to that of earlier empires.

3 on Marius and...Caesar, etc.: In this series of pairings, Augustine demonstrates that God entrusts supreme power to the worthy and unworthy alike. The first pairing by implication condemns Marius, whom earlier Augustine portrays as cruel and treacherous (see III 27, 29) and approves of Julius Caesar, who is depicted neutrally in earlier books, but praised earlier in this book at ch. 12 and also later at IX 5, with no condemnation of his subversion of the senatorial government.

on Augustus and on Nero as well: Similarly Augustine by implication praises Augustus by contrast with Nero. At III 21 it is acknowledged that Augustus deprived the Romans of political freedom, but this he found necessary to restore the state to health; likewise at III 30 he is reproached for waging civil wars and permitting the murder of Cicero, but thereby he inaugurated more enlightened days by bringing peace to the Roman world (so XVIII 46, XXII 7). For the condemnation of the cruelty and depravity of Nero, see ch. 19.4 above, and for his role as Antichrist persecuting the Church, XVIII 52, XX 19.

the Vespasians...Domitian: The Flavian emperors (Vespasian, AD 69–79, Titus, 79–81, Domitian, 81–96) do not appear prominently elsewhere in this treatise. The tribute to Vespasian echoes that of the sources, which praise him for restoring peace after the anarchy of AD 68–9, and for his modest life-style as emperor; see B. Levick, *The Emperor Vespasian* (London 1999). His son Titus likewise enjoyed esteem in his two-year reign; Suetonius (*Titus* 1) describes him as 'amor ac deliciae generis humani' in recognition of his benevolent administration. See B.W. Jones, *The Emperor Titus* (London 1984). By contrast, his brother Domitian was a more ruthless autocrat. His execution of at least twelve consulars and his unhappy relations with the senate made the sources (Tacitus, the Younger Pliny, Suetonius) uniformly hostile. See B.W. Jones, *The Emperor Domitian* (London 1992).

Constantine...the apostate Julian: The first Christian emperor is appropriately contrasted with his nephew, who converted from Christianity to Neoplatonism. For Constantine, see ch. 25 below. The disastrous campaign of Julian on the eastern frontier has already been signalled by Augustine at IV 29. The emperor ordered all his ships except twelve small vessels to be burnt to ensure that they did not fall into enemy hands. For this and his subsequent death in AD 363, see my nn. on IV 29.

a sacrilegious and abominable curiosity: Augustine inherited the phrase *sacrilega curiositas* from the *Golden Ass* of his compatriot Apuleius. In the story of Cupid and Psyche, Cupid warns his bride not to succumb to such *sacrilega curiositas* by gazing on his sleeping form (5.6.6). The word *curiositas* occurs no fewer than twelve times in the romance, and is the key to the moral of the story, for both the hero Lucius, and Psyche in the inserted folk-tale, are guilty of prying into the world of magic (Lucius) or hidden divinity (Psyche). Like Tertullian before him, Augustine extends the relevance of *sacrilega curiositas* to describe recourse to knowledge of God by any path other than the Christian religion. Thus at III 9 in this treatise he condemns Numa's *curiositas* for introducing the cult of gods at Rome. At IV 34 the Israelites are criticised for being seduced by *impia curiositas* in worshipping alien deities. At ch. 26 below Theodosius is praised for not relapsing into *curiositates sacrilegas*. See my article, 'The Rights and Wrongs of Curiosity, Plutarch to Augustine', *GR* 35 (1988), 74–85, drawing upon A. Labhardt, 'Curiositas', *Mus. Helv.* 17 (1960), 206ff.

if the frontier...had not been pulled back: After Julian's death mentioned above, his successor as emperor Jovius was compelled to accept a humiliating settlement in order to extricate the beleaguered Roman army. According to Ammianus 25.7.9–12, five of the nine satrapies across the Tigris were ceded to Persia.

that omen of the god Terminus: At IV 23.4 Augustine records that Terminus, god of boundaries, refused to vacate his shrine to make way for the building of the temple of Jupiter Capitolinus. Hence his shrine was unobtrusively incorporated into the new building. For the conflicting accounts of the sources, see my n. at IV 23.4.

XXII *The duration and outcome of wars are subject to the judgement of God*

1 **The war with the pirates:** In his review of the numerous struggles endured by Rome, Augustine makes brief mention of the menace of piracy and its suppression by Pompey

in 67 BC; see III 26.3 with my n. Pompey swept the western Mediterranean clear in forty days before turning to the eastern waters, bringing the whole campaign to a successful conclusion within three months.

the Third Punic War: The war actually lasted from 149 to 146 BC, but Augustine at III 21.6 refers to the capture of Carthage by Scipio Aemilianus in 'a single attack' of a few days in early 146 BC. See Florus 1.31.14ff.

the war with the runaway gladiators: Augustine refers briefly to this insurrection of slaves under the gladiator Spartacus at III 23.1; see my n. there. The war broke out in 73 BC, and the insurrection was finally crushed by Crassus two years later. The two consuls defeated were the chief magistrates for 72, L. Publicola and Lentulus Clodianus. For Spartacus's successes against other Roman generals, see R. Seager in *CAH IX²*, 121ff.

the Picentes, Marsi, and Paeligni: These tribal groups were prominent in the rising known as the Social or Italian War, to which Augustine twice refers at III 23.2 and 26.2. It broke out in 91 BC following the assassination of the tribune M. Livius Drusus, who had agitated on behalf of the Italian allies for political and economic concessions. Following a series of military operations (in which the two consuls killed were P. Rutilius Rufus in 90 BC, and L. Porcius Cato in 89) and political concessions, Rome was able to bring the war to a conclusion by late 89, rather than 87 as Augustine suggests. See E. Gabba, *CAH IX²*, ch. 4.

2 **The Second Punic War:** The privations of Rome in the Hannibalic War are discussed earlier by Augustine at III 19. The war lasted from 219 to 201 BC.

in two of the battles about 70,000 Romans fell: The reference is to the battles at Lake Trasimene (217 BC) and Cannae (216). The figure given by Polybius (3.84.7) and Livy (22.7.2) for Roman deaths at Trasimene is 15,000. At Cannae Polybius (3.117.4) states that 70,000 fell, whereas Livy offers the more modest figure of 48,200. Augustine may be citing the figures in Eutropius (3.10) of 25,000 plus 43,500. These figures are doubtless exaggerated; Scullard suggests that the figure for Cannae was about 25,000.

the First Punic War: See III 18 for earlier discussion of this war, which lasted from 264 to 241 BC.

the fighting with Mithradates for forty: This is the figure stated by Florus (3.5.2). The initial encounter between the Romans and the king of Pontus was in the mid-90s, when Sulla induced Mithradates to withdraw from Cappadocia. The sporadic engagements known as the First, Second, and Third Mithradatic Wars took place between 89 and 66 BC, which suggests that the alternative period of duration cited by Orosius (5.19) of thirty years is nearer to the mark.

war with the Samnites...for almost fifty years: The First Samnite War was fought in 343–1 BC, the Second in 327–321, and resumed in 316–304, and the Third in 298–290. See E.T. Salmon, *Samnium and the Samnites* (Cambridge 1967), chs. 5–7; T.J. Cornell, *CAH VII 2²*, 359–91. Augustine's phrase *ferme quinquaginta* suggests that Florus (1.5.8) or Eutropius (2.5), citing 50 and 49 years respectively, is Augustine's source here.

one defeat...sent under the yoke: This signal humiliation, already mentioned at III 17, was suffered in 321 at Caudium in the Second War. For the dispute which lies behind Augustine's condemnation of the Romans' duplicity ("they violated the peace and the treaty"), see Salmon, 225ff., Cornell, 370.

3 **many are ignorant...some even conceal their knowledge:** Augustine repeats the charge already made at IV 1, that hatred of Christianity impels pagans to conceal past disasters in order to attribute present hardships to the new Christian dispensation.

that war would already have been concluded: With particular reference to the hostile presence in Italy since AD 401 of the Visigoths under Alaric, culminating in the sack of Rome in 410.

with the aid of Mars and Bellona: The war-deities have been repeatedly cited together in Augustine's critique of Roman polytheism; see IV 11, 21, 34.

to resemble the sea under the heavy lash of a storm: This *uulgata similitudo* (the phrase is Livy's, citing a similar example at 38 10.5), by which dislocation in human affairs is compared with a storm at sea, occurs spontaneously to the rhetorician in Augustine. For the cliché, see *TLL* s.v. 'mare', III.

XXIII *The war in which Radagaesus, king of the Goths and worshipper of demons, was defeated with his forces on a single day*

1 **in very recent days:** The battle actually took place in 406, four years before Rome was pillaged by Alaric. In view of the tragic events of 410, it seems at first sight curious to hymn the mercies shown by the Christian God a little earlier. But Augustine claims that the massive forces led by a pagan princeling would have inflicted more grievous atrocities than the hardships endured under the Arian Christian Alaric, which from I 1 onwards he has been at pains to depict as unprecedented in their moderation. Hence the highly rhetorical string of rhetorical questions in §2 below, and the conclusion drawn in §4.

2 **Radagaesus, king of the Goths:** The evidence for this invasion in AD 405–6 by the Ostrogoth Radagaesus and his motley force of Germans is in Zonaras 5.26; Orosius 7.37. The battle, which was fought at Faesulae (and not near Rome) in August 406, is also exultantly hymned by Paulinus of Nola in Poem 21.4ff. Paulinus claims that the battle was fought "at the very entrance to Rome" so that one wonders if Augustine is following him here. The Roman commander was Stilicho, who as regent of the youthful Honorius was the *de facto* ruler of the western empire from 395 to 408. See Jones, *LRE* 1.184; E. Demougeot, *De l'unité à la division de l'empire romaine, 395–410* (Paris 1951), 361.

with his massive and monstrous column: Zonaras states that it was 400,000 strong; Orosius, more modestly, 200,000. Jones, *LRE* 1107 n. 55, regards these figures as 'not wholly incredible', in view of the huge number of captives sold as slaves.

suffered the deserved punishment of execution: So Orosius 7.37.

because he appeased and enticed the gods with daily sacrifices: It is clear that Radagaesus unlike Alaric was a pagan. Doubtless Augustine's contemporaries emulated Tacitus (*Germania* 9f.) in equating the German deities by syncretism with Mercury and Hercules.

3 **word came to us at Carthage:** Augustine was frequently in Carthage in these years, attending the series of councils called by Aurelian. The tenth council took place in August 405; it was then that Augustine would have heard these anti-Christian sentiments from pagans who as much as Donatists were the foes of the Catholic bishops; see Brown, *Augustine*, 230f.

to ensure that glory was not bestowed on demons: Throughout the discussion on the Roman gods in these early books, Augustine repeatedly argues that the deities are malevolent demons, familiar to him from the writings of the Middle Platonists (see *C.D.* VIII 15ff.) and from scripture. They are implicitly identified as fallen angels in such passages as VIII 22, XI 33.

4 **contrary to all precedent:** For this claim made earlier, see I 2.

5 **the true Lord...whipped the Romans:** Cf. *Hebr.* 12 6: "The Lord...whips the one whom he accepts".

XXIV *The true blessedness of Christian emperors*

1 **This dispensation:** That is, pagan emperors no less than Christians have administered the office equally successfully; see ch. 21.3 above, where the Flavian emperors receive praise.

2 **We count them blessed,** etc.: Augustine here presents the blueprint of his ideal emperor. Treatises on the good monarch were frequent in Hellenistic philosophy, but none have survived. Their influence, however, is perceptible in Cicero's *Republic* (1.54ff.) and in Seneca, *De clementia*, addressed to the youthful Nero in AD 55–6. In the exordium to this work, Seneca urges the emperor to take stock of his attitudes towards his subjects, which would serve the purpose of a mirror. The importance of impartial justice and a warning against vainglory are features there likewise emphasised by Augustine, who naturally lays additional emphasis on the emperor's obligation to live the moral life befitting a Christian, and to observe his duties towards God. See P. Hadot, 'Fürstenspiegel', *RAC* 8. 535–632.

XXV *Successes bestowed by God on the Christian emperor Constantine*

1 **the emperor Constantine:** Flavius Valerius Constantinus (Constantine the Great, AD 272/3–337) was proclaimed emperor by the troops at York in AD 306, following the death of his father Constantius Chlorus, the senior Augustus. He was grudgingly granted the title Caesar by the surviving Augustus Galerius, who had succeeded Diocletian on his retirement the previous year. For Constantine's career, see T.D. Barnes, *Constantine and Eusebius* (Oxford 1981).

worshipped the true God: Constantine attributed his victory over his rival Maxentius at the Milvian Bridge in 312 to the support of the Christian God. Thereafter as senior Augustus in Italy he gave privileges and benefactions to the Church and its clergy, and built several churches. In 313 the so-called 'Edict of Milan' (in fact a circular issued by his fellow-Augustus Licinius, granting the freedom of worship in the eastern provinces already granted by Constantine in the west) allowed Christianity to flourish throughout the empire. See Lactantius, *Mort. Pers.* 48; Eusebius, *Hist. Eccl.* 10.5; N.H. Baynes, 'Constantine the Great and the Christian Church' *Proc. Brit. Acad.* 15 (1929), 341–442.

the glory of founding an allied city: Concord with his fellow-Augustus did not last. Following his victory at Chrysopolis and the abdication of Licinius, Constantine founded

the city of Constantinople on the site of Byzantium in AD 324; it was solemnly dedicated in 330. Augustine's claim, derived from Eusebius, *Life of Constantine* 2.47.4ff., that the city contained no pagan temples or statues, is contradicted by Zosimus (2.31), who states that he built a sanctuary to the Dioscuri and set up statues of Apollo and Rhea. For bibliographies on the foundation, see *OCD*[3], 280; *ODCC*[3], 496.

as the sole Augustus: After his victory at Chrysopolis and the abdication of Licinius, he ruled as the sole Augustus from 324 till his death in 337.

In managing and waging wars: Already before becoming emperor he had experience of fighting on the eastern front as a junior officer of Diocletian, and on joining his father in Britain he had waged war against the Picts. As emperor initially based at Trier, he fought against the Franks on the Rhine. He was later occupied in a struggle for control of the western empire with Maximinus and his son Maxentius. After the victory over Maxentius at the Milvian Bridge in 312, warfare on the Rhine again engaged him in 313–15. The subsequent rupture with his fellow Augustus Licinius led to a further bout of civil war; after he twice defeated his rival in 316, as a result of which he became master of all Europe except Thrace, he conducted lengthy operations in the Balkans. But when Licinius resumed persecution of the Christians, he again resorted to arms, and defeated him at Chrysopolis; Licinius's abdication gave him control over the whole empire. In his later years based at Constantinople, he undertook further military operations on the Rhine and Danube. In short, he was an experienced and able soldier; for his genius in military organisation, see Jones, *LRE* 97ff.

He died...of sickness and old age: Shortly after Easter 337, he fell ill at Nicomedia, where bishop Eusebius baptised him on his death-bed. (It was the custom at that time to delay baptism so that the soul would be cleansed of sin at death.) He was about sixty-five years old.

leaving the imperial throne to his sons: In his anxiety to establish dynastic succession, Constantine had already appointed two of his sons, Crispus and Constantine II, as Caesars in 317; a third son Constans was similarly designated in 333. Crispus, however, was executed in mysterious circumstances in 326; Constantine II quarrelled with Constans, and was killed in 340 at Aquileia. Constans was thus left in control of the western empire. He was killed in a coup engineered by the general Magnentius in 350. See Jones, *LRE* 84f., 112ff.

2 **He removed Jovian much more quickly than Julian:** Augustine has already referred to the circumstances of Julian's death at IV 29 and ch. 21 above (see the nn.). He had been proclaimed Caesar in 355 and Augustus in 361; he died in battle in 363. His staff-officer Jovian was then proclaimed emperor by his troops, but died eight months later in February 364, allegedly choked by fumes from a charcoal stove (Ammianus 25.10).

Gratian...killed by a tyrant's sword: Flavius Gratianus had been named Augustus at the age of eight by his father Valentinian I in 367. When his father died in 375, he ruled the empire from Trier, and in 379 appointed Theodosius I as Augustus in the east. A good Christian, but an inexperienced administrator, Gratian was killed in 383 when the usurper Magnus Maximus was proclaimed Augustus by his troops in Britain, and invaded Gaul to seize the leadership of the west. The officer of Maximus who dealt the

fatal blow was Andragathius. See Zosimus 4.35.6; Orosius 7.34; Jones, *LRE* 156ff.

Pompey could not be avenged by Cato: When Pompey was defeated in the Great Civil War by Julius Caesar at Pharsalus in August 48 BC, he fled to Egypt, where on the king's orders he was treacherously murdered on landing. The Younger Cato, who had remained at Dyrrachium during the engagement at Pharsalus, took over the leadership of the senatorial rump at Utica in Africa, but after the defeat at Thapsus in April 46, he committed suicide rather than submit to Caesar. Augustine discussed his suicide earlier at I 23; see my nn. there, and in general, Scullard, *From the Gracchi to Nero*, 142ff.

Gratian...was avenged by Theodosius: After Gratian's death, Theodosius initially (383–7) recognised Magnus Maximus's sovereignty over the Gallic provinces. But when in 387 Maximus invaded Italy and expelled the Augustus Valentinian II (who was then sixteen; Augustine gives the impression that he was younger) Theodosius responded to the appeal of Valentinian and his mother Justina, and marched against Maximus, defeating him in Pannonia at Siscia and Poetovio. Maximus retired to Aquileia, where he was executed. See Zosimus 4.52ff.; Orosius 7.35; Jones, *LRE* 159.

in spite of his having a very young brother: This was Valentinian II who was eight at that time in 379.

XXVI *The faith and devotion of the Augustus Theodosius*

1 **received...Valentinian into his sphere of the empire:** Valentinian II and his mother Justina retired to Thessalonica; see Jones, *LRE* 159.

hemmed in by his responsibilities: Theodosius vas heavily involved at this time in Thrace and Pannonia with the incursions of the restless Visigoths.

sacrilegious and forbidden superstitions: For Augustine's fondness for the phrase *sacrilega curiositas* as description of non-Christian religious practices, here with reference to Theodosius's refusal to consult pagan oracles about his future, see the n. at ch. 21.3.

he communicated with John: John of Lycopolis was famed for his gift of clairvoyance. He is given pride of place at the beginning of *Historia monachorum in Aegypto* (Greek text edited by A.J. Festugière in *Subsidia Hagiographica* 34 (Brussels 1961); Latin text edited by Rufinus in *PL* 21, 387–442; translated as *The Lives of the Desert Fathers* by N. Russell (Oxford 1981), where it is claimed that "to Theodosius he not only predicted everything that God was going to bring about in the world, but also indicated the outcome, foretelling the rebellion of usurpers against him and their subsequent swift destruction". Augustine later discusses this prophecy in his *De cura pro mortuis gerenda*, XVII 21; it is also mentioned by Palladius, *Lausiac History* 35; Cassian, *Inst.* 4.23–6. Theodosius has recourse to a Christian oracle as substitute for pagan *curiositas*.

2 **the boy soon died:** Following the execution of Maximus, Theodosius restored Valentinian II to the government of Gaul in 388, with the Frankish *magister militum* Arbogast as his aide-de-camp. He died four years later at Vienne by suicide or murder at the instigation of Arbogast, who proclaimed Eugenius as Augustus in his place.

Theodosius then crushed Eugenius: Flavius Eugenius, by origin a Roman rhetorician,

was a bureaucrat (*magister scrinii*, with legal and administrative duties; see Jones, *LRE* 367f.) at the court of Valentinian II. When Valentinian died, he was proclaimed Augustus at the prompting of Arbogast. Though nominally a Christian, he increasingly bowed before the influence of pagan voices in his entourage, and made concessions to pagan ritual, including the restoration of the Altar of Victory to the Roman senate-house. This development led Theodosius to march westward in September 394. He broke through the defences of the Julian Alps, and in a two-day battle defeated Arbogast and Eugenius in the plain below. This was the momentous battle of the Frigidus (modern Wipbach), which finally removed all prospect of a pagan revival at Rome. There is a good account of the battle in Homes Dudden, 429ff. For the sources, see especially Zosimus 4.58, Orosius 7.35, and others cited in the nn. below.

a second prophetic response: After the first day's engagement, in which Theodosius's army suffered heavy casualties, the emperor retired to an oratory to pray. In a dream John the Evangelist and the apostle Philip bade him to take heart, and to lead out his troops again to do battle. See Theodoret, *H.E.* 5 24.

soldiers who were on the spot have told me: This interesting citation by Augustine of the evidence of eye-witnesses does not indicate on which side they were fighting, though the impression left is that they were serving with Theodosius.

a fierce wind: This sudden and violent storm is attested by Ambrose, *Epp.* 62.4, 61.3, and also by Ambrose's biographer Paulinus, *Vita Ambrosii* 31. Both emphasise that it was providential and miraculous. Claudian incorporates the theme in the poem cited here by Augustine (see the nn. below), 93ff.

the poet Claudian...a foreigner to Christ's name: Claudius Claudianus, a native of Alexandria, migrated to Rome as a young man of twenty-four in 394, the year of the battle of the Frigidus. He at once made his name as a poet by composing a panegyric in honour of the two brothers Olybrius and Probinus, members of the illustrious Christian family of the Anicii, when they were designated as consuls for 395. His association with them, and later with the Christian court of Honorius at Milan, together with his sympathetic handling of Christian themes and personalities, has led some to argue that he was a Christian. He may have become a nominal Christian, or as Augustine and Orosius (7.35) state, remained a benevolent pagan, and perhaps there was not much difference. See Alan Cameron, *Claudian* (Oxford 1970), ch. VIII.

O one so greatly loved, etc.: The citation is from *The Third Consulship of Honorius*, 96–8 (the first line in Augustine combines the first half of 96 with the second half of 97). The poem was composed in 396. Theodosius had died in the previous year, leaving the empire to his two sons. Arcadius, who was eighteen, ruled the east; Honorius, a boy of ten, was left under the supervision of Theodosius's son-in-law Stilicho to govern the west. Stilicho became the *de facto* controller of the western empire from 395 to 408. Augustine is mistaken in assuming that these lines are addressed to Theodosius, for the addressee is Honorius. But Theodosius is lauded in the poem as the heroic victor at the Frigidus.

3　**he dismantled statues of Jupiter:** The defence of Italy against Theodosius had been entrusted to Nicomachus Flavianus, the praetorian prefect and a champion of the

traditional religion of Rome (see J.J. O'Donnell, 'The Career of Nicomachus Virius Flavianus', *Phoenix* 32 (1978), 129–43). Augustine's claim that he set up statues of Jupiter with golden thunderbolts (see Livy 22.1.17) along the fortifications of the Alps is not otherwise attested; the source may be the oral testimony of the soldiers earlier mentioned.

their sons, though not yet Christians, etc.: Among those who sought sanctuary in churches at Aquileia (see Paulinus, *Vita Ambrosii* 31) was the son of Flavianus. Following his father's suicide after the battle, he became a Christian. Arbogast's grandson likewise abandoned paganism for Christianity (so Sid. Apoll., *Ep.* 4.17; John Matthews, *Western Aristocracies and Imperial Court, AD 364–435* (Oxford 1975), 247).

to express the desire that they become Christians: According to Zosimus (4.59) and Prudentius (*Contra Symm.* 1.410ff.), Theodosius visited Rome later in 394, and urged the senators to renounce paganism. But since he was close to death from dropsy (he died on January 17, 395) this alleged visit has been regarded sceptically; see, e.g., Homes Dudden, 434–6; N.B. McLynn, *Ambrose of Milan* (Berkeley 1994), 354.

He showed them Christian affection, etc.: The role of Ambrose was crucial in Theodosius's merciful treatment of the survivors of Eugenius's forces. The bishop wrote to Theodosius repeatedly (see *Epp.* 62.3, 61.7) and finally visited him at Aquileia to plead for clemency. See Paulinus, *Vita Ambrosii* 31. Despite Augustine's claim, Flavianus's estates were confiscated, but later restored to his sons. Otherwise there were no proscriptions.

unlike Cinna, Marius, Sulla, and that ilk: Augustine has already condemned at length these leading figures in the disorders of the 80s BC, at III 27–8, and more briefly at II 22 and 24. See my nn.

4 by most just and merciful laws: Theodosius's legislation was incorporated in the codex Theodosianus (*CTh*) published under Theodosius II in 429–38 (edd. T. Mommsen–P.M. Meyer (1905); tr. C. Pharr, *The Theodosian Code and Novels* (N.Y. 1952)). In AD 380 the emperor issued a recommendation that all subjects subscribe to the Christian faith; all who did not comply were to be branded as heretics. In 381 he ordered that all churches be surrendered to bishops who accepted the decrees of Nicaea, and that no other religious gatherings should be permitted. Eighteen other constitutions debarred heretics from assemblies, and confiscated their buildings. Manichees were forbidden even to make wills or inherit property. Minor sects were to be rooted out, if necessary by executions (see *CTh* XVI 5 1–2, 6–24, 381–94). Even more drastic prohibitions were issued in 391–2. All pagan sacrifices were forbidden, and all temples closed. Even private worship of the Lares and Penates was outlawed (*CTh* XVI 10.10–11). See Jones, *LRE*, 165–9.

Valens had shown favour to the Arians: When Valentinian I succeeded Jovian as emperor in AD 364, he took over government of the western empire, and appointed his younger brother Valens, then aged thirty-six, to rule the east. Valens held office from 364 to 378 when he was killed at Adrianople in Thrace in attempting to repress a rebellion of the Goths. He had been baptised an Arian, but until 371 he had little leisure for ecclesiastical concerns. Thereafter he supported the Arians in opposition to the decrees

of the council of Nicaea, and their adhesion to the 'dated creed' of Sirmium (AD 359), which was ratified in slightly altered form at Constantinople (360). For his vigorous persecution of the 'Nicaean' party, see Jones, *LRE* 151f. Christian leaders expressed their dismay: Jerome, *Dial. contra Lucif.* 10, mourned that *"Death with Nicaea* was the cry. The whole world groaned, and was astonished to find itself Arian". When in 378 Ambrose wrote the *De fide* for the instruction of Gratian, he claimed that the heresy of Valens had brought disaster on the empire (2.139).

for he was well aware...not at that of the demons: Throughout the earlier books Augustine insists that the Roman deities are demons in disguise, inhabiting the pagan statues. Theodosius's decree that the statues be dismantled was enthusiastically obeyed by bishop Theophilus of Alexandria, who struck the first blow at the statue of Serapis when the Serapeum was levelled. For the ancient evidence, see Jones, *LRE* 1101, n. 77.

5 **a most serious crime perpetrated by the Thessalonicans:** In AD 380 a riot broke out at Thessalonica when the German commandant Botheric imprisoned a popular charioteer and refused to release him to participate in the races. In the ensuing disorder Botheric was murdered, and his body dragged through the streets. When Theodosius at Milan proposed to exact exemplary vengeance on the citizens, bishop Ambrose remonstrated with him and was assured that the emperor had relented. But Theodosius (so runs the story) at the prompting of his officials invited the citizens to a show in the Circus. At a given signal soldiers swept in and slaughtered 7,000 citizens. Ambrose excommunicated the emperor in a private letter (*Ep.* 51). Theodosius submitted to public penance, hearing mass but refraining from taking communion, and expressing contrition before receiving pardon. For details and sources, see Homes Dudden, 381–92; McLynn (with reservations about the details), 315–30.

those citizens: Augustine mistakenly suggests that Theodosius underwent his public penance at Thessalonica, and not at Milan.

6 **as a whiff of smoke:** Cf. *James* 4.14: "You are smoke (*uapor*) that appears for a little while, and then vanishes".

God bestows on good and evil alike: See the Preface to the *C.D.* and nn. there. Augustine at I.7–9 had already explored this theme, with its scriptural base at *Matt.* 5.45: "God makes his sun to rise on good and evil alike, and sends his rain on just and unjust". The discussion there is primarily concerned with the afflictions suffered by Christians no less than pagans, but I 8 refers also to worldly blessings bestowed impartially on both.

7 **the clearest proofs:** Book II was devoted to the moral bankruptcy of the Roman state as depicted by Sallust and Cicero, and Book III to the physical hardships which had plagued Rome since its foundation. Augustine stresses that the Roman deities had encouraged the moral degeneration, and had stood by during the physical disasters.

the advantages...which they bring to life after death: Augustine is to devote Books VI–X to refutation of this pagan claim.

to obtain friendships in this world, etc.: In other words, the friendly support of their deities in obtaining the material blessings in this world. The decrees of Theodosius had outlawed the ritual practices by which Romans sought such favours.

8 **after I had published the first three of these books:** Augustine thus indicated that he had begun the piece-meal publication of this work by first issuing Books I–III. The preface to I indicated that Marcellinus was still alive; since this imperial commissioner at Carthage was executed in September 413 (see Augustine, *Ep*. 151.6; Frend, *The Donatist Church*, 202f.), these books were circulating before that date – but not long before it, since the first book deals with the aftermath of the sack of Rome in August 410.

 when they can publish it without danger to themselves: It is not known if this rejoinder to Books I–III ever appeared. Augustine probably wrote these words in 415, for *Ep*. 169, sent to Evodius in that year, states: "To the three books…I have added two others". Following the repression of the Donatists in 410–12, and the earlier prohibitions of pagan sacrifices, it was inevitable that pagans would hesitate before publishing anti-Catholic pamphlets. See Peter Brown, 'Religious Coercion in the Later Roman Empire: the Case of North Africa', in *Religion and Society in the Age of Saint Augustine* (London 1972) 301–31.

9 **the shallowness typical of lampoons and of the mimic stage:** The expression *satyrica leuitas* may have reference to narrative counterparts of the mime such as Petronius's *Satyrica*, since it is unlikely that the satyric drama as a genre distinct from the mime still existed in Augustine's day. For the mime, see G.E. Duckworth, *The Nature of Roman Comedy* (Princeton 1971) 13ff.; for bibliography, *OCD*[3]. The genre was still popular in Augustine's day, incorporating such traditional themes as the senile man bedded with the nubile maiden, and the wicked stepmother (see Jerome, *Epp*. 52.2, 54.15). But there is good evidence that there were anti-Christian performances ridiculing baptism (see Augustine, *De baptismo* 7.53.101) and other ceremonies. C. Panayotakis, 'Baptism and Crucifixion on the Roman Stage', *Mnem*. 50 (1997) 302–19, cites among other evidence the Passion of St Genesius, who in the course of such a mimic performance before Diocletian dramatically turned an anti-Christian skit into confession of his conversion to Christianity.

 the man who Cicero says was called happy: Perhaps Augustine recalls from memory Cicero, *Tusc*. 5.55, where Cinna is condemned for murder of senators of integrity: "So is the man who slew them happy? On the contrary, he seems to me wretched, not only on account of what he did, but also because he behaved in this way as though he had licence to do these things, though no-one has licence to sin".

Indices

(References are to Chapters and Sections)

1. SCRIPTURE

2. GENERAL